HOW
ART
BECOMES
HISTORY

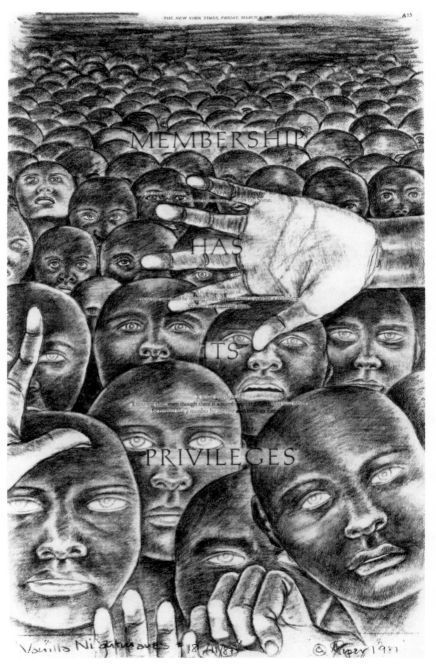

Adrian Piper, *Vanilla Nightmares #18*, 1987.
COURTESY JOHN WEBER GALLERY, NEW YORK

HOW ART BECOMES HISTORY

Essays on Art, Society, and Culture in Post–New Deal America

MAURICE BERGER

IconEditions
An Imprint of HarperCollins*Publishers*

The essays in this book, with the exception of "Black Skin, White Masks," were previously published in the periodicals or catalogs cited below, for which grateful acknowledgment is made:

"FSA: The Illiterate Eye," in *FSA: The Illiterate Eye*, New York, Hunter College Art Gallery, 1985, n.p.

"Of Cold Wars and Curators," *Artforum* 27, no. 6 (February 1989), pp. 86–92.

"World Fairness," *Artforum* 28, no. 2 (October 1989), pp. 131–34.

"Broken Bodies, Dead Babies, and Other Weapons of War," in *Representing Vietnam, 1965–1973*, New York, Hunter College Art Gallery, 1988, n.p.

"Race and Representation: The Production of the Normal," in *Race and Representation: Art, Film, Video*, New York, Hunter College Art Gallery, 1987, pp. 10–15.

"Yvonne Rainer's *Privilege*," *Artforum* 29, no. 3 (November 1990), pp. 27–28.

"The Myth of Tolerance: Young K.'s *Friendly America*," in *Young K.: The Friendly America*, New York, INTAR Gallery, 1990, pp. 3–9.

"Barbet Schroeder's *Reversal of Fortune*," *Artforum* 29, no. 6 (February 1991), pp. 23–25.

"Are Art Museums Racist?" *Art in America* 78, no. 9 (September 1990), pp. 68–77.

"Speaking Out: Some Distance to Go," *Art in America* 78, no. 9 (September 1990), pp. 78–85.

HarperCollins books may be purchased for educational, business, or sales promotional use. For information, please call or write: Special Markets Department, HarperCollins Publishers, Inc., 10 East 53rd Street, New York, NY 10022. Telephone: (212) 207-7528; Fax: (212) 207-7222.

FIRST EDITION

Library of Congress Cataloging-in-Publication Data
Berger, Maurice.
 How art becomes history: essays on art, society, and culture in post—New Deal America / Maurice Berger.
 p. cm.
 ISBN 0-06-430385-3 / ISBN 0-06-430202-4 (pbk.)
 1. Arts and society—United States—History—20th century. 2. United States —Civilization—20th century. I. Title.
NX180.S6B47 1992 90-56354
700'.1'03—dc20

92 93 94 95 96 DT/CW 10 9 8 7 6 5 4 3 2 1
92 93 94 95 96 DT/CW 10 9 8 7 6 5 4 3 2 1 (pbk.)

CONTENTS

LIST OF ILLUSTRATIONS

1. Mel Rosenthal, *Balducci's Greengrocer*, 1986. Black and white photograph, size variable.
2. Barbara Kruger, *Untitled (Your Body Is a Battleground)*, 1989. Poster for a march on Washington on behalf of reproductive rights, April 9, 1989, size variable. Collection of the artist.
3. Gran Fury, *Read My Lips*, 1988. Poster, size variable. Courtesy Gran Fury.
4. John Vachon, *House*. West Aliquippa, Pennsylvania, January 1941. Black and white photograph, 10 x 8". Library of Congress Collections.
5. Ben Shahn, *A member of a wheat threshing crew showing "chigger" bites*. Central Ohio, Summer 1938. Black and white photograph, 10 x 8". Library of Congress Collections.
6. Arthur Rothstein, *Farm Hand*. Goldendale, Washington, July 1939. Black and white photograph, 10 x 8". Library of Congress Collections.
7. Dorothea Lange, *The wife and children of a tobacco sharecropper*, Person County, North Carolina, July 1939. Black and white photograph, 10 x 8". Library of Congress Collections.
8. Ben Shahn, *Farmer sampling wheat*. Central Ohio, 1938. Black and white photograph, 10 x 8". Library of Congress Collections.
9. Eddie Adams, *South Vietnamese National Police Chief Brigadier General Nguyen Ngoc Loan executes a Vietcong soldier with a single pistol shot in the head.* Saigon, South Vietnam, February 1, 1968. AP Wirephoto.
10. Marion Post Wolcott, *"Buddy," the youngest child of packing house workers, sitting on the only bed for six people in their quarters. It is rolled out on the floor at night and rolled up and placed in the corner during the day.* Belle Glade, Florida, January 1939. Black and white photograph, 10 x 8". Library of Congress Collections.
11. Russell Lee, *May's Avenue Camp, an agricultural workers' shacktown. Children in the sleeping quarters of a family housed in a small shack.* Oklahoma City, Oklahoma, July 1939. Black and white photograph, 10 x 8". Library of Congress Collections.
12. Alexander Gardner, *A Burial Party*. Cold Harbor, Virginia, April 1865. Black and white photograph, dimensions unknown.

ACKNOWLEDGMENTS

These essays, written from 1985 to 1990, are indebted to Mason Klein, Barbara Kruger, Therese Lichtenstein, Adrian Piper, and Brian Wallis—good friends and colleagues who were never reticent about offering criticism, commentary, and editorial suggestions. It is through my many discussions with them that my ideas on post–New Deal art and culture were first developed. I have been fortunate to work with outstanding editors—Cass Canfield, Jr., of HarperCollins, David Frankel of *Artforum,* Ruth Limmer of Hunter College, and Brian Wallis of *Art in America*— and I would like to thank them for their brilliant editorial advice. Additionally, I am grateful to those friends and associates who have contributed in countless ways to this book: Jon Arterton, Frank Asterita, Elizabeth Baker, Yve-Alain Bois, Johnnetta Cole, Katherine Dieckmann, Donna DiSalvo, Patricia Falk, Henry Louis Gates, Jr., Ann Gibson, William Gilson, David Hammons, Mary Kelly, Rosalind Krauss, Maud Lavin, Louis Lo Monaco, Rose-Carol Washton Long, Lou Martarano, Robert and Lucy Morris, Linda Nochlin, Kathy O'Dell, Craig Owens, Ida Panicelli, Yvonne Rainer, Rob Rushton, Amy Schewel, Mary Schmidt Campbell, Donna Shalala, Lowery Sims, Carol Squiers, Shirley Verrett, Al Weisel, Pat Ward Williams, Leland Wheeler, and Sanford and Pip Wurmfeld.

Introduction:
How Art Becomes History

IN THE FALL OF 1986, the Whitney Museum of American Art sponsored a panel entitled "The Coming *Fin-de-Siècle*." Each panelist was asked to compare the loss of conviction in the modernist/industrialist revolution at the end of the nineteenth century with our own present-day cultural and social conditions. While challenging the undeniable historicism of the question, I ventured the following analogy:

> Among the enlightened upper classes in *fin-de-siècle* Vienna, art enjoyed such respect that even its most radical manifestations (along with its most mediocre) were "given the honor of excited debate and the balm of responsible patronage." Nevertheless, it appears that little was learned from the tormented images of Egon Schiele and Oskar Kokoschka. We need only look to Vienna of 1930 to understand the effects of such ideological myopia. We need only look to the legions of homeless people who sleep in the doorways of our culturally rich city to sense our own pathetic shortsightedness.[1]

Several months later, Roger Kimball "reviewed" the panel for the neo-conservative journal *The New Criterion*. Kimball felt compelled to deconstruct its Leftist dynamic. His most telling analytical stab came, not surprisingly, in reference to my remarks on homelessness:

> ... [Mr. Berger] concluded by citing the plight of the homeless as evidence of our shortsightedness. Of course, he never specified just what the homeless might have to do with art—how could he have done so, since they have nothing at all to do with art?—but for those susceptible to such pious invocations a mention of the homeless undoubtedly contributed something to the aura of virtue with which Mr. Berger was attempting to surround himself.[2]

It would be easy, even justified from the standpoint of good scholarship, to simply dismiss Kimball's argument as unrigorous and naive, for if one were to accept his reasoning then Courbet's disenfranchised *Stonebreakers* or Manet's wayward *Absinthe Drinker* would "have nothing at all to do with art."[3] The fact that a number of contemporary artists and art institutions through *aesthetic* means have explored the cultural and political ramifications of homelessness and poverty further undermines the logic of Kimball's claim [1].[4]

The post-Reagan era continues to be characterized by a myopic and heartless decline of government funding for the ever increasing ranks of desperate Americans: the poor, the homeless, the elderly, the handicapped, the drug-addicted, and people with AIDS have all seen the dissipation or elimination of programs that in the long term would benefit us all. Rather than ignoring such social injustice (or seeing it as irrelevant), a number of artists—in the spirit of Manet's critique of Haussmann's destructive replanning of the city of Paris or Courbet's support of the rights of the lower classes —have chosen to act as full participants in society rather than buy into the myth of the artist as the bohemian who lives outside the reality of class. These artists have also chosen to examine the complicity of the art world in the current reign

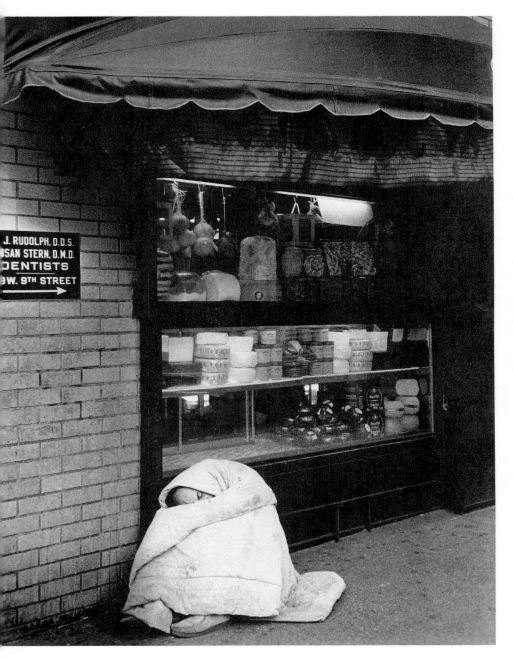

1. Mel Rosenthal, *Balducci's Greengrocer*, 1986

Your body

March on Washington
Sunday, April 9, 1989

is a

Support Legal Abortion
Birth Control
and Women's Rights

battleground

On April 26 the Supreme Court will hear a case which the Bush Administration hopes will overturn the Roe vs. Wade decision, which established basic abortion rights. Join thousands of women and men in Washington D.C. on April 9. We will show that the majority of Americans support a woman's right to choose. In Washington: Assemble at the Ellipse between the Washington Monument and the White House at 10 am; Rally at the Capitol at 1:30 pm

2. Barbara Kruger, *Untitled (Your Body Is A Battleground)*, 1989

of social reaction and oppression of the disenfranchised [2, 3]. The gentrification of the Lower East Side in the early to mid-1980s offers an outstanding example of this complicity as thousands of low-income tenants were driven out of their

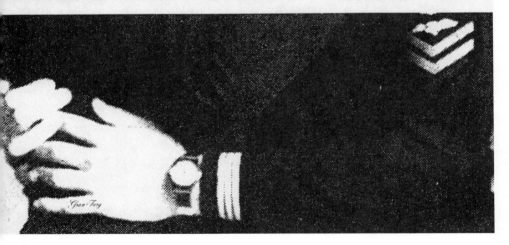

3. Gran Fury, *Read My Lips,* 1988

homes by ever increasing rents and the rapid influx of galleries, restaurants, and condominiums.[5]

Art historians and critics have generally avoided such issues. Ruled by the interests of upper-class white patrons, the

art world has long accepted the mythology of its own social removal—a system of belief that obtains even for journals far to the left of *The New Criterion*. The Baudelairean dandy, a hallmark of early modernist conceptions of the role of the artist in society, celebrated his distance from the grimy reality of a new, urbanized Paris by refusing to self-identify with a specific economic class. For the critic Clement Greenberg a century later, formalism could serve as a way out of the harsh realities of late-industrial society, but only as a *negation* of social reality—as a metaphysical transcendence from politics and mass culture (or what he called "kitsch").[6] And more recently, art history rooted in structuralist and poststructuralist methodologies—while considerably more sophisticated than formalism in its analyses of visual representation—most often continues formalism's apolitical bias by refusing to contextualize cultural artifacts in their broader socioeconomic context. The rise of neo-Marxist methodologies in the 1980s has not been without problems: frequently lacking a rigorous theory of representation, such writing has often settled on a naive iconographical approach. And all of these methods have preserved a fundamentally conservative and restrictive definition of high culture—one that invariably embraces the interests of white, upper-class people at the exclusion of others. Greenberg's racist and classist definition of high culture ironically continues to obtain: "There has always been on one side the minority of the powerful—and therefore the cultivated—and on the other the great mass of the exploited and the poor—and therefore the ignorant," he wrote in 1939. "Formal culture has always belonged to the first, while the last have had to content themselves with folk or rudimentary culture, or kitsch."[7]

Over the past decade, however, the biased ideological basis for art history and criticism has shown definite signs of weakening. For one, the nature of history writing—the historiography of art history and history in general—has come under intense scrutiny. The French historian Michel Foucault's influential analyses of history writing served as one important catalyst in this transgression of the tyranny of traditional historical models. In *Les Mots et les choses* (translated and published in the early 1970s in the United States as *The Order of*

Things), Foucault fundamentally undermined the linear organization of historical discourse, acknowledging not only the complex reality of these voices but the need to "approach [them] at different levels and with different methods."[8]

For Foucault, the historian was charged with a new responsibility: to constitute events synchronically in relation to the monuments and issues that defined them in their own time. His was a discourse liberated from traditions that imposed an often artificial causality on a given period's disparate meanings. The new history, Foucault wrote in *The Archaeology of Knowledge,* would establish a network of *discontinuous* events rather than a linear narrative based on historical convention.[9] For Foucault, the enemy of this historical reconstruction—and of the acceptance of diversity and discontinuity that it implies—is the conservative function of historical methodologies driven to produce neat cultural totalities. To accept openly the categories of discontinuity and difference in historical analysis is most often to be accused of "murdering history," to be denounced for attacking the "inalienable rights of history and the very foundations of any historicity." But one must not be deceived, Foucault continues, for

> what is being bewailed with such vehemence is not the disappearance of history, but the eclipse of that form of history that was secretly, but entirely related to the synthetic activity of the subject . . . what is being bewailed is the possibility of reanimating through the project, the work of meaning, or the movement of totalization, the interplay of material determinations, rules of practice, unconscious systems, rigorous but unreflected relations, correlations that elude all lived experience; what is being bewailed, is that ideological use of history by which one tries to restore to man everything that has increasingly eluded him for over a hundred years.[10]

While Foucault's deconstruction speaks to the structure of the historical narrative itself, the broader problems of who is entitled to write history and what is permitted to enter into the canon of history have recently come into sharper focus.

Since the mid-1970s in the United States and Europe, a number of influential cultural journals have challenged, mostly through poststructuralist theoretical methods, the conception of art and literary criticism and art history as ideologically neutral disciplines. But the monolithic hegemony of white, upper-class, heterosexual men was rarely questioned. Some historians and critics have recently attempted to move beyond diversity to include the possibility of *difference*—to allow those voices marginalized by official history to speak and to be heard: the colonized, the working classes, people of color, women, gay men, and lesbians have begun the process of writing their own histories, more or less independent of the hierarchies of the academic patrimony. Such enterprises as subalternist and feminist studies, the history workshop movement in Europe and the United States (which sponsors the publication of local-history pamphlets and workshops on the oral history of working-class people), and the Lesbian and Gay Activist History Project (sponsored by ACT UP, the AIDS Coalition to Unleash Power) have brought together academics, activists, and workers to change the social agenda of history.[11] Indeed, it is these projects that have cogently demonstrated the inability of "conventional methods of historical analysis—which create polarities or tend to choose the most 'dramatic' movement or end in the typical trajectory of linearity—[to] . . . excavate and disentangle all the voices" that constitute any historical moment.[12]

The essays in this book represent my own attempt to "disentangle" some of the numerous voices that have existed in America in the post–New Deal period. Having begun my art historical studies as an undergraduate at Hunter College in the mid-1970s, my own early and rigorous exposure to the discipline was undeniably formalist. My doctoral studies at the City University of New York—culminating in my dissertation and first book on the artist Robert Morris—was no less rigorous, but this time my work was grounded in the more eclectic theoretical realm of poststructuralism, centering on such figures as Roland Barthes, Michel Foucault, and the neo-Marxist art historian T. J. Clark. But in some sense, my art historical training remained at odds with my personal past. For nearly all of my childhood and early adult life, I

lived in a predominantly black and Hispanic low-income public housing project on Manhattan's Lower East Side. My white face often entitled me to privileged information concerning the disrespect of the white social and cultural bureaucracy for the art, character, and intellect of people of color. I am reminded of the time when a case worker in the Bernard Baruch Houses patronizingly explained to my mother and me why our economic poverty should not detract from the pleasant reality that we were "different" from most of the others in the project. I suppose that as the comforting fantasy of my art historical education began to fade —an education that did, at least for a while, distance me from my own difficult and painful past—the concept of what it meant to be "different" began to trouble me. For just like the social worker, I was taught how to construct defensive rationalizations in order to exclude people whose art was incommensurate with the dominant culture.

The effort of this book, then, is to place a number of powerful theoretical models in the service of a new art history—to change the terms of the art-historical canon to permit institutional and cultural analyses of such diverse subjects as the manipulative documentary tactics of the Farm Security Administration, racism at the 1964–65 World's Fair in New York, the inability of the art museum to embrace broader political and cultural subjects, the cultural politics of the Cold War, strategies of representation in Vietnam protest art, artists' efforts to expose the mythologies of truth and tolerance in the American legal system, and the pervasive racism of American art museums. These essays envision a broad-based cultural history that today is rarely accepted in the specialized space of academia. But if the discipline of art history is to survive and to remain relevant in a global economy fraught with deepening social and economic divisions, it will need to liberate itself from the shopworn methods of the past and to question the nature of its own biases. Rather than allowing social hermeticism and indifference to contribute to the problem, cultural historians must begin the project of constructing a discourse that can be part of the solution. Such positive ventures offer hope that our cultural and academic institutions will grow along with society and

not just protect the antiquarian interests of static, albeit valuable, objects. If we are to transcend the immoral and selfish values of the Age of Reagan, we must realize, as *The New Criterion* and most other cultural journals blindly miss, that the cliché of the pristine, socially removed art object offers no excuse for ignoring even a single life compromised by the interests of culture.

NOTES

1. Maurice Berger, opening remarks, "The Coming *Fin-de-Siècle,*" panel discussion, the Whitney Museum of American Art, 19 October 1986. The phrase within quotation marks was taken from Carl Schorske, *Fin-de-Siècle Vienna: Politics and Culture*, New York, Vintage Books, 1981.

2. Roger Kimball, "Sundays in the Dark at the Whitney," *The New Criterion* 5, no. 5 (January 1987), p. 84.

3. For more on the relationship of these artists to issues of class one should refer to the excellent work of T. J. Clark. See, for example, his *Image of the People: Gustave Courbet and the Second French Republic 1848–1851*, Greenwich, New York Graphic Society, 1973, and *The Painting of Modern Life: Paris in the Art of Manet and His Followers*, New York, Alfred A. Knopf, 1984.

4. These artists include, among many others, Krzysztof Wodiczko, Group Material, Candace Hill, Dennis Adams, Adrian Piper, Mel Rosenthal, and Martha Rosler. For more on this subject, see Rosalyn Deutsche, "Krzysztof Wodiczko's *Homeless Projection* and the Site of Urban 'Revitalization,'" *October*, no. 38 (Fall 1986), pp. 63–98, and Brian Wallis, ed., *If You Lived Here: The City in Art, Theory, and Social Activism/A Project by Martha Rosler*, Seattle, Bay Press, 1991.

5. See, for example, Rosalyn Deutsche and Cara Gendel Ryan, "The Fine Art of Gentrification," *October*, no. 31 (Winter 1984), pp. 91–111.

6. For an important analysis of Greenberg's strategy of negation, see T. J. Clark, "Clement Greenberg's Theory of Art," in Francis Frascina, ed., *Pollock and After: The Critical Debate*, New York, Harper & Row, 1985, pp. 47–63.

7. Clement Greenberg, "Avant-Garde and Kitsch," in Frascina, pp. 28–29.

8. Foucault continues: "If there is one approach that I do reject, however, it is that (one might call it, broadly speaking, the phenomenological approach) which gives absolute priority to the observing subject, which attributes a constituent role to an act, which places its own point of view at

the origin of all historicity—which in short leads to a transcendental consciousness. It seems to me that the historical analysis of scientific discourse should, in the last resort, be subject, not to a theory of the knowing subject, but rather to a theory of discursive practice." See Michel Foucault, *The Order of Things: An Archaeology of the Human Sciences,* New York, Vintage Books, 1971, p. xiv.

9. See Michel Foucault, *The Archaeology of Knowledge,* trans. A. M. Sheridan Smith, New York, Pantheon, 1972. On the collective inquiry of the new history, Foucault writes (pp. 5–6): "What one is seeing, then, is the emergence of a whole field of questions, some of which are already familiar, by which this new form of history is trying to develop its own theory: how is one to specify the different concepts that enable us to conceive of discontinuity (threshold, rupture, break, mutation, transformation)? By what criteria is one to isolate the unities with which one is dealing; what is a science? What is an *oeuvre?* What is a theory? What is a concept? What is a text? How is one to diversify the levels at which one may place oneself, each of which possesses its own divisions and form of analysis? What is the legitimate level of formalization? What is that of interpretation? Of structural analysis? Of attributions of causality?"

10. *Ibid.,* p. 14.

11. For more on this shift, see James Green, "Engaging in People's History: The Massachusetts History Workshop," in Susan Porter Benson, Stephen Brier, and Roy Rosenzweig, eds., *Presenting the Past: Essays on History and the Public,* Philadelphia, Temple University Press, 1986, pp. 339–59 and 415–19; Janet Abu-Lughod, "On the Remaking of History: How to Reinvent the Past," in Barbara Kruger and Phil Mariani, eds., *Remaking History,* Seattle, Bay Press, 1989, pp. 110–29; Gayatri Chakravorty Spivak, *In Other Worlds: Essays in Cultural Politics,* New York and London, Routledge, 1988, pp. 241–68; The Lesbian and Gay Activist History Project of ACT UP, "A His & Herstory of Queer Activism," unpublished manuscript, June 1989, n.p.; Douglas Crimp, ed., *AIDS: Cultural Analysis/Cultural Activism,* Cambridge, Mass., and London, MIT Press, 1988; and Ellen Willis, "Radical Feminism and Feminist Radicalism," in Sohnya Sayres, et al., eds., *The 60s Without Apology,* Minneapolis, University of Minnesota Press, 1984, pp. 91–118.

12. Barbara Kruger and Phil Mariani, "Introduction," in *Remaking History,* p. xi.

I

FSA: *The Illiterate Eye*

HE ARTS HAVE PRODUCED many works in which the poor are heroic, their plight sentimentalized, and the details of their lives made spiritual. (One thinks, for example, of the bittersweet moments of Vittorio De Sica's classic film *The Bicycle Thief* and the dignity of migrant workers in John Steinbeck's *The Grapes of Wrath.*) Set in the slums of Rome, Pier Paolo Pasolini's novel *A Violent Life* (1959) challenges this comfortable idea of the innocence of poverty.[1] Pasolini's world is brutal and violent: the poor are hungry. They are filthy. They are robbed. They are beaten by the police. They are devastated by physical and emotional illness. They die. Even the children's play yields to suspicions that their games are temporary escapes from horror and deprivation. Pasolini creates a field of provocation where the stench of urine and feces and the sight of blood, drool, and vomit constitute a leitmotif.

Pasolini wished to represent the brutality of "reality" and hence truth: "I would like to make it quite clear to the reader," he writes in a prefatory note to *A Violent Life,* "that everything he reads in this novel really happened, substantially, and continues to really happen." In preparation for

1

the novel, Pasolini lived in the slums, observing the day-to-day details of the lives of his subjects. In so doing, he reenacted a role frequently played in the history of photography, that of the documentarian determined to record society's darker, more tragic side. The Civil War albums of Alexander Gardner, Mathew Brady, and George Barnard, the survey of the Lower East Side poor conducted by Jacob Riis, and the child labor photographs of Lewis Hine are notable examples of the imperative to effect social change through photography. (Hine's disturbing images, in fact, served as the catalyst for significant reforms.) While such documentary photographs seem to be neutral, however, Pasolini's literary vision is admittedly influenced by his subjective judgment that Italy had degenerated into selfishness. Bristling with bitterness and resentment, *A Violent Life* is an uncompromising indictment of post-war Italy.

The contradiction between the will to represent "truth" and the fact that no representation can be entirely value-free poses the central ideological problem of the Farm Security Administration's eight-year effort to document rural poverty in Depression-era America. On 30 April 1935, by executive order, President Franklin Delano Roosevelt established the Rural Resettlement Administration, an agency assigned the task of documenting and ultimately alleviating the plight of the rural poor and migrant farmers displaced by dust storms. By 1936, 650,000 impoverished farm families lived on 100 million acres of substandard land. The Depression had placed more than a million rural families on relief rolls, families that even in good times lived in or on the edge of poverty. Like the rural poor in all times, they suffered out of sight of most Americans.

It was for the purposes of accumulating detailed statistical and photographic "proof" to help justify the need for action that Roy Emerson Stryker was hired to head the Historical Section of the Resettlement Administration, known after its reorganization as the Farm Security Administration.[2] Stryker, a young member of Columbia University's economics department and a protégé of Resettlement chief Rexford Guy Tugwell, was faced with a dual task: his unit had to demonstrate to an often unsympathetic Congress and public

the magnitude of rural America's problems while simultaneously stressing the relative success of government programs.

Stryker was acutely aware of the persuasive powers of photography. Assembling a staff of talented photographers that included Walker Evans, Dorothea Lange, Ben Shahn, Marion Post Wolcott, Russell Lee, Arthur Rothstein, John Vachon, Jack Delano, Carl Mydans, John Collier, and Gordon Parks, Stryker developed a "camera team" that he felt would help to "connect one generation's image of itself with the reality of its own time in history."[3] This "reality," in Stryker's mind, accepted the emergence of photography itself as a dominant medium. In the 1930s, photography in the United States—the popularity of "picture-taking" in everyday life—was developing concurrently with the FSA.[4] Flash units and small-format cameras were becoming readily available, while photojournalism burgeoned.[5] The rotogravure was replaced by the first picture magazines—*Life* (1936) and *Look* (1937). If the documentary approach initially served as a means to embarrass the Hoover Administration,[6] the New Deal soon institutionalized documentary photography, establishing it as an essential adjunct to reform. By the late 1930s both the widely disseminated images of the FSA and photography in general had become an important part of American life: "In a year or so," Stryker has written, "and with a suddenness matched only by the introduction of television twelve years later, picture-taking became a national industry."[7]

A window and front door of a country house in Pennsylvania, shot squarely by John Vachon's camera [4], suggests confinement. The window and door are closed, their curtains tightly drawn. A sharply cropped field reveals a rhythmic play of rectangles that accentuates the presence of a small sign on the door. It reads: PNEUMONIA. Vachon's scene is perversely empty, for the core of information—the racked body of the patient—is artfully elided, replaced by a single word. In its avoidance of traumatic evidence, Vachon's sterile image sequesters, like the state of quarantine it signifies. The blood and gore, the unsanitary conditions and violence of poverty are tempered in the FSA archive as they are not in Pasolini's uncompromising view. Neither mental ill-

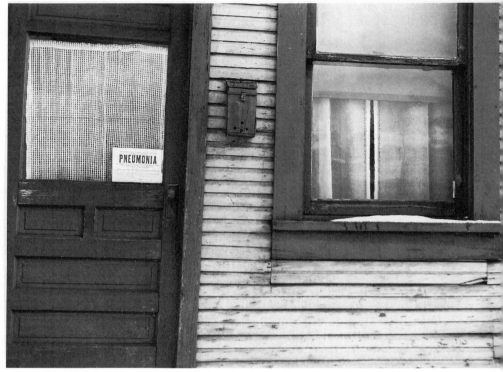

4. John Vachon, *House*, 1941

ness nor infant mortality,[8] for example—important indica-
tors of the gravity of economic devastation[9]—appear in the
Library of Congress subject index for the FSA file. In con-
trast, Ben Shahn's close-up of a young wheat thresher's torso
graphically illustrates the effects of insect infestation [5];
open sores juxtaposed against filthy, ragged clothing. While
such an image would have been rejected by most American
newspapers, it suggests the quality of "proof" necessary to
persuade a complacent country.

Fundamentally, it was Stryker who determined the ar-
chive's direction. Exerting almost dictatorial control over his
camera team, he wished, above all, to protect the dignity of
the poor: "To my knowledge," Stryker wrote, "there is no
[FSA] picture . . . that . . . represents an attempt by a pho-
tographer to ridicule his subject, to be cute with him, to

violate his privacy, or to do something to make a cliché."[10] But by limiting the right to expose demeaning details, he also limited the photographers' freedom to represent an essential condition of poverty: its denial of power and dignity.

Throughout the FSA project, Stryker maintained a moralist's view:

> The pictures that were used [by the press] were mostly pictures of the dust bowl and migrants and half-starved cattle. But probably half of the file contained positive pictures, the kind that gave the heart a tug.
>
> But the faces to me were the most significant part of the file. . . . Experts have said to me, oh no, that's a face of despair. And I say, look again, . . . you see the set of that chin. You see the way that mother stands. You see the straight line of that man's shoulder. You see something in those faces that transcends misery. . . .
>
> Those tragic, beautiful faces were what inspired [John Steinbeck] to write *The Grapes of Wrath*. He caught in words everything the photographers were trying to say in pictures. Dignity versus despair. Maybe I'm a fool, but I believe that dignity wins out.[11]

5. Ben Shahn, *A member of a wheat threshing crew showing "chigger" bites*, 1938

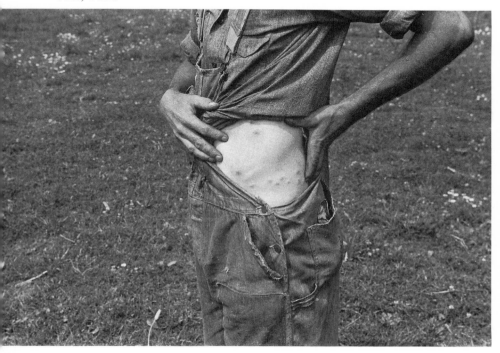

In his self-congratulating paean to the FSA, *In This Proud Land,* Stryker meditated on the agency's accomplishments and selected the photographs he believed best expressed its intentions. A number of the reproductions are misleadingly recaptioned by Stryker, their meanings manipulated. Russell Lee's image of the uneducated sons of day laborers evolves with Stryker's touch into a depiction of innocence: "You just know they're nice kids," he writes. Contrasted with a picture taken in an era when farmers were starving, the caption "simple pleasures . . . simple things" charges Lee's banal shot of a man enjoying a milkshake.[12]

As the spectre of American involvement in World War II grew, Stryker became a vehement protector of the country's positive image, almost abandoning the program's initial sympathies (the FSA was absorbed by the Office of War Information in 1942).[13] Marion Post Wolcott's pastoral wheat field in Marion, Virginia (1940), for example, is disturbingly coupled with Stryker's admonishment: "Emphasize the idea of abundance—the 'horn of plenty'—and pour maple syrup over it. . . . I know your damned photographer's soul writhes. . . . Do you think I give a damn about a photographer's soul with Hitler at our doorstep?"[14] Stryker's hidden agenda resulted in a controversial editing of the FSA file. Of the 270,000 photographs actually taken during the project's lifetime, Stryker destroyed—by punching holes in the negatives—about 100,000.[15]

Outside of the archive, the photograph itself is thought to project an instance of reality, a representation of nature free of cultural determinations. The FSA project, however, exposes the myth of photographic truth: "Every photographic image," writes Allan Sekula, "is a sign, above all, of someone's investment in the sending of a message."[16] The notion of the photographer's neutrality is untenable, for there exists, in the end, an innate "rhetoric of the image," where factors such as point-of-view, posing, distance, attention to and choice of details, and ultimately the selection of the subject and the cropping of the field connote innate motives and biases. Thus, Roland Barthes's analysis of a photograph on the cover of *Paris-Match:*

... A young Negro in a French uniform is saluting, with his eyes uplifted, probably fixed on a fold of the tricolor. All this is the *meaning* of the picture. But, whether naively or not, I see very well what it signifies to me: that France is a great Empire, that all her sons, without any color discrimination, faithfully serve under her flag, and that there is no better answer to the detractors of an alleged colonialism than the zeal shown by this Negro in serving his so-called oppressors. I am therefore again faced with a greater semiological system: there is a signifier, itself already formed with a previous system *(a black soldier is giving the French salute)*; there is a signified (it is here a purposeful mixture of Frenchness and militariness); finally, there is a presence of the signified through the signifier.[17]

Barthes's deconstruction of the image of a Black soldier in the context of French racial politics of the late 1950s elucidates the way in which a relatively ordinary press photograph organizes its field of meaning, both hidden and overt. Blind to such an ideological reading, however, most viewers see journalistic photography as providing information, possessing in its "empiricism" the legal power of proof. Thus the FSA was quick to seize photography as an evidential tool. "An image of a man's face," the FSA reasoning went, "stands for a man, and perhaps, in turn, for a class of men."[18] And yet, over and over again, the photographers of the Historical Section, as Sally Stein has observed, in general "avoided seeking out regularly those juxtapositions that challenged the customary myths of American democracy."[19] Faced with the rhetoric of FSA photography, one ponders to what extent protection of these myths sacrificed the cause of America's poor.

The rhetoric of the FSA image often rests on distortion: take, for example, a typical photograph by Arthur Rothstein, that of a farmhand in Goldendale, Washington [6]. Like many FSA subjects, the farmhand is shot from below, from an angle that traditionally signifies stature and esteem—the pose of the star, the dignitary, the hero. His affect is stilted and artificial as his eyes gaze out into the distance. A hoe planted firmly in his left hand strengthens the metaphor of

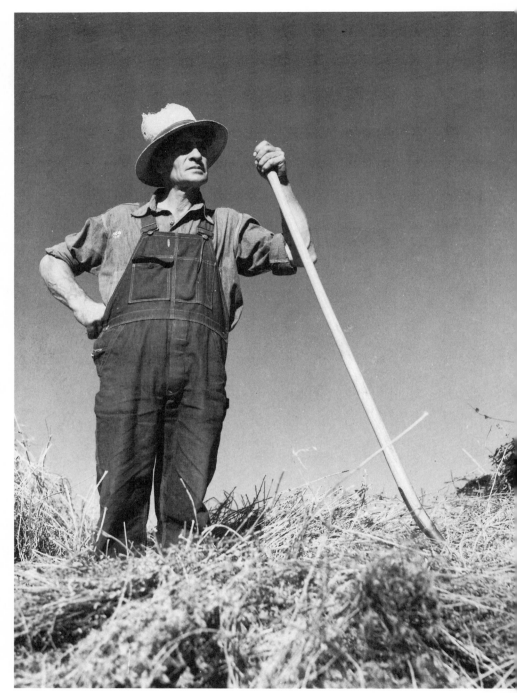

6. Arthur Rothstein, *Farm Hand*, 1939

stability. Rothstein's image rejects the bitterness of desperate times; like Jean François Millet's noble gleaners, the farm-hand speaks to a respect for hard labor and the dignity of toil. Dorothea Lange's *The wife and children of a tobacco share-cropper, Person County, North Carolina, July 1939* [7] similarly ignores the devastation. Not only do the robust mother and son smile, but the children appear clean, well-fed, and neatly dressed. The FSA archive overflows with portraits of com-fort. Middle-aged couples sitting in easy chairs in neat living rooms, people smiling, healthy children, and rugged faces proliferate, weakening the effect of the depictions of abject poverty, racial unrest, crime, disease, and despair.[20]

7. Dorothea Lange, *The wife and children of a tobacco sharecropper,* 1939

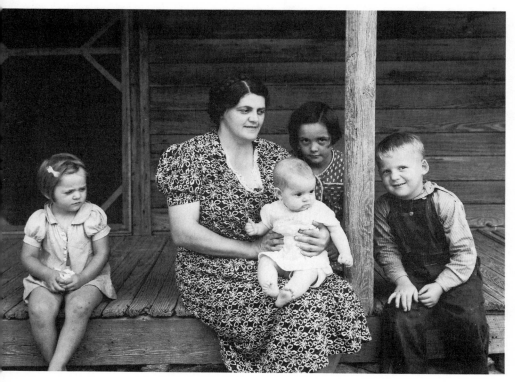

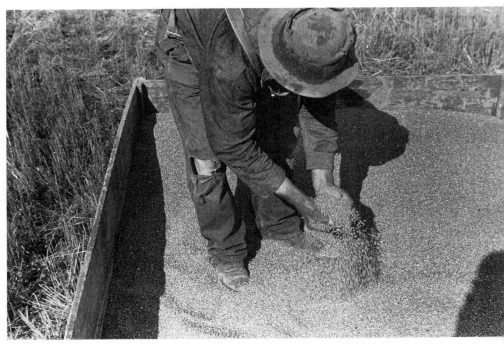

8. Ben Shahn, *Farmer sampling wheat,* 1938

There are, of course, compelling exceptions. Ben Shahn's
Farmer sampling wheat in Central Ohio, Summer 1938 [8] sug-
gests a corrective to FSA glorification of farm labor. In con-
trast to Rothstein's posed farmhand, Shahn shoots the filthy
and ragged farmer from above (a common device in his FSA
work), short-circuiting metaphors of dignity. Bent over and
completely anonymous, the farmer is captured from a per-
spective that underlines his position on the economic ladder.
More tragic is John Vachon's *Sick Child, Aliquippa, Pennsylva-
nia, January 1941.* Nestled in a heap of rags, old clothing,
and filth, the girl is too ill to respond to the photographer's
intrusion; in the midst of detritus and decay, she lies unpro-
tected. The viewer is left gasping at the utter desperation
and perilousness of her condition: "I cannot help her," one
thinks, "but neither can she help herself." But before such a
response is possible, one must experience the image's initial
impact, its potential to arrest speech, to produce trauma.

It is through trauma that the unstaged photograph manipulates most effectively. Thierry de Duve, in an analysis of the paradox of the time exposure and the unstaged snapshot, ascribes a "trauma effect" to the snapshot's instantaneous recording of an event. A special connection, he argues, exists between the snapshot and the temporal action it registers. Fundamentally, the camera collapses time, allowing an instant to represent an incident. Unlike the time-exposed, contrived photographic portrait, still-life, or landscape—images that appeal to memory, history, cultural convention, and language itself—the snapshot's prerequisites of instantaneity, sharpness, and precision initially inhibit speech:

> Language fails to operate in front of the pinpointed space of the photograph, and the onlooker is left momentarily aphasic. Speech, in turn, is reduced to the sharpness of a hiccup. It is left unmoored, or better, suspended between two moorings that are equally refused. Either it grasps at the imaginary by connecting the referential series, in order to develop the *formerly* into a plausible chronology, only to realize that this attempt will never leave the realm of fiction. Or it grasps at the symbolic by connecting to the superficial series, in order to construct upon the *here* a plausible scenography; and in this case also the attempt is structurally doomed. Such a shock, such a breakdown in the symbolic function, such a failure of any secondary process—as Freud puts it—bears a name. It is trauma.[21]

This breakdown in the symbolic function, the "trauma" induced by the snapshot, does not always depend on its content. While certain photographs are uncontestably traumatic —scenes of brutality, violence, obscenity—de Duve suggests that the ultimate trauma effect lies in the "immanent features of [the photograph's] particular time and space."[22] In other words, the temporal disposition of the image and the concomitant frustration of the viewer's sense of control render the photograph traumatic. For example, de Duve recalls a famous (and politically effective) press photograph from the war in Vietnam in which a Saigon police chief executes a Vietcong soldier with a pistol shot in the head [9]:

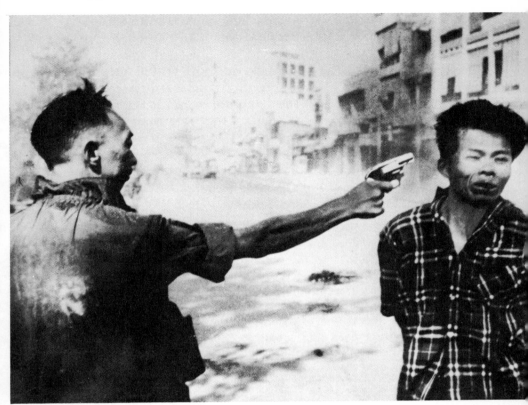

9. Eddie Adams, *South Vietnamese National Police Chief Nguyen Ngoc Loan executes a Vietcong soldier,* 1968

This is certainly a traumatic photograph. But although the traumatism seems to be generated by the depiction of the atrocities of war and assassination, it depends instead on the paradoxical "conjunction of the here and the formerly": I'll always be too late, in real life, to witness the death of this poor man, let alone to prevent it; but by the same token, I'll always be too early to witness the uncoiling of the tragedy, which at the surface of the photograph, will of course never occur. Rather than the tragic content of the photograph, even enhanced by the knowledge that it has really happened. . . . It is the sudden vanishing of the present tense, splitting into the contradiction of being simultaneously too late and too early, that is properly unbearable.[23]

The contradiction of being simultaneously too late and too early and the resultant denial of speech constitute a source of power for the image. The momentary aphasia produces more than trauma; it robs the viewer of a sense of center. Roman Jakobson observed that personal pronouns are the last elements to be acquired in a child's speech and the first to be lost in aphasia.[24] Thus, "to become aphasic before a photograph is to be effaced—to lose contact with the 'I' which would ordinarily begin any utterance made in response to the observed photo."[25] This effacement—this momentary loss of self—affronts complacency and, at times, has driven a vigilantly fearful media toward the censorship of the truly traumatic.[26]

Marion Post Wolcott's image of "Buddy" [10], the youngest child of destitute packing house workers, offers the passive viewer some insight into the truly traumatic. The child, straddling a rolled-up mattress, the only bed for his family of six, looks out at us as numbly, blankly, confused. His hand penetrates a small tear in the cloth walls of the tent, accen-

10. Marion Post Wolcott, *"Buddy,"* 1939

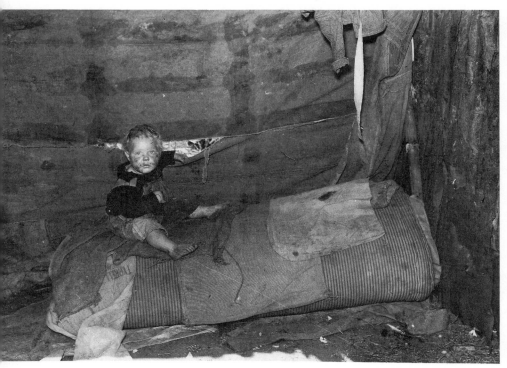

tuating how little protected he is from the even harsher reality that lies outside. Wolcott's eye neither sentimentalizes the child nor trivializes his condition. As with the Vietnam press photograph, the reader of the image is rendered momentarily speechless, caught between the ambiguous temporal space of being simultaneously too late to rescue the child and too early to witness the full extent of his suffering. Franz Kafka, in his short story "A Hunger Artist," portrays an equally pathetic world: "Our life happens to be such that a child, as soon as it can run about a little and a little distinguish one thing from another, must look after itself just like an adult; the areas on which for economic reasons we have to live in dispersion are too wide, our enemies too numerous, the dangers lying in wait for us too incalculable—we cannot shelter our children from the struggle for existence; if we did so it would bring them to an early grave." The tragedy of Wolcott's image is that the boy may be too emotionally fragile and is certainly too young for the struggle that lies ahead of him. More than forty years after this photograph was taken we wonder if he survived at all.

"Our editors, I'm afraid, have come to believe that the photograph is an end in itself," wrote Roy Stryker. "They've forgotten that the photo is only the subsidiary, the little brother, of the word."[27] Not surprisingly, Stryker required his camera team to maintain written records, to research fully the sociological profile of the area they were surveying, and, perhaps most important, to supply captions for each picture taken. While this information can indeed enhance the photograph's capacity to provide "facts," it also serves to reassert the rhetoric of the image. Because "visual and nonvisual codes interpenetrate each other in very extensive and complex ways,"[28] such reinforcement is unavoidable. Initially, however, the caption allows the reader to recover from the trauma induced by the photograph's temporal contradictions or shocking content. The caption provides a handle, a means by which language, in the act of constructing a logical narrative, may reenter the space of the photograph.

It is at this point that many truly shocking FSA images fail —either because they have been misleadingly recaptioned or because the photographer was indifferent to facts pin-

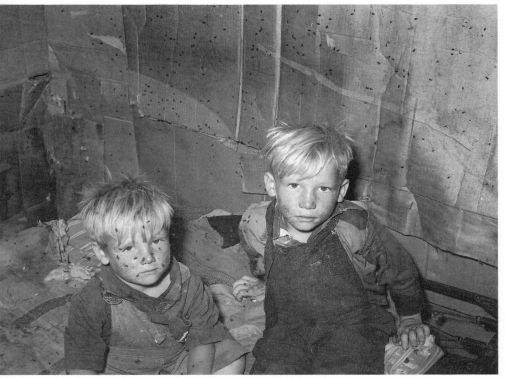

11. Russell Lee, *May's Avenue Camp*, 1939

pointed by his or her lens.[29] While Post Wolcott's caption for "Buddy"—in its attention to some of the horrific details of his life—refuses to temper the image's initial impact, many accompanying texts by FSA photographers assuage the mechanisms of shock. Although the photograph itself is direct and uncompromising, Russell Lee's caption for the image of two brothers [11] is a striking example: *May's Avenue Camp, an agricultural workers' shacktown. Children in the sleeping quarters of a family housed in a small shack.* Lee's written observation ignores the picture's most disquieting fact: the younger boy's face is covered with flies, the child exhausted by the futile act of shooing them away. Intentionally or not, the matter-of-factness of Lee's caption acts to soften the po-

litical potential of the scene it describes. Walter Benjamin
has written:

> . . . The camera will become smaller and smaller, more
> and more prepared to grasp fleeting, secret images whose
> shock will bring the mechanism of association in the viewer
> to a complete halt. At this point captions must begin to
> function, captions which understand the photography
> which turns all the relations of life into literature, and
> without which all photographic construction must remain
> bound in coincidences.
>
> Not for nothing were pictures of Atget compared with
> those of the scene of the crime. But is not every spot of
> our cities the scene of a crime? every passerby a perpetra-
> tor? Does not the photographer—descendent of augurers
> and haruspices—uncover guilt in his pictures? It has been
> said that "not he who is ignorant of writing but ignorant
> of photography will be the illiterate of the future." But
> isn't a photographer who can't read his own pictures worth
> less than an illiterate? [30]

Pier Paolo Pasolini has suggested that in questions of mo-
rality or behavior, an extreme offense is made acceptable by
reasserting metaphors of innocence. At the point that this
aura of innocence is transgressed—as in the brutal and filthy
space of *A Violent Life*—the audience, Pasolini argues, en-
gages in a kind of "nostalgia for the norm" and a subsequent
"reconfirmation of itself." [31] "An offended bourgeoisie," he
writes, "thereby presumes the right to opt once again for the
familiar, as if it were new." [32] The American media's elision
of sensational imagery—graphic evidence of death and dis-
ease—is usually justified as necessary to "protect" the public.
Such a view represents, in the end, a conservatism which
traditionally refuses to transgress the codes of acceptability,
offering instead what is most familiar, most tolerable.

The "nostalgia for the norm" has been evident in the his-
tory of photography from its inception. It is striking how
vacant, how empty of corpses are most of the photographs
taken by Mathew Brady and George Barnard during the
Civil War. Rather than a detailed record of war, most of their
images propose the visual terms on which victory and heal-

ing might be conceived. "By memorializing, celebrating, remembering as sacred, [these] images participate in the process of making whole again, restoring American society to its familiar place in the bosom of nature."[33] But by masking the ravages of war, these Civil War albums offer little insight into the meaning of war, into the debased, perverse nature of human conflict. A single photograph from Alexander Gardner's *Photographic Sketchbook of the Civil War* suggests the potential for understanding [12]. And while the banal caption—*A Burial Party, Cold Harbor, Virginia, April 1865*—nearly subverts the impact of the image, its resonance, as Alan Trachtenberg writes, "continues beyond text

12. Alexander Gardner, *A Burial Party,* 1865

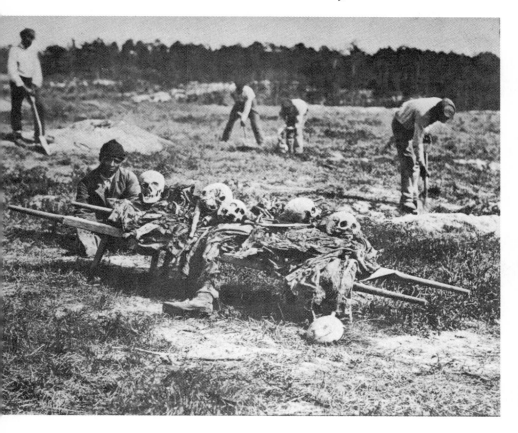

and frame, its grim ironies and bizarre revelations suddenly
flashing up before us, the very image of the remains [Oliver
Wendell] Holmes and his culture wished to bury: the decom-
posing flesh and bleached bones of the dead attended by
those whose claim to full humanity represented an aim of
the war already repressed during the war itself."[34]

The transgression of the code requires an artist who is
willing to defy the fundamental ideologies of his culture. In
its brief history, the FSA project yielded little activism on the
part of its photographers. "There takes place from time to
time," wrote Ben Shahn, "an imbalance between the stabiliz-
ing and visionary elements in society. Conformity is then
pressed upon everyone, and growth and change and art
come to a standstill."[35] Shahn's distrust of the government,
his apprehension of the archives' normalizing effect were so
great that he refused to allow a government lab to process
his film.[36] Post Wolcott exchanged a flurry of critical letters
with Stryker, attacking his penchant for "cheesecake" pho-
tography.[37] But on the whole, the picture that emerges from
the Historical Section is that of America's perseverance and
its triumphs over poverty.

It may have been impossible to save the FSA, to para-
phrase Walter Benjamin, from the "conformism that [was]
about to overpower it." But just as the Civil War was a real
conflict, so too was the Depression. If, as Shahn has sug-
gested, the degree of nonconformity present and tolerated
in society can be seen as a test of the state of its health,[38] then
Stryker's archive may allude to something as poisonous as
the conditions it often concealed. While the impulse to see
America as healthy and vital is as strong as ever, the suffer-
ing continues. In our own time, when the problems of pov-
erty and unemployment are subjected to the abstract myths
of dignity and self-sufficiency, we must begin to reexamine
the motives of seemingly blind media and political establish-
ments, to question the illiterate eyes that cannot read the
evidence that lies before them.

NOTES

1. See William Weaver's English translation of *A Violent Life*, New York, Carcanet, 1985.

2. For a detailed history of the Historical Section of the Farm Security Administration, see F. Jack Hurley, *Portrait of a Decade: Roy Stryker and the Development of Documentary Photography in the Thirties*, Baton Rouge, Louisiana State University Press, 1972; Warner Joseph Severin, "Photographic Documentation by the Farm Security Administration, 1935–42" (University of Missouri, unpublished master's thesis, 1959); and Hank O'Neal, *A Vision Shared: A Classic Portrait of America and Its People, 1935—1943*, New York, St. Martin's Press, 1976.

3. Roy Emerson Stryker and Nancy Wood, *In This Proud Land*, Boston, New York Graphic Society, 1973, p. 9.

4. John Tagg has explored the correlation between the rise of photography's popularity in America and the emergence of the sweeping documentary sensibility of the Historical Section, a relationship often built on the myth of photographic truth. See "The Currency of the Photograph" in *Thinking Photography*, ed. Victor Burgin, London, Macmillan, 1982, pp. 110–141.

5. As early as 1925, a Gallup survey showed high reader interest in pictures in newspapers and magazines. The poll was very influential, inspiring publishers, such as the Cowles brothers of the *Des Moines Register and Tribune*, to rethink the format of their publications. See Severin, p. xii.

6. For a discussion of Roosevelt Administration policies on the use of documentation, see William Stott, *Documentary Expression in Thirties America*, New York, Oxford, 1973.

7. Stryker and Wood, p. 7.

8. Michael Lesy's *Wisconsin Death Trip*, New York, Pantheon, 1973, explores the issue of infant mortality in relationship to a society's self-image. Lesy's intelligent analysis of Charles van Schaick's photographs of rural Wisconsin taken in the 1890s unmasks another period when the American Dream dissolved into the American nightmare. As the euphoria of the frontier myth faded, a growing awareness of rural decline, disease, death, and poverty developed. It was photographs like Van Schaick's—mostly images of dead children and infants—that best served to expose the deadly frustrations and disillusionment of the epoch. Of infant mortality, he writes:

> These diseases were awful and perverse not only because they paralyzed and destroyed whole countries, but because they inverted a natural order—that is, they killed the youngest before the oldest; they killed the ones who were to be protected before their rightful protectors; they killed the progeny before the forebears; they killed the children before their parents. When such

diseases created circumstances of fate so grotesque, so perverse, that they permitted the parents to outlive their infants, they permitted them to live on not only in grief but in guilt, since it was they who had failed to preserve their bloodline; it was they who had failed to maintain the immortality of their genes.

9. Exceptions within the archive are Jack Delano's arresting photographs of the inmates and brutal confinement chambers of an insane asylum in St. Thomas, U.S. Virgin Islands (1941).

10. Stryker and Wood, p. 7.

11. As quoted by Nancy Wood in Stryker and Wood, p. 14. In order to keep a balanced view of America, Stryker assigned elaborate shooting scripts to his photographers, and he expected them to follow the general outline of things to be singled out and photographed.

12. Not surprisingly, Lee was one of Stryker's favored colleagues. As Sally Stein has written, "Russell Lee . . . enjoyed far greater freedom in choosing his own subjects and determining his own work schedule, and Stryker's reasons for his trust in Lee's judgment were included in Nancy Wood's essay . . .' "When his photographs would come in, I always felt that Russell was saying 'now here is a fellow who is having a hard time, but with a little help he's going to be all right.' " ' From Stryker's perspective, Lee's photography accorded perfectly with the optimistic liberal rhetoric of the New Deal, exemplified by FDR's memorable phrase, 'the only thing we have to fear is fear itself.' " See Sally Stein, *Marion Post Wolcott: FSA Photographs*, Carmel, The Friends of Photography, 1983, p. 9.

13. The meaning of the FSA photographs has often been distorted for the sake of preserving America's image. In Edward Steichen's 1942 "Road to Victory" exhibition at the Museum of Modern Art, writes Christopher Phillips, "the dramatic turning point of the exhibition hinges on the juxtaposition of a photograph of the Pearl Harbor explosions with a Dorothea Lange photograph of a grim-visaged 'Texas farmer' who is made to say, in a caption, 'War—they asked for it—now, by living God, they'll get it!' Examining the original Lange photograph in the MoMA archive, one finds this very different caption: 'Industrialized agriculture. From Texas farmer to migratory worker in California. Kern County, November 1938.' " In 1962, Steichen curated a photo-essay exhibition entitled "The Bitter Years." Coming at the height of the Cold War, the exhibition served to reinterpret Depression-era photographs as an inspirational demonstration of, in Steichen's words, the "fierce pride and courage which turned the struggle through those long bitter years into an American epic." See Christopher Phillips, "The Judgment Seat of Photography," *October 22* (Fall 1982), p. 46. For a discussion on the problem of cropping and re-cropping, see Ulrich Keller, "Photographs in Context," *Image* (December 1976), pp. 1–12.

14. As quoted by Wood in Stryker and Wood, p. 16.

15. *Ibid.*, p. 17.

16. "On the Invention of Photographic Meaning," in *Thinking Photography*, p. 87.

17. *Mythologies*, trans. Annette Lavers, New York, Hill and Wang, 1957, p. 116.

18. Sekula, "On the Invention of Photographic Meaning," p. 94.

19. Stein, p. 4. Stein's work is pioneering in its effort to expose the Historical Section's general indifference to such matters as racial and gender discrimination and class difference. Stein sees Post Wolcott's FSA work as atypical of the archive in its unwillingness to mythologize the plight of the poor. Wolcott's keen eye—her will to contrast the complacency of the middle class with images of abject poverty, her acknowledgment of the moralizing attitude of social workers, and her attention to the bitter racism that exacerbated tensions in the South—produced a far more realistic picture of the indignity of the rural poor than most of the archive.

20. Stryker's shooting scripts often enforced distortive imagery. An entry from an outline which went to all FSA photographers in 1936 reads:

> Home in the evening
> Photographs showing the various ways that different income groups spend their evenings, for example: Informal clothes, listening to the radio, bridge, more precise dress, guests.

The gentility of Stryker's list is totally irrelevant to the impoverished. For a reprint of several of the assignment sheets, see Newport Harbor Art Museum, *Just Before the War*, Balboa, Newport Harbor Art Museum, 1968.

21. Time Exposure and Snapshot: The Photograph as Paradox," *October* 5 (Summer 1978), p. 119.

22. *Ibid.*

23. *Ibid.*, pp. 119–20.

24. For an analysis of Jakobson's idea in relation to language see Roland Barthes, *Elements of Semiology*, trans. Annette Lavers and Colin Smith, New York, Hill and Wang, 1967, pp. 22–23.

25. Kathy O'Dell, "Images of Violence: Functions of Representation," unpublished essay, 1982, p. 6.

26. O'Dell has explored the apprehensions of television and newspapers toward precise images of extreme violence. "By absenting the . . . gory core," O'Dell writes, "newspeople believe that they evade sensationalism. . . . What began as a protest against the exploitative and manipulated use of language has been transmuted into a sort of photographic and televised conservatism. Out of an effort to protect us . . . from the potentially traumatic effect of violence, we are provided with references which, in their continual elision of the central act of violence, keep us ever mindful of its having taken place and ever searching for its manifestation." *Ibid.*, p. 2. Of the nature of the media, Fredric Jameson writes: "One is tempted to say that the very function of the news media is to relegate such recent historical experiences as rapidly as possible into the past. The informational function of the media would thus be to help us forget, to serve as the very agents and mechanisms for our historical amnesia." See "Postmodernism and Consumer Society" in *The Anti-Aesthetic*, Port Townsend, Bay Press, 1983, p. 125.

27. Stryker and Wood, p. 8.

28. Victor Burgin, "Photographic Practice and Art Theory," in *Thinking Photography*, p. 83.

29. See note 13.

30. "A Short History of Photography," trans. Phil Patton, *Artforum* (February 1977), p. 51.

31. "What Is Neo-Zhdanovism and What Is Not," trans. Norman Mac-Afee and Craig Owens, *October 13* (Summer 1980), p. 7.

32. *Ibid.*

33. Alan Trachtenberg, "Albums of War: On Reading Civil War Photographs," *Representations 9* (Winter 1985), p. 23.

34. *Ibid.*, p. 29.

35. *The Shape of Content*, New York, Vintage, 1957, p. 97.

36. See O'Neal, p. 46. Shahn also wished to avoid the artistic look of fine art photography. He was opposed to using flashbulbs. He felt that his photographs for the FSA should "convey . . . the essence of human interaction and/or personality." To avoid an artificial or posed look, Shahn used a right-angle view finder that allowed him to look in another direction when he focused, detracting from "any self-consciousness people have." See John D. Morse, "Ben Shahn: An Interview," *Magazine of Art* (April 1944), p. 137.

37. Stein, p. 9.

38. *The Shape of Content*, pp. 100–101.

II

Of Cold Wars and Curators: The Case of Julius and Ethel Rosenberg

O N THE EVENING of June 19, 1953, the journalist Bob Considine offered an eyewitness account from Sing Sing Prison of the execution of Julius and Ethel Rosenberg. Convicted of conspiracy to steal and then pass to the Soviet Union "the secret" of the atomic bomb, Ethel, 38 when she died, and Julius, 35, were the only American citizens ever given a death sentence for espionage by a United States civil court. Considine's lengthy description, filmed by Hearst Metrotone News but never distributed, was alternately scornful, emotional, and rattled—not surprising for one who had just witnessed the gruesome spectacle of death by electrocution.

As Considine reported, Julius Rosenberg went to the electric chair first. He stared impassively as he walked slowly to the death chamber. Preceding him was Sing Sing's Jewish chaplain, who chanted the 23rd psalm: "The Lord is my shepherd, I shall not want. . . ." Rosenberg said nothing. He sat down in the chair, straps and electrodes were applied, and the first of three jolts of electricity was sent into his body. Two minutes later, the prison doctor announced to the three press-corps witnesses that Julius Rosenberg was dead.

Considine continued with a description of the execution of Ethel Rosenberg. "She died a lot harder," began his account. In fact the strangeness of Ethel's death provided another level of journalistic intrigue to an already unprecedented event in the history of American jurisprudence. When it seemed that she had received enough electricity to kill her (the exact amount received by her husband), the doctors approached her, lowered her "cheap prison dress . . . that little dark-green printed job," and placed a stethoscope to her heart. To the amazement of those present, she was still alive. So she was reconnected to the straps and electrodes and given more electricity. A plume of smoke drifted from her head toward the overhead skylight. After two more jolts, Ethel Rosenberg "had met her maker." Concluding his unbearable account of Ethel's unquiet death, Considine added, "she'll have a lot of explaining to do." [1]

Considine's report from Sing Sing exemplifies the pervasive clichés, stereotypes, and biases that informed media coverage of the Rosenberg case. For one, his assumption of the Rosenberg's lack of moral responsibility, implicit in his comment on Ethel's judgment before God, could only have fueled the anti-Semitism that charged the trial and its aftermath.[2] And the "cheap . . . printed job" he slighted— Ethel's green smock with white polka dots—was in fact an institutional version of the inexpensive summer dresses worn by millions of American working class women (including Rosenberg herself). But beyond these subliminal messages of ethnicity and class an even more gripping subtext was unfolding, one related to the issue of Ethel's gender. In the eyes of her accusers she was not "just a housewife"; she was stubborn, intransigent, perhaps even the driving force behind her mild-mannered husband. With her stoic manner, her refusal to admit her "guilt" (even if such an admission would save her life, and spare her two young children from orphanage), and her final defiance of death, Ethel Rosenberg signified a denial of men's authority over women. Her alleged communist affiliations seemed allied with that denial in mutually reinforcing abnormality. In short, Rosenberg threatened the patriarchy that supported the social order of American capitalism.[3]

Historically, an art museum would be an unlikely venue for reenacting this drama of cultural subjugation and otherness. The atrocities of Reaganism and Thatcherism, however, have generated an unprecedented cultural response that has included important political art and a number of exhibitions oriented toward the themes of marginalization and dissent. Perhaps none more dramatically exposes the innate difficulties of these projects than the traveling exhibition "Unknown Secrets: Art and the Rosenberg Era." Sponsored by the Rosenberg Era Art Project (REAP), instituted to support this exhibition and to publish its accompanying book, "Unknown Secrets" covers three areas of art sympathetic to the Rosenbergs; art of the period, works made in subsequent years, and new pieces commissioned specifically for the exhibition. Commensurate with its status as a museum show, "Unknown Secrets" turns to reified art objects, including generic prints by Pablo Picasso and Fernand Léger [13],[4] to explore the role of the artist in the protests against the execution of the Rosenbergs. But this curatorial focus on the "high culture" response to the case obscures critical questions about representation and power; who controlled the

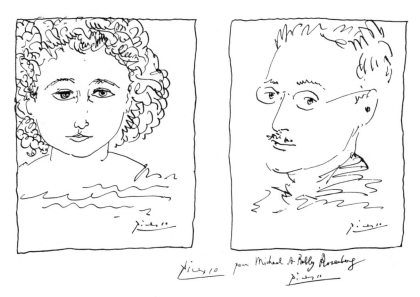

13. Pablo Picasso, *Untitled*, 1952

media discourse surrounding the Rosenbergs? [14][5] How might visual and written representations of the trial and its aftermath have worked against the hysterical cold war ideologies of the period? How could artists have transcended their own marginality (as in Berlin Dada, the Farm Security

14. *Ethel and Julius Rosenberg after arraignment,* 1951

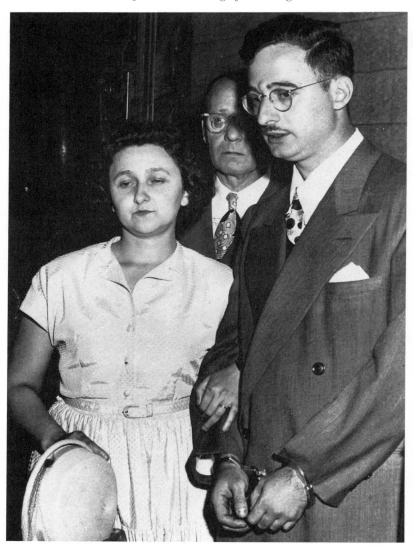

Administration in America in the '30s, the Vietnam period, or currently in the war against AIDS) by serving a more public role in the mass dissemination of visual and verbal information? Rather than addressing such questions, both the exhibition and the accompanying catalogue essays, by curator Nina Felshin and REAP director Rob A. Okun,[6] rehearse a range of myths about artistic sensitivity and the power of art to move people. As such, "Unknown Secrets" constitutes an important example of how issues of marginalization are themselves marginalized by the institutional hierarchies of the contemporary museum exhibition.

Given the abundant representations of the Rosenbergs in the mass media—radio, newspaper, and newsreel accounts, photographic documentation, posters and leaflets [15]— Okun's assertion that "the artwork of the Rosenberg era serves as a visual diary of one of the most horrific political events of the 1950s," seems myopically partial. It's not that the high-art approaches to the case are insignificant or un-revealing, but that they were only a corner of the battlefield. Enmeshed in the cold war ideologies of the late '40s and '50s, the investigation, trial, and punishment of Julius and Ethel Rosenberg and their alleged co-conspirator Morton Sobell fueled an explosive ideological conflict.[7] In that period of repressive domestic policies—the moment of McCarthyism —the protectors of establishment interests (including the Congress, the presidency, the courts, and the media) bol-stered their support of traditional social and economic values and practices that advanced the interests of affluent white men at the expense of other social groups.[8] The soldiers conscripted in this campaign for the political conscience of America were words and images—a plethora of verbal and visual representations that, like Bob Considine's stark report from Sing Sing Prison, offer insight into how public opinion was shaped and the role that mass culture played in the process.

The kind of political exhibition exemplified by "Unknown Secrets" remains substantially indifferent to these public rep-resentations. Buying into the museum's innate preference for high over popular culture, the shows eschew the kind of representations produced for mass consumption [16].[9] With

15. Louis Mittelberg, *His Famous Smile*, 1952

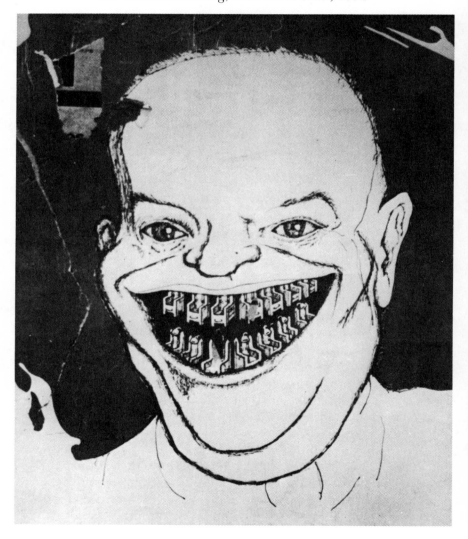

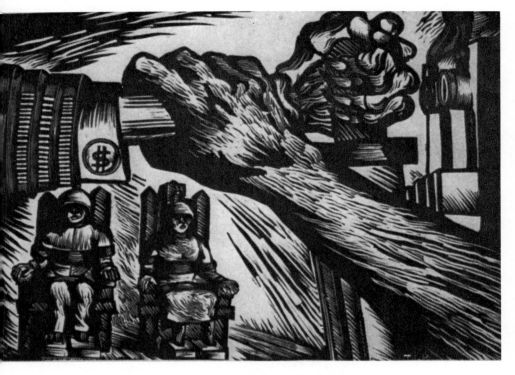

16. Francisco Mora, *Help Stop This Crime*, 1952

the exception of several posters and some of the commissioned theoretical works,[10] "Unknown Secrets" is comprised of conventional art objects [17]. The installation of the show in the fall of 1988 at its first venue, the Hillwood Art Gallery at the C. W. Post Campus of Long Island University, followed the static manner of the modern exhibition: paintings, prints, drawings, and mixed-media pieces arranged linearly on the walls, sculptural works centered in discrete gallery spaces. The hierarchies of the revered art object/reverent viewer are challenged only by the few new works employing television monitors or sound. The problem with "Unknown Secrets," as with many shows devoted to radical social issues, is deeper than the projection of sentimental or estheticized imagery: in order to constitute an "underground social history"[11] of marginal culture, such exhibitions would have to reorient the patrician social order of the museum.

17. Arnold Mesches, *The Funeral #2*, 1955

Over the last twenty years, a sizable critical discourse has explored how the institutional hierarchies of the museum, which are durable and hostile to change, reinforce an imaginary threshold beyond which art and social issues must not mix. When New York's Metropolitan Museum of Art, for example, refused to close its doors in support of the 1970 Artists' Strike against American involvement in the Vietnam War, and other issues of racism and oppression, it essentially reasserted its interior as a kind of neutral space that holds such issues magically in suspension. At the time, the board of directors explained their decision by citing the belief that art must be allowed to "work its salutary effect on the minds and spirits of us all." [12] Yet no one pretends that a museum visit can "cure" the disenfranchised. The directors' apparently altruistic belief in the healing power of art was actually a statement that urgent social concerns were irrelevant to the workings of the Met. In this respect, little has changed since 1970: of the approximately 250 museums and galleries invited to consider exhibiting "Unknown Secrets," only nine have agreed to take it (conformist as it is). Of these, eight are college-affiliated or alternative spaces.

In the work of the curator, which fastens on objects, conservation, and elegant installation, a resistance to the flux and chafe of the social sphere (and most particularly to issues of marginality) may be the path of least resistance. Despite the longstanding presence of Marxist methodologies in art history, and, more recently, of broad social and cultural investigations in the discipline,[13] contemporary curatorial method continually returns to shopworn principles established more than half a century ago by Alfred H. Barr, Jr., the first director of the Museum of Modern Art, New York, and uncontestably the father of Modernist curatorial studies. It was Barr's ambition to provide analyses of Modern art that were as scholarly as academic studies of earlier work. Despite his exposure to debates on the nature of social cause in art (particularly during his travels in Soviet Russia), his writing largely overlooked this particular kind of historical specificity. By attending to stylistic concerns above all others, Barr generally produced what is now commonplace in catalogue essays—a curatorial history constructed outside political or

social issues. In effect, he retrospectively validated certain sectors of the Modernist esthetic at the expense of others. While he read the abstract symbolism of Gauguin, for example, as a progenitor of German Expressionism, he omitted the activist realism of Gustave Courbet or Honoré Daumier from his historical equation.

The dualistic Modern art that Barr proposed—an art predicated either on abstract, rationalist tendencies or on dreamlike, romantic sensibilities—virtually occluded the idea of diversity, forcing actually contradictory elements into agreement in broadly defined and vigorously defended dialectical categories and movements. Barr's reading was fundamentally motivated by his belief in the exhaustion of "representational" art, and consequently in the autonomy of art from social conditions.[14] Ultimately, this hermetic style of curatorial discourse preempted the notion that one purpose of the art exhibition could be to analyze the relationship between society and the cultural artifacts it produces and sanctions. What is most problematic about Barr's still-prevalent model is that it rarely considers the audience or the societal imperatives for art; it presumes that such issues as patronage and the social temperature at both the art's creation and its reception are somehow irrelevant to the institutional interests of the museum. But the museum is not just a place to preserve beautiful objects; it is also a space where the relics and events of history can be juxtaposed in order to allow access to a range of social and cultural meanings.[15] Barr's and later curators' Wölfflinian obsession with style yields little insight into these broader questions, which over the past half century have liberated the discipline of art history from a mere recapitulation of the moribund practices of 19th-century esthetics and connoisseurship.

In the politically charged atmosphere of the United States in the late '60s and early '70s, the museum was challenged on a number of fronts.[16] Many of the early protests of the Art Workers' Coalition and the Guerrilla Art Action Group, for example, were waged specifically against the exhibition policies of various New York museums—policies that denied a voice to virtually all but an exclusive group of predominantly white male artists.[17] Robert Morris withdrew his "ret-

rospective" (itself an attempt to subvert the curatorial concept of the oeuvre) from the Whitney Museum of American Art in May 1970 in response to the continuing escalation of American involvement in the Vietnam War and to the tragic killing of four students by National Guardsmen at Kent State University; and Hans Haacke's social commentaries spoke directly enough to political issues of patronage and art-world money that the director of the Solomon R. Guggenheim Museum, Thomas Messer, canceled his 1971 one-person exhibition there in response to several offending pieces, including one that detailed the New York property holdings of slumlord Harry Shapolsky and his real estate group.[18]

A paradox of works like these was that as confrontationally as they treated the institution, the institution was crucial and integral to them. The counterculture activities of the '60s generated numerous alternatives to the museum, including performance art, street and guerrilla art, mail art, and protest spectacles; and the rise of alternative art spaces in this period gave voice to a number of marginal cultural positions —from feminist and gay issues to the politics of race and class. Yet it was important to the strategies of artists like Haacke that their major installations be exhibited in museums and galleries, functioning within the system but undermining its oppressive conventions and hierarchies. Rather than settling for the margins of the art world, and of the society at large, they argued, artists could gain empowerment through a subversive relation to institutional establishments. And eventually, with pressure from such organizations as the Art Workers' Coalition and in response to the growing importance of certain radical artists (it became increasingly clear that to exclude them would reflect a large museological failure), curators began to adapt to the idea of reorienting their exhibitions. Shows like "Anti-Illusion: Procedures/Materials," at the Whitney in 1969, and "Information," at MoMA in 1970, attempted to overturn the dependence on rarefied esthetic objects and static installations, allowing the inclusion of politically oriented and nontraditional art forms.

Such shows are the ancestors of the social-protest exhibi-

tions of the '80s. But these later manifestations rarely address the possibility of realignments that could actually help empower marginal subjects. An exhibition like "Unknown Secrets" does bring politics into the museum—indeed, the charged imagery of the show far oversteps the curatorial proscriptions that have developed out of the example set by Barr. Yet the show fails to demonstrate an understanding of the fact that the working-class affiliations of its marginal subjects, the Rosenbergs, are irrelevant to the upper-class interests of the institution, which is committed to validating rarefied esthetic objects. Conforming to the traditional bias of the museum, "Unknown Secrets" replicates a belief in the moral and spiritual efficacy of unique works of art. It ignores the important question of the action of cultural representations among the lower and middle classes—the socioeconomic sphere to which the Rosenbergs themselves belonged. An exhibition addressing that issue, of course, would not be the same show that these curators conceived; one cannot really say that they failed in their handling of the role of the media when they simply excluded it from their purview, which was theirs to define as they pleased. What one can say is that the area of contention they chose to focus on was easily homologized with a conventional idea of the museum's spatial politics—a politics in fact antithetical to the inclusion of the marginal, with which their sympathies clearly lay.

Undoubtedly, some of the unique artworks of the 1950s that dealt with the Rosenbergs were motivated by a personal desire for catharsis, or by the need to vent frustration with the increasingly hopeless battle to save them. The work, in other words, is not academic, or need not be (though its emotional urgency is no guarantee of its interest). But such art could not have politically empowered its subjects, or helped the Rosenbergs, since its social hermeticism and the fact of its uniqueness would have prevented it from reaching the broad audience that had already been manipulated and influenced by the anticommunist and anti-Rosenberg media campaign [18]. The art is revealing of a deep strain of popular sentiment, but in the end it had no power—if a criterion of power might have been, for example, the saving of the Rosenbergs' lives. The actual powers at play in the case can

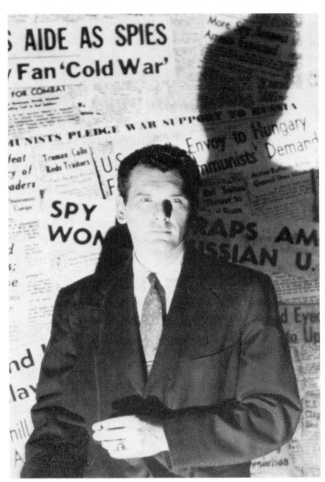

18. R. G. Springsteen, still from *The Red Menace*,
 1949

be perceived breathing through testaments such as the Con-
sidine narrative of the execution. Yet "Unknown Secrets"
essentially reinforces a doomed esthetic/political strategy by
valorizing its poignant remains.

The problem with "Unknown Secrets" is typical rather
than unique today,[19] but the Rosenberg case illuminates it
particularly clearly. The period of the investigation and trial
marked the beginning of an effort by American intellectuals

to examine the media's relationship to the dominant ideologies of American life. In this research the biases of popular culture and mass communication began to emerge as valuable indexes of the social state of the lower and middle classes. In the '30s, members of the Frankfurt School, motivated by Hitler's manipulation of the media to maintain power, had engaged in similar analyses. After the war, their writing influenced a number of American intellectuals to discuss the normalizing (and hence alienating) strategies of mass-cultural representations.[20] These critics began to analyze the way the media undermined the individual's will to resist both the state and the prescribed rules of social behavior. They argued that mass-cultural messages, supported by large corporations, must perpetuate the status quo, must affirm normative standards against which America can judge which endeavors, and which people, are successes and which are failures. Thus Murray Hausknecht, for example, discussing the popular '50s TV program *Person to Person,* which brought television cameras into the homes of famous people, pointed out a technician assigned to conceal a small microphone in the "bosoms" of the women who appeared on the show so that they might be seen and heard without the visual intrusion of any technical apparatus. His function, then, was to enable television to project the seamless illusion of a "normal" everyday life. And, Hausknecht continued,

> this tactful technician—he is reported to do his job with a craftsmanlike efficiency, courtesy, and discretion—is a symbol of the main drift of contemporary society. In the dim world of mass communication and mass culture he stands out as a startlingly clear figure.
>
> Consider *Person to Person* as we see it after the tactful technician and his colleagues have prepared the way. With Edward R. Murrow we look at a picture of one of the homes we are going to "drop in on" that night. Then, as Mr. Murrow turns his attention from us to our "host," we are plunged into the interior of the home. . . . Along with the ubiquitous camera and the hidden mike we poke and pry nearly everything which is exposed to us—the magic of television makes *voyeurs* of us all.[21]

Television, Hausknecht argued, supplied exemplary (wholesome, God-fearing, patriotic) people and situations for the public to emulate. Popular culture was conditioning us for our own alienation, a loss of control over our lives and our privacy:

> When the man slips the mike in the bosom he helps train us for the time when we shall willingly do the job for ourselves; he is preparing us for adjustment to a future nightmare.[22]

This brand of ideological reading of the media emerged in the '50s as a kind of parallel debate to the increasingly sophisticated coordination of mass-media representations exemplified in the Rosenberg case. Interestingly, it is also the view of mass culture closest to the curatorial biases of the contemporary art museum: the media as the enemy of art. In the writings of Clement Greenberg, Ernest van den Haag, and Dwight Macdonald, an argument that had once envisioned a radical critique of the establishment's use of the media came instead to register a paradoxical mandarin conservatism.[23] The social order that emerged after the Great Depression, the argument went, was one of cultural uniformity. The invasion of our culture by television, pop music, magazines, and other mass-media forms precipitated a blurring of class distinctions that diminished the power and influence of its affluent protectors. "It is an art and a culture of instant assimilation, of abject reconciliation to the everyday, of avoidance of difficulty, pretence to indifference, equality before the image of capital," writes T. J. Clark, summarizing the ideas of Greenberg.[24] For Greenberg, "kitsch" was a danger to be fought:

> Because it can be turned out mechanically, kitsch has become an integral part of our productive system in a way which true culture could never be, except accidentally. . . . While it is essentially its own salesman, a great sales apparatus has nevertheless been created for it, which brings pressure to bear on every member of society. Traps are laid even in these areas, so to speak, that are the preserves

of genuine culture. It is not enough today, in a country like ours, to have an inclination towards the latter; one must have a true passion for it that will give him the power to resist the faked article that surrounds and presses in on him from the moment he is old enough to look at the funny papers. Kitsch is deceptive. It has many different levels, and some of them are high enough to be dangerous to the naive seeker of true light.[25]

On the class associations of popular culture, Greenberg continued:

> There has always been on one side the minority of the powerful—and therefore the cultivated—and on the other the great mass of the exploited and the poor—and therefore the ignorant. Formal culture has always belonged to the first, while the last have had to content themselves with folk or rudimentary culture, or kitsch.[26]

Greenberg's patronizing and classist rhetoric parallels the inherent biases of many curatorial methods, and affirms the modern museum's role as the preserver of an avant-garde that would continue the battle for "high" standards. Where a truly constructive practice would engage the media, illuminating their workings—and, when appropriate, their positive effects—the museum undiscriminatingly excludes them. Thus an oppositional critique is transformed into a conventional one, and a nexus of power that has assumed an increasingly dominant role in our lives over the past 30 years is left for other analysts than curators to study. It is revealing that elements of mass culture such as posters, leaflets, newspapers, and images distributed by artists, writers, and designers in *support* of the Rosenbergs[27] are as scarce in "Unknown Secrets" as are the voluminous media attacks on them.

New methodologies are needed for allowing the museum to respond to the needs of the ever increasing ranks of desperate Americans who, like the Rosenbergs, are imprisoned by their representational voicelessness: the poor, the homeless, the elderly, the handicapped, the drug-addicted (despite the Reagan administration's "Just Say No" campaign),

victims of AIDS. This curatorial realignment must acknowl-
edge that the disenfranchised most often come from a back-
ground entirely removed from the evaluative standards of
beauty, quality, taste, and economic worth as defined by the
museum. Traditionally, historical narratives (for example of
wars, monarchies, governments, science, politics, culture)
rarely consider the flow of events from the perspective of the
powerless; a celebration of wealth and strength, the historical
text examines the individual lives of working people only
when they radically upset the status quo, or, more danger-
ously, threaten the dominant culture—a situation exempli-
fied by the Rosenberg case. Yet in projects such as the history
workshop movement, which, in Europe and America, has
published local-history pamphlets and sponsored workshops
that have brought together academics, activists, and workers,
the social agenda of history is changing.[28] The same kind of
shift should be possible in the curation of art. And the mu-
seum's commitment to this effort must acknowledge that the
dynamics of dissent cannot be divorced from the socioeco-
nomic and cultural space of the oppressed. A curatorial his-
tory of the Rosenberg era, for example, should also consider
the *public* culture of the period: eyewitness accounts from
people who were powerless to speak at the time, verbal and
visual manifestos of the leftist press and pro-Rosenberg
groups, and the media campaign to make America "safe"
from these radical incursions. By offering insight into how
social struggles are waged and won through cultural repre-
sentations—rather than uncritically presenting historical art,
and allowing recent theoretical pieces to compensate for the
lack of incisive curatorial interpretation—a revised Rosen-
berg project could have radically altered the way the exhibi-
tion itself addresses and influences its audience.

An experiment recently undertaken by curator William
Olander at the New Museum of Contemporary Art, New
York, offers insight into the way the museum can engage
rather than marginalize disenfranchised people. In 1987,
Olander invited the AIDS Coalition To Unleash Power (ACT
UP) to do an installation in the New Museum's Broadway
window. An ad hoc committee from this nonpartisan group
of diverse individuals committed to direct cultural and polit-

ical action to end the AIDS crisis responded with an extraor-
dinary multimedia installation. Entitled *Let the Record
Show* . . . , the project both provided current, sometimes dis-
turbing information about the AIDS epidemic and placed the
crisis in cultural and historical perspective. In an accompa-
nying brochure, Olander wrote:

> The intention [of the installation] is to make the viewer
> realize the depth of the problem and understand that his-
> tory will judge our society by how we responded to this
> calamity, potentially the worst medical disaster of the cen-
> tury. . . . The installation is more pointedly directed to
> those national figures who have used the AIDS epidemic to
> promote their own political or religious agendas. It is in-
> tended to serve as a reminder that their actions or inac-
> tions will soon be a matter of historical record.[29]

Indeed, foregrounded in the installation were a series of six
compartments, each containing a silhouetted photograph of
an "AIDS criminal" and an inflammatory statement by that
person etched on a slab of concrete. Among the most infa-
mous of these were United States Senator Jesse Helms' call
for the quarantining of those infected with the HIV virus and
William F. Buckley's suggestion that infected people should
be tattooed in order to "prevent the victimization" of oth-
ers.[30] A large, theatrically lit photomural of the Nuremberg
trials served as a historical backdrop for the figures (an allu-
sion to the fact that those trials both revealed the horrendous
transgressions of Nazi medical doctors and helped reshape
contemporary codes of medical ethics). An electronic infor-
mation display, positioned overhead, was programmed with
a running text consisting of devastating AIDS statistics coun-
terposed with examples of the indifference of the establish-
ment to the problem.[31]

A discussion of *Let the Record Show* . . . may at first seem
irrelevant to a critique of the Rosenberg Era Art Project and
the art of exhibition. Indeed, the kinds of representational
strategies employed by ACT UP are evident in a number of
the commissioned works in "Unknown Secrets." But the in-
novations of *Let the Record Show* . . . do not entirely rest on
the details of the piece itself; rather, what is most radical,

even instructive, about this union between the voices of dissent and the museum is the installation's shifted institutional frame. In offering ACT UP the New Museum's main window, Olander was aware that their project would be visible throughout the day and night to thousands of pedestrians. Moreover, the window opens onto Broadway, a busy thoroughfare noted for economic, racial, and cultural diversity. And even if certain aspects of the piece require a special knowledge of history, its most powerful points are communicated through popular images, direct statements, and statistics. *Let the Record Show* . . . represented an informed cooperation between activists and the museum, of a kind that is exceedingly rare. It serves as a paradigm of a very necessary kind of curatorial realignment: a protest exhibition— functioning within the walls of the museum, supported by its curators, and sanctioned by its patrons—that communicates its message *directly* to some of the people most affected by its tragic subject. Such an enlightened dismantling of our cloistered, class-conscious culture might actually change a mind, save a life, or prevent the unjust punishment of people who may be guilty of no greater crime than being different.

NOTES

1. I would like to thank Terry Berkowitz, Antonio Muntadas, and Pierce Rafferty for their assistance in securing audio portions of the Considine film, which is in the Hearst Collection of the University of California, Los Angeles. A section of it also appears in Berkowitz's *The Children's Hour*, 1987, which is included in "Unknown Secrets."

2. For a discussion of the pervasive anti-Semitism surrounding the Rosenberg case, see Rita Marion Rose, "The Rosenberg Case and the American Jewish Community," MA thesis, Graduate Center of the City University of New York, 1988.

3. On June 16, 1953, several days before the Rosenberg execution, President Eisenhower wrote to his son John in Korea: "To address myself . . .

to the Rosenberg case for a minute, I must say that it goes against the grain to avoid interfering in the case when a woman is to receive capital punishment. Over against this, however, must be placed one or two facts that have greater significance. The first of these is that in this instance it is the woman who is the strong and recalcitrant character, the man is the weak one. She has obviously been the leader in everything they did in the spy ring. The second thing is that if there would be any commuting of the woman's sentence without the man's, then from here on the Soviets would simply recruit their spies from among women." Quoted in Martha Rosler's contribution to the REAP show, *Unknown Secrets*, 1988, in both the installation and a handout manuscript. Recently, certain historians of the Rosenberg case have concluded that the government framed Ethel in order to coerce Julius to confess. Even some accounts that assume the couple's guilt question the centrality of Ethel's involvement. See, for example, Ronald Radosh and Joyce Milton, *The Rosenberg File: A Search for the Truth*, New York, Holt, Rinehart and Winston, 1983, pp. 102–3.

4. These limited-edition posters by Picasso and Léger were sold to raise money for the Rosenberg defense fund. In this sense, they served an important political function. Their position in the "Unknown Secrets" exhibition as significant protest statements, however, is questionable, given their sentimental and unspecific message.

5. Though numerous texts have been written on the Rosenberg case, they seem mostly to ignore the issue of media coverage.

6. Nina Felshin, "Unknown Secrets: Art and the Rosenberg Era," and Rob A. Okun, "Haunted Memories: The Rosenberg Era Art Project," in Okun, ed., *The Rosenbergs: Collected Visions of Artists and Writers*, New York, Universe Books, 1988, pp. 14–24, 29–33.

Okun writes, "It is curious to note that throughout the intensive research that went into uncovering the historical [art] pieces, I was unable to locate any anti-Rosenberg art or editorial cartoons" (p. 18). Yet anti-Rosenberg and anti-Communist sentiment was pervasive in the popular culture of the period. To compensate for this omission, Okun and REAP have completed a short film on the cultural scene of the Rosenberg era which will eventually become part of the exhibition.

7. For detailed studies of the case see Walter and Miriam Schneir, *Invitation to an Inquest*, New York, Doubleday, 1965; Louis Nizer, *The Implosion Conspiracy*, Garden City, N.Y., Doubleday, 1973; Alvin H. Goldstein, *The Unquiet Death of Julius and Ethel Rosenberg*, New York and Westport, Conn., Lawrence Hill, 1975; and Radosh and Milton.

8. See, for example, Paul Von Blum, "Not So Happy Days: The Politics and Culture of the 1950's," in Okun, ed., *The Rosenbergs*, pp. 89–97. Von Blum's essay, which addresses the broad cultural implications of McCarthyism, is an important supplement to Felshin's and Okun's texts in the book, helping to make it more an extension of the issues raised by the art in "Unknown Secrets" than a traditional exhibition catalogue.

9. Other recent examples of this resistance include the ICI's "Disarming

Images" project on nuclear disarmament; the "War and Memory" exhibition at the WPA, in Washington, D.C., on coming to terms with the Vietnam period; and, less problematically, the "Committed to Print" show at the Museum of Modern Art, New York, on protest-oriented graphic art.

10. The posters, published by the left-wing Mexican graphics cooperative Taller de Gráfica Popular, were Angel Bracho's and Celia Calderón's woodcut *We Have Not Forgotten the Rosenbergs*, 1953–54, and Francisco Mora's woodcut *Help Stop This Crime*, 1952. The most challenging theoretical pieces were Rosler's *Unknown Secrets* (on the relationship between public perceptions of Ethel Rosenberg and '50s pop representations of women and femininity); Margia Kramer's *Covert Operations*, 1987–88 (on the CIA plan to commute the Rosenbergs' death sentence in exchange for their preaching to world Jewry on the evils of communism); Antonio Muntadas's *6/19/53*, 1987–88 (on the news media's uncritical representations of the Rosenberg execution); Terry Berkowitz's *The Children's Hour*, 1987 (on the media's indifference to the moral questions surrounding the Rosenbergs' punishment); and Deborah Small's *Witch Hunt*, 1987 (on the public language of the cold war).

11. Okun, p. 14: "My search [for artwork of the Rosenberg era]—and the later, important decision to invite artists to create new work—has taught me a great deal about an underground social history missing from the official chapters on those years."

12. Statement released by the Metropolitan Museum of Art on 22 May 1970; as quoted in Therese Schwartz and Bill Amidon. "On the Steps of the Met," *New York Element* II no. 2, June–July 1970, p. 4.

13. Writers in this mode include T. J. Clark, Thomas Crow, Judith Williamson, Lisa Tickner, Simon Watney, Rosalyn Deutsche, Allan Sekula, Christopher Phillips, and Sally Stein.

14. For a discussion of Barr and the origins of contemporary museum practice see Francis Frascina, "Introduction," in Frascina, ed., *Pollock and After: The Critical Debate*, New York, Harper & Row, 1985, pp. 3–20. See also Meyer Schapiro, "Nature of Abstract Art," *Marxist Quarterly* 1 no. 1, January 1937, reprinted in Schapiro, *Modern Art: 19th & 20th Centuries*, New York, George Braziller, 1978, pp. 187–88: "If the book is largely an account of historical movements, Barr's conception of abstract art remains essentially unhistorical. He gives us, it is true, the dates of every stage in the various movements, as if to enable us to plot a curve, or to follow the emergence of the art year by year, but no connection is drawn between the art and the conditions of the moment. He excludes as irrelevant to its history the nature of the society in which it arose, except as an incidental obstructing or accelerating atmospheric factor."

15. For more on the museum's conservative institutional hierarchies and its resistance to this kind of social reading of art, see Carol Duncan and Alan Wallach, "The Universal Survey Museum," *Art History* 3 no. 4, December 1980, pp. 448–69. On the ideological needs of a museum devoted to Modern art see Duncan and Wallach, "The Museum of Modern Art as

Late Capitalist Ritual: An Iconographic Analysis," *Marxist Perspectives* no. 1, Winter 1978, pp. 28–51, and Douglas Crimp, "The Art of Exhibition," *October* no. 30, Fall 1984, pp. 48–81.

16. See, for example, Maurice Berger, "The Iron Triangle: Challenging the Institution," in *Labyrinths: Robert Morris, Minimalism, and the 1960s*, New York, Harper & Row, 1989, pp. 107–27.

17. See, for example, Schwartz and Amidon, pp. 3–4 and 19–21, and Lucy R. Lippard, "The Art Workers' Coalition," in Gregory Battcock, ed., *Idea Art*, New York, E. P. Dutton, 1973, pp. 102–15.

18. See Brian Wallis, ed., *Hans Haacke: Unfinished Business*, New York, The New Museum of Contemporary Art, and Cambridge, Mass., MIT Press, 1986, and in particular Haacke's "Shapolsky et al., Manhattan Real Estate Holdings, a Real Time Social System, as of May 1, 1971," in ibid., pp. 92–97.

19. One exception recently was an important 1986 exhibition at New York's Museum of Contemporary Art, "Damaged Goods: Desire and the Economy of the Object," which questioned the very issue of how the exhibition addresses its audience and the extent to which this address is determined by the interests of the patron. Here curator Wallis challenged the social hermeticism of the museum as he and exhibition designer Judith Barry self-consciously examined the exhibition space of the museum as institution and its potential physically and ideologically to manipulate the spectator. Fundamentally, Wallis argued that such manipulation rests on the issue of desire, on the extent to which art is involved in the commodity system, which exhibitions support by heightening our desire for pristine objects. See Wallis, ed., *Damaged Goods: Desire and the Economy of the Art Object*, New York, The New Museum of Contemporary Art, 1986.

20. For an overview of this debate see Richard Pells, "The Message of the Media," in *The Liberal Mind in a Conservative Age: American Intellectuals in the 1940s and 1950s*, New York, Harper & Row, 1985, pp. 216–32. Important early examples of this work include Murray Hausknecht, "The Mike in the Bosom," and Paul Lazarsfeld and Robert Merton, "Mass Communication, Popular Taste and Organized Social Action," in Bernard Rosenberg and David White, eds., *Mass Culture: The Popular Arts in America*, Glencoe, Ill., The Free Press, 1957, pp. 375–78 and 457–73; and Harold Innis, *The Bias of Communication*, Toronto, at the University Press, 1951. Also see Kingsley Widmer, "The Electric Aesthetic and the Short-Circuit Ethic: The Populist Generator in Our Mass Culture Machine," in Rosenberg and White, eds., *Mass Culture Revisited*, New York, Van Nostrand Reinhold, Co., 1971, pp. 102–19. Much of this writing, of course, underestimated the way repressive forces inhibited industrial society and controlled people's actions and movements even before the advent of the mass media. See, for example, Michel Foucault, *Discipline and Punish: The Birth of the Prison*, trans. Alan Sheridan, New York, Vintage Books, 1979.

21. Hausknecht, p. 375.

22. Ibid., p. 378.

23. For examples of this dialectic between high and popular culture, see

Clement Greenberg, "Avant-Garde and Kitsch," in *Art and Culture*, Boston, Beacon Press, 1961, pp. 3–21; Dwight Macdonald, "A Theory of Mass Culture," and Ernest van den Haag, "Of Happiness and Despair We Have No Measure," in Rosenberg and White, eds., *Mass Culture*. Also see Pells, pp. 216–32.

24. Clark, "Clement Greenberg's Theory of Art," in Frascina, ed., *Pollock and After*, p. 53.

25. Greenberg, p. 11.

26. Ibid., p. 16.

27. While Okun's text makes reference to some of these popular images, including posters and leaflets distributed in France and Italy, they are for the most part excluded from the exhibition itself.

The greater subversive potential of mass-media over high-art strategies was the cornerstone of Ernst Friedrich's paradigm of pacifist propaganda, *War Against War!* Published in Germany in 1924 and translated into as many as 40 languages, the book demonstrated how mass-reproduced photographs could serve both as documentary evidence and as an argument for a humanitarian cause. These tactics were effectively revived in the '60s by artists protesting the Vietnam War, and in the '80s by activists in the battle against AIDS. For more on Friedrich see Douglas Kellner, "Introduction: Ernst Friedrich's Pacifist Anarchism," in Friedrich, *War Against War!*, Seattle, The Real Comet Press, 1987, pp. 9–18. On strategies of cultural protest during the Vietnam period see Berger, "Broken Bodies, Dead Babies, and Other Weapons of War," in *Representing Vietnam, 1965–73: The Antiwar Movement in America*, New York, Hunter College Art Gallery, 1988.

28. See, for example, James Green, "Engaging in People's History: The Massachusetts History Workshop," in Susan Porter Benson, Stephen Brier, and Roy Rosenzweig, eds., *Presenting the Past: Essays on History and the Public*, Philadelphia, Temple University Press, 1986, pp. 339–59 and 415–19.

29. William Olander, "The Window on Broadway by ACT UP," in *On View*, New York, New Museum of Contemporary Art, 1987, p. 1.

30. For the complete texts see Crimp, "AIDS: Cultural Analysis/Cultural Activism," *October* no. 43, Winter 1987. Reprinted as a book, under the same title, by Cambridge, Mass., and London, MIT Press, 1988, p. 8.

31. For an important discussion of *Let the Record Show . . .* and the broader cultural activities related to the battle against AIDS, see Crimp, "AIDS: Cultural Analysis/Cultural Activism," pp. 3–16. See also Christian Leigh, "ACT UP," exhibition review, *Artforum* XXVI no. 7, pp. 137–38.

III

World Fairness

As THE 1980s draw to a close, it is becoming increasingly difficult for the guardians of first world culture to ignore the production of third world peoples and Western people of color. Sometimes the acceptance of the Other in mainstream contexts merely reiterates old exploitive patterns: the comfort with which white artists have appropriated the styles and forms of the "exotic," for example —in "primitivist" high Modernism as in the ongoing confiscation of black musical idioms by white rock 'n' roll artists— can certainly be collusive with a power dynamic that excludes, ignores, and steals. The dealings of the Western cultural apparatus with non-Western cultural manifestations are virtually bound to be troubled, given their history and perhaps the very structure from which they emerge. But the need to make the approach is strong, even when the effort is marred. The recent *"Magiciens de la terre"* (Magicians of the earth) exhibition in Paris, in which artists from numerous non-Western countries exhibited alongside Western artists, is a case in point: though *"Magiciens"* may in the end have distorted third world practices by filtering them through decidedly Western intellectual and esthetic value systems, the

show was nevertheless an important confrontation between a complacent, powerful cultural community and the world's real, non-Western majority. More effectively, some of the current attempts at facing how we have treated the Other aim at a fundamental shift in the balance of power—a transfer of authority in which Others are not spoken for but speak for themselves.[1]

Twenty-five years ago in Flushing, New York City, the 1964–65 New York World's Fair made an early and well-publicized attempt to bring together first and third world nations in a cultural forum, under the lofty motto of "Peace through Understanding." Like international expositions in general, however, the fair was principally concerned with commerce—with fostering the spirit of free enterprise and trade, and with making a profit. Ironically, it was an unqualified economic disaster,[2] but more to the point, it marked no discernible shift in diplomatic relations between nations. (This seems less surprising today than the optimism attached to the fair at the time: no less a politician than Indira Gandhi, in an opening-day speech, talked of the "firm faith in the brotherhood of man and in the future of the human race" behind its "gay facade."[3]) In the late 1980s—when a shift toward globalism is discernible in both high and popular Western culture—the tactics of the fair seem crude and obvious. The effort to tie the interests of capital to what seemed a validation of national differences, however, has broad ramifications. In effect, the fair is a working document for historians, a means for understanding the virtually innate, virtually perpetual imperialism and colonialism of our cultural institutions, even when they are well-intentioned. In the end, the 1964–65 World's Fair, as unusual and seemingly unique as it was, it neither a historical anomaly nor an anachronism in its own time; instead, its magical, insulated world is a blueprint for understanding patterns of oppression that continue to the present day.

The 1964–65 World's Fair was dominated by a literal global symbol—the massive steel Unisphere, the largest representation of Earth ever made, a 140-foot-high, 900,000-pound armillary globe covered with representations of the continents and encircled by three rings denoting the orbits

of the first man-made satellites [19]. These rings accorded
with another theme of the fair, the belief that technology,
scientific knowledge, and communication, which seemed to
be advancing so rapidly, would further the cause of peace by
blurring the cultural and societal boundaries between na-
tions.[4] But the Unisphere's symbolism cannot mask the real-
ity that the fair became known as much for national absences
as for national presences. Because of World's Fair Corpora-
tion President Robert Moses' brusque treatment of a Paris
coordinating organization for international expositions (he
objected to regulations that might have reduced the fair's
anticipated profits), most Western European governments
boycotted the event;[5] none except Spain contributed a publ-
ically funded pavilion. France, Belgium, Italy, Austria, Swit-
zerland, Greece, Ireland, and Sweden were represented by
corporate- or privately-sponsored exhibits, but Great Brit-
ain, Norway, Denmark, Finland, Iceland, the Netherlands,
Luxembourg, and Portugal (as well as the Europe-derived
cultures of Canada and Australia) were not represented at
all. In an improvement over the 1939–40 New York World's
Fair, a large number of non-Western countries did partici-
pate, including India, Indonesia, Jordan, Lebanon, Mexico,
Pakistan, Sierra Leone, Sudan, and Venezuela. Moreover, if
corporate religious pavilions and the venues of the American
states are excluded, national delegations from Africa, Cen-
tral and South America, and Asia actually outnumbered
North American and European ones. On the other hand, in
perhaps the largest incongruity in the fair's version of world
unity, communist countries, though invited, were totally ab-
sent, an omission in part attributable to the capitalistic rhet-
oric surrounding the event. Inclusion in the fair, then, was
conditional on the political and commercial concerns of the
organizers. The politics involved may seem transparent to us
now, but when a contemporary curator can base a suppos-
edly radical show of non-Western artifacts on the criteria of
his own taste, we have to wonder how much has changed.[6]

Though the U.S. State Department cooperated closely
with fair organizers in foreign negotiations, the Fair Corpo-
ration was not a government, and its officers had no diplo-
matic experience to help them resolve tensions among the

19. *Unisphere*, 1964

nations sharing the grounds.[7] The agreements between them and the exhibitors—"agreements of participation," they were called—were business contracts, not treaties. And the real business of the 1964–65 World's Fair, of course, was business. Racial and class conflicts may have been coming to the surface in the America of the early '60s, but the economic status of the white middle class had improved dramatically since 1945: the explosion of consumer culture and the booming economy had allowed it to buy freely, and to explore new technologies for home, office, and leisure. Accordingly, just as synthetic fabrics, plastics, and television were introduced to the public at the 1939–40 World's Fair, visitors to Flushing Meadow in 1964 were tempted by a fresh range of products: touch-tone phones, laser devices, atomic and solar energy, new plastics and other synthetic polymers such as neoprene, a plethora of kitchen appliances, and more.[8]

These displays, often couched in the seductive rhetoric of futurism, were carefully orchestrated, as if in some monumental suburban shopping mall. Many pavilions used entertainment attractions as the bait to entice visitors toward displays of commodities.[9] Even national pavilions employed the clever strategies of seduction traditionally employed by advertising agencies. Neither were their cultural treasures spared: Michelangelo's *Pietà*, encased behind glass at the Vatican Pavilion, was seen from a kind of conveyor belt, affording spectators a swift, television-eye view. If countries were associated with "exotic" crafts and pageants, they were also identified with specific products: Sierra Leone with diamonds, Pakistan with industrial equipment, even Belgium with waffles (the rather flavorless "Bel-Gem" Waffle, a batter cake topped with strawberries and whipped cream). Frequently lost in the maze of shops, theaters, and restaurants was the kind of informational content that might have encouraged the predominantly American audience to learn about different cultures and political systems. Products and artifacts, in other words, were decontextualized; the conditions from which they emerged were simplified for the American viewer.

The commercial slant of the fair was everywhere visualized. At the entrance to the American Express Pavilion—the

first inside the grounds' main gate—stood the Money Tree, a specimen of artificial timber sprouting $1 million worth of multinational banknotes for leaves [20]. Further on one

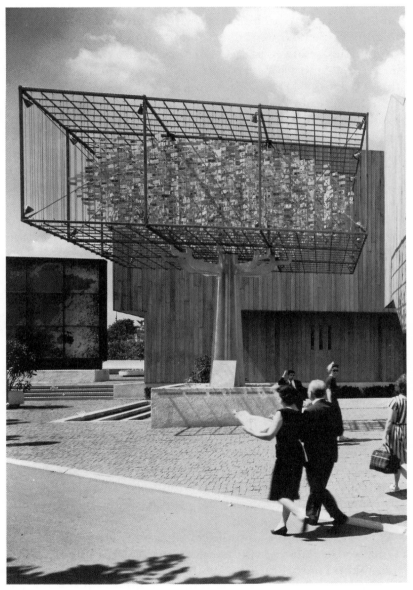

20. Samuel Gallo, *The Money Tree*, 1964

found the Hall of Free Enterprise, which taught visitors about the "principles and benefits of 'free competitive enterprise, properly regulated, unhampered by unwarranted interference.' "[10] In addition to such attractions as "Economics on Stage" (where an animated wire figure demonstrated the dilemma in which workers demand higher wages while consumers desire lower prices), "Money in Motion" (a wall panel in which "America's corporate economy [came] to life"), and the revolving "Tree of Economic Life" (which charted principles of economic growth), the hall offered an accredited graduate seminar in economics. It was situated, interestingly enough, in the international area of the grounds, among the national pavilions. But then these installations too had adopted probusiness themes. The pavilion of socialist Sweden, for example, sponsored "by leading industries and businesses," was a "testimonial to that nation's private enterprise."[11] India's pavilion used visual displays and recordings to show "how this once backward nation is now able to manufacture such heavy items as aircraft engines, locomotives and automobiles, as well as producing goods for export and exploiting the peaceful possibilities of atomic energy."[12] And in the pavilion of the Republic of Korea, "ancient art and folk dances" were shown beside "products for sale from . . . [the nation's] rebuilt industries."[13] These manufactured, usable goods may well have as much claim as folk-art objects and dances to inclusion in an exhibition that aimed to represent a whole society. But in a context brought into being to promote the sale of such goods, all other manifestations of culture became exotic details, vehicles toward the commercial end. If third world nations such as Korea and India could take the opportunity to represent themselves to Western fairgoers (and investors) as politically and culturally independent and economically viable, they were also encouraged to define themselves by one common denominator: money.

The emphasis on commerce was enthusiastically encouraged by the Fair Corporation's powerful president. Moses had taken control in May 1960, when he was 71, and when his illustrious career as New York's builder and master was beginning to ebb. But years of appointments to key state-

government positions, free of the hazards of election campaigns, had left him an enormous power base: few dared privately to challenge his ideas, and even fewer would defy him openly.[14] As the creator of nearly 700 city parks, virtually all of the city's expressways and parkways, many of its public pools, most of its large-scale housing projects, and such landmarks as Jones Beach, the Triborough Bridge, and the United Nations headquarters, he had a strong, more durable reputation with press and public than most of the elected officials who came and went during the decades of his tenure. To capitalize on the public esteem for Moses, the fair's promoters centered much of the event's publicity on him [21]. Thus, in a procedure still familiar to us now, an event devoted to extending the concept of the global to include a spectrum of third world nations focused its public self-representations on a member of the white male ruling class. Actually, Moses had expressed his vision of the functioning of a world's fair in an article he wrote for the *Saturday Evening Post* in 1938, discussing the then-upcoming exposition of 1939–40: "There may be no public announcement of it," he remarked, "but the shows, the entertainments, the amusements, fun, food, drinks, and everything else that goes with a gigantic circus, are going to come out first . . . Business will run a close second. Culture, which is somehow associated with long walks and aching feet, will be third."[15] If this was what Moses believed, then the theme of "peace through understanding" could only have been a cynical device.

Many of the pavilions were insensitive or outright racist. During a programmed 15-minute walk through the Coca-Cola pavilion, for example, visitors passed through "recreations of exotic places" such as India, Hong Kong, Cambodia, and Brazil—a compendium of travel-agency clichés that trivialized complex societies. As with Jean-Léon Gérôme's lush 19th-century paintings of snake charmers and slave markets, these opulent tableaux now read as visual documents of "colonialist ideology, an iconic distillation of the Westerner's notion of the Oriental couched in the language of a would-be transparent naturalism."[16] Some pavilions engaged in a more insidious kind of racism. The General Motors "Futur-

Join Mr. Moses
and Jinx Falkenburg in the
best of fare...at Festival 65 –
the American Restaurant

You'll find it in the Festival of Gas Pavilion. It's directed by the renowned Restaurant Associates. Their chefs here specialize in truly authentic American regional dishes. And they use nothing but precise Gas heat to prepare them, of course. Gas does the cooking at virtually *all* of the Fair's 75 restaurants.

What's more, Gas does 80% of the cooling and 90% of the heating at the Fair. Wherever you go, Gas is doing the behind the scenes jobs. Quietly and efficiently. Just as back home, and in industry, Gas energy is the power behind much of America's future. AMERICAN GAS ASSOCIATION, INC.

Do it tomorrow's way...with Gas

21. Advertisement with Robert Moses and Jinx Falkenburg for the American Gas Association, 1964

ama" ride, for example, displayed new technologies to convert the world's undeveloped land and resources to modern use, including a futuristic self-propelled road builder that mowed down rain-forest vegetation and animals, leaving an elevator superhighway in its wake [22]. Postulating that the machine would bring "a new way of life to an area that has long—and successfully—defied man's attempts to develop its natural resources and take advantage of its climate and fertile soil,"[17] the General Motors press release overlooked as if they were invisible the men and women who were already "taking advantage" of the forest environment—the tribal peoples who inhabit such regions, and who would be and have been put at risk by Western-style development.

Nowhere at the fair was racism more virulent than in the Pavilion of 2000 Tribes, run by the Wycliffe Bible translators, an interdenominational missionary organization "devoted to sharing the Bible with minority groups . . . by translating it into their own unwritten languages."[18] The central feature of the pavilion was a 100-foot mural, accom-

22. Detail of model for the General Motors "Futurama" ride, 1964–65

panied by a recorded narrative and light and sound effects, depicting the "impact of the Word of God" in amending the "murderous heart" and "hateful life" of Peruvian jungle chief Tariri. (In keeping with the economic imperatives of the fair, a plea for funds was made after the mural was unveiled.[19]) In the extraordinary accompanying brochure— "From Savage to Citizen"—chief Tariri offers a personal testimony of his life before spiritual redemption: "I was an unhappy savage chief. I used to cut off heads at the shoulders, then cut down the back of the head for scalping. I loved to kill—I took many heads. We went on raids. We speared, we killed, we hated." Then came Tariri's conversion to Christianity at the hands of two Wycliffe translators, "helpless girls": "After three years, I believed. Jesus overcame me. Christ came into my heart. The hatred went out. . . . I [had] believed in the witch doctor, the boa, the war spirit, and chanting. I have now left all these things because of God." To prove the "primitivism" of the forest tribe by its supposed violence, of course, is to ignore the endemic violence of Western society, along with the fact that few cultures are beyond acting in self-defense against invaders. The blatancy of the racism here illuminates a crucial, ongoing issue in our dealings with Others: "good intentions," assuming that the Wycliffe people were well-meaning, can prove utterly destructive when the vision from which they develop is thus constricted.

Given the continued tendency of Western historians to omit the voices of Others from the narratives they write, it is important to acknowledge that the nostalgia that often tempers writings about events like the fair necessarily marginalizes dissenting voices. An examination of dissent at the fair is in fact imperative to producing a more complete picture of both its audience and the people it alienated. When the World's Fair opened, on April 22, 1964, the House of Representatives had recently passed the Civil Rights Act; a long filibuster stalled the bill in the Senate, but was eventually broken, and President Lyndon B. Johnson signed the legislation into law in early July. The exposition came, then, at a time when civil rights activists were sharpening and defining their strategies. Its racist manifestations were almost inevita-

bly a target for protest, and the Congress of Racial Equality (CORE) attempted a massive "stall-in" on its opening day. As James Farmer, CORE's national director, explained shortly before his arrest on the grounds, the demonstrations were meant to highlight "the contrast between the [fair's] glittering world of fantasy and the real world of brutality, bigotry and poverty."[20] Proposals included blocking traffic to the fair, picketing on the grounds (an action expressly forbidden by the corporation), and heckling President Johnson as he spoke at the Federal Pavilion. Though the large crowds necessary to block transportation routes failed to materialize, protesters were able to disrupt Johnson's speech and to upset activities at other venues, including the pavilions of some of the more racially oppressive Southern states [23]. Some 300 demonstrators were arrested. Perhaps because of this civil action (though also because of bad weather), the turnout on opening day was over 150,000 less than the corporation had expected. Mainstream political leaders and the press were

23. *Picketing in front of New York City Pavilion, 1964*

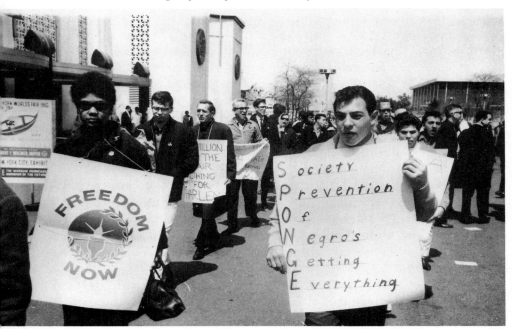

largely hostile to the protests: *U.S. News & World Report,* in a characteristic article entitled "What the Negroes Lost in New York," suggested that "sabotage as a method of Negro protest" had led to a national decline of support for the civil rights movement. As part of its coverage of the stall-in, the magazine also printed congressional testimony by F.B.I. director J. Edgar Hoover on the infiltration of "the Negro movement" by the Communist Party.[21] Offering no rebuttal to Hoover's statement, the report implicitly contributed to his campaign of fear—a campaign meant to discourage disenfranchised Americans from empowering themselves through civil disobedience.

Despite complaints from civil rights leaders, not a single black or Puerto Rican person served on the Fair Corporation's administrative staff of 200. Few people of color, in fact, were employed at the fair in any capacity.[22] Though mass transit was critical for an event expected to draw tens of thousands of people a day, Moses had vetoed a New York Transit Authority proposal to build a subway extension to the fair. Many of the city's poor families do not have automobiles, and Moses biographer Robert Caro has suggested that the planner's motives, as in many of his previous projects, were racist: the long-term status of Flushing Meadow Park was far more important to him than the short-term needs of the fair, and easy access to the park "was not desirable . . . [Moses] did not want his great parks to be open to low-income people, particularly the Negro and Puerto Rican people who made up so large a percentage of the city's lower-income families."[23] Such inequities remind us that it was to white, middle-class Americans that the fair was addressed. "Despite its international theme, the Fair was in many ways a piece of white-bread America—religious, conservative, middle-class—plunked down in the heart of ethnic New York," Morris Dickstein writes. "The whole enterprise was a throwback to a more homogeneous era in which blacks, like slums and other 'social problems,' were kept out of sight and out of mind."[24]

Yet if the fair's suppression of racial, cultural, and economic differences was designed to make consumerism as comfortable as possible for its middle-class patrons, that goal

is ultimately implicit in capitalism itself. In effect, the fair recreated what the German filmmaker Alexander Kluge has called the "pseudo-public sphere." As Rosalyn Deutsche extrapolates on Kluge,

> Because economic gain, protected from public accountability by its seclusion within the private domain, actually depends on conditions that are publicly provided, the bourgeois public sphere developed as a means by which private interests seek to control public activity. But since capitalism requires the preservation of the illusion that a well-defined boundary divides the public and private realms, the contradictions that gave birth to the public sphere are perpetuated and "reconciled" in its operations. Conflicts between groups are obfuscated by generalizing dominant interests as universal and by simultaneously privatizing experience. Homogenization of divergent concerns can, however, only be effected through exclusions: "A representative public sphere," Kluge argues, "is representative insofar as it involves exclusions. . . . [It] only represents parts of reality, selectively and according to certain value systems."[25]

The "peace through understanding" in the fair's "pseudo-public sphere" could only temporarily conceal the ultimate reality that it was the interests of capital that bound these nations together. (The symbolism of national pavilions run by private enterprise is irresistible here.) As Kluge suggests, it is only through homogenization and exclusion that such a mirage of unity can occur: a communist country would not have looked right in Flushing Meadow in 1964, and neither would an unexoticized third world. Nor would working American women have looked right—the place of women was at Frigidaire's Kitchen Idea Center, or at the "women only" Clairol Color Carousel. And the civil rights struggles and the counterculture that were beginning to emerge in the United States were utterly omitted from the fair's picture of America, despite the organizers' putative commitment to the allowance of difference. Thus do institutions insulate themselves from dissent at the same time that they appear to embrace it.

Though Moses called his exposition an "Olympics of Progress,"[26] he did not want to acknowledge the future. The 1964–65 World's Fair embraced a middle America of boy scouts and Arlington hats. (So puritanical was Moses that he was rumored to have personally censored risqué costumes from the grounds, insisting that even the puppets in the *"Poupées de Paris"* show don brassieres.) This was an event crucially out of contact with the dramatic present, let alone suggesting the complex future. Yet the 1964–65 World's Fair is important to whatever extent it brought Americans into contact with representations of other cultures, perhaps even for the first time. Furthermore, the fair reminds us of how little America has advanced in the past quarter century toward a general acceptance of difference, and illuminates the traps into which a Western institutional apparatus can fall when it attempts to make welcome a non-Western culture. Certain power dynamics appear to be built into the first world institutional frame; they may seem obvious in hindsight, but that is no guarantee that they are contained and sealed off in the past.

NOTES

1. See, for example, Edward W. Said's "Yeats and Decolonization," Janet Abu-Lughod's "On the Remaking of History: How to Reinvent the Past," Homi K. Bhabha's "Remembering Fanon: Self, Psyche, and the Colonial Condition," and Gayatri Chakravorty Spivak's "Who Claims Alterity?," in Barbara Kruger and Phil Mariani, eds., *Remaking History*, Seattle, Bay Press, 1989; "The Global Issue: A Symposium" and "The Peripatetic Artist: 14 Statements," in *Art in America* 77 no. 7, July 1989, pp. 86ff. and 130ff.; and Cynthia Schneider and Brian Wallis, eds., *Global Television*, Cambridge, Mass., and London, MIT Press, 1989.
2. New York City lost $24 million on the fair; bankers who had invested

nearly $30 million had a return of only $10 million. See Robert A. Caro, *The Power Broker: Robert Moses and the Fall of New York,* New York, Alfred A. Knopf, 1974, pp. 1102–7 and 1112–13.

3. Indira Gandhi, "Speech on behalf of the International Participants at the Opening of the New York World's Fair," 22 April 1964.

4. See Sheldon J. Reaven, "New Frontiers: Science and Technology at the Fair," in *Remembering the Future: The New York World's Fair from 1939 to 1964,* New York, Rizzoli, 1989, p. 76. I would like to thank Robert Janjigian of Rizzoli International Publications for supplying me with page proofs of this book.

5. See John Brooks, "Diplomacy at Flushing Meadow," *The New Yorker* 39 no. 15, 1 June 1963, p. 41, and Caro, *The Power Broker,* pp. 1093–94.

6. See Benjamin H. D. Buchloh, "The Whole Earth Show: An Interview with Jean-Hubert Martin," *Art in America* 77 no. 5, May 1989, pp. 150–58 and 211–13.

7. Julius Edelstein, a New York City executive assistant to the mayor in 1964, remarks, "Moses had never been involved with foreign policy; now he was overlord of something that touched on the fringes of foreign policy. . . . Moses was really all powerful. His values were free enterprise; he had no concern for people going hungry." Interview with the author, New York, 18 July 1989. For more on the fair's foreign policy initiatives see Brooks, "Diplomacy at Flushing Meadow," and the U.S. Congress House Committee on Foreign Affairs, "Hearing before the Subcommittee on International Organizations and Movements of the Committee on Foreign Affairs, House of Representatives, Eighty-Seventh Congress, first session, on H.R. 7763, and other bills, to provide for planning the participation of the United States in the New York World's Fair to be held in New York City in 1964 and 1965, and for other purposes," 10 August 1961, Washington, D.C.: U.S. Government Printing Office, 1961.

8. See Reaven, pp. 93–96.

9. On the relationship between commodity and entertainment the filmmaker Alexander Kluge has written, "In order to cheat spectators on an entrepreneurial scale, the entrepreneurs have to designate the spectators themselves as entrepreneurs. The spectator must sit in the movie house or in front of the TV set like a commodity owner: like a miser grasping every detail and collecting surplus on everything which has any value. Value *per se.* So uneasy this spectator-consumer, alienated from his own life so completely like the manager of a supermarket or department store who—even at the price of death (heart attack)—will not stop accumulating the last scraps of marketable goods in the storeroom so that they may find their buyers." See Alexander Kluge, "On Film and the Public Sphere," *New German Critique* nos. 24–25, Fall/Winter 1981–82, p. 210.

10. *Official Guide: New York World's Fair, 1964–65,* New York, Time-Life Books, 1964, pp. 151–52.

11. Ibid., p. 148.

12. Ibid., p. 127.

13. Ibid., p. 128.

14. Moses' conduct of the fair substantially damaged his reputation, opening him to attack from former supporters in the press. See Caro, pp. 1091–95; Moses, *The Fair, the City and the Critics*, Flushing, New York, New York World's Fair 1964–65 Corporation, 1964, pp. 2–3; Vincent J. Scully, Jr., "If This Is Architecture, God Help Us," *Life* 57 no. 5, 31 July 1964, p. 9; Richard J. Whalen, "A City Destroying Itself," *Fortune* 70 no. 3, September 1964, pp. 115–21, 213–36, and 241–45; and Roberta Strauss Feuerlicht, "God and Man at Flushing Meadow," *The Reporter* 31 no. 3, 13 August 1964, pp. 54–56.

15. Moses, quoted in Marc Miller, "Something for Everyone," in *Remembering the Future*, p. 71. As New York City parks commissioner in the late '30s, Moses had been marginally involved in the planning of the 1939–40 World's Fair.

16. Linda Nochlin, "The Imaginary Orient," *Art in America* 71 no. 5, May 1983, p. 119. See also Edward Said, *Orientalism*, New York, Vintage Books, 1979.

17. The release is quoted in Morris Dickstein, "From the Thirties to the Sixties: The World's Fair in its Own Time," in *Remembering the Future*, p. 30.

18. "From Savage to Citizen," Santa Ana, Ca.: Wycliffe Bible Translators, 1964, n.p. Brochure published for the 1964–65 New York World's Fair, in the fair archives at the Queens Museum, Flushing, New York City. I would like to thank Ileen Sheppard, director of exhibitions at the Queens Museum, for her generous assistance in securing archive material for this essay.

19. For more on the Wycliffe pavilion see Feuerlicht, p. 56.

20. James Farmer, quoted in "Fair Opens, Rights Stall-In Fails," *The New York Times*, 23 April 1964, p. 26.

21. "J. Edgar Hoover Speaks Out on Reds in Negro Movement," *U.S. News & World Report* 56 no. 18, 4 May 1964, p. 33.

22. See Caro, p. 1101.

23. Ibid., pp. 1086–87n. For more on Moses' plans to turn Flushing Meadow Park into "one of the very great municipal parks of our country," see Moses, *The Saga of Flushing Meadow*, souvenir booklet, published for the Flushing Meadows–Corona Park Public Ceremonies, 3 June 1967, pp. 7–24.

24. Dickstein, p. 34.

25. Rosalyn Deutsche, "Uneven Development: Public Art in New York City," *October* no. 47, Winter 1988, pp. 11–12. For Kluge's argument itself see Kluge, pp. 212–14. T. J. Clark has discussed the concept of a homogenizing public "spectacle" in relation to the Paris Universal Exposition of 1867, in Clark, *The Painting of Modern Life: Paris in the Art of Manet and His Followers*, New York, Alfred A. Knopf, 1984, pp. 60–66.

26. Moses, in his public remarks at the opening ceremonies of the fair, 22 April 1964.

IV

Broken Bodies, Dead Babies, and Other Weapons of War

At last, at last the mask has been torn away from this "field of honor," from this lie of an "heroic death," and from all other beautiful phrases, from all this international swindle the mask has at last, yea, at last been torn away.
ERNST FRIEDRICH,
War Against War! (1924)

AT THE OUTSET of Emile de Antonio's *In the Year of the Pig* (1969)—an important film documentary on the history and meaning of the Vietnam War—one encounters a disquieting image of a young American soldier [24]. Amidst de Antonio's collage of rare newsreel footage, government and antiwar speeches, interviews, and political propaganda films, the presence of the soldier is sobering. For one thing, he appears to be very young, no more than a teenager. And while the expression in his eyes is hidden by the shadow cast by his helmet, his face betrays the numb stoicism of the obedient soldier. Such a depiction of the pressures of war would be ordinary were it not for the presence of a painful detail. On the young man's helmet are scrawled the words "make war not love," a perverse, tragic inversion of a principal slogan of the antiwar movement in America.

One is struck by the youth's naïveté, his lack of awareness or, more likely, his macho indifference to the horrors that await him. The inverted slogan reminds us of the relentless presence of those men who have lived, generation after generation, in parasitic relation "to the production of useful things, who lived for perpetual war, the production of

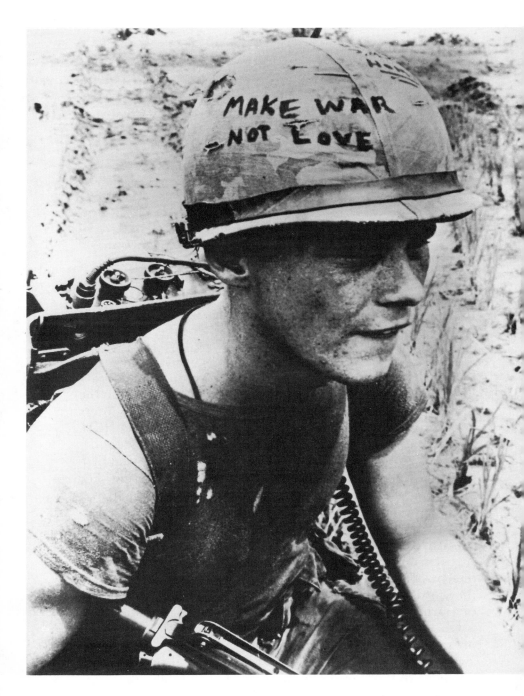

24. Emile de Antonio, still from *In the Year of the Pig*, 1969

death."[1] Equally unnerving is another connotation of the image: its allusion, through its collapsing of antiwar rhetoric, to a crippling division within America itself. The United States involvement in the Vietnam conflict polarized America, separating it into camps of "doves" and "hawks." Each evening on television Americans witnessed the systematic murder of the peoples of Indochina and the plundering of their land. Hawks and doves alike watched helplessly as their (mostly poorer and less educated) sons were conscripted. They saw young American men killed or mutilated. And they became aware of the astonishing number of people who elected to protest against an increasingly costly and unpopular war. In short, America was also engaged in a battle at home, a combat whose subject—the bloody military incursions being fought thousands of miles away—existed only in absence. In this country, the antiwar movement and the defenders of the Pentagon were ultimately waging a war of representation, a battle of words and images.

The conflicting forces of doves and hawks were supremely conscious of the power of representation in their explosive battle for the hearts and minds of America. For the Departments of State and Defense it was imperative to convince a somewhat skeptical (and to some extent war weary) public of the life-and-death importance of a region so distant and removed from the everyday life of America. One important militarist strategy was to invoke the need to protect Western-style "democracy" from the cold-blooded, totalitarian drives of communism (an oversimplification of the complex politics of Southeast Asia).[2] In fact, until 1968, the hawks were relatively successful in dodging the difficult questions raised by the antiwar movement in the United States and Europe.

But the shock of the Tet offensive in early 1968—an incursion that in its first three weeks left an estimated 165,000 Vietnamese civilians and 500 American soldiers dead, scores of Vietnamese cities and towns destroyed, and more than two million refugees homeless—reversed the fortunes of the Pentagon propaganda machine. The widely televised pictures of the bloodied corpses of National Liberation Front commandos strewn over the shrubbery and walkways of the American Embassy in Saigon contributed little to the cause

of American involvement in Vietnam. These images joined forces with other, now famous, representations: the monk who set himself afire, the napalmed child running, the American soldier igniting a Vietnamese hut, the gun pointed at the head of a Vietcong officer. The undeniable power of these images helped motivate the major news magazines, *Time*, *Life*, and *Newsweek*, to criticize the war policy overtly for the first time; probing questions were now being asked by television news commentators, many of whom, like Walter Cronkite, had generally supported the Administration.[3] Despite President Johnson's desperate effort to regain public support through a series of televised addresses to the nation, confidence in his handling of the Vietnam conflict had dropped to a new low in the opinion polls. Such was the strength of the Vietnam atrocity imagery that the student-run presidential campaign of Senator Eugene McCarthy, a campaign built on an antiwar platform, gained sufficient momentum to damage (and eventually derail) President Johnson's reelection effort.

By the late 1960s, the antiwar movement in America had achieved unprecedented success.[4] Its message reached a vast audience; through folk music, protest buttons, posters, street theater and other venues, antiwar sentiment entered the everyday discourse of American life. Especially powerful forms of protest were located in the actions and rhetoric of students and soldiers—the Americans most immediately affected by the war.[5] The American cultural community, as well, played an instrumental role in the peace movement. Cultural forums such as the Art Workers' Coalition, the Guerrilla Art Action Group, Poets for Peace, Angry Arts Against the War in Vietnam, the Artists' Strike Against Racism, Repression, and War, and the Emergency Cultural Government helped to generate words and images that reinforced the place of dissent in American life.[6]

Among the most effective representational strategies of the antiwar movement were those that addressed the fact of atrocity itself. While rotting, bloodied, or dismembered bodies are generally avoided in media images for reasons of

good taste, it was such direct evidence that charged the most powerful Vietnam images. In these sober pictures it is the napalm-burned face or the severed baby's arm that serves as the *punctum*, the point of shock, that arouses revulsion against war.[7] Indirect evidence can also be moving. Glancing at a photograph of a child's corpse lying on the torn-up pavement of a Nicaraguan street, Roland Barthes notices a mesmerizing detail of tragedy: "the corpse's one bare foot" as it pokes out from under a concealing white sheet.[8] There were many such images generated by the Vietnam conflict, pictures that mutely attested to the awful human waste of war. But until the fervor of the antiwar movement rediscovered them, such depictions remained underrepresented in the media, presumably because they revealed too graphically the ugly side of the human spirit.

It was such ugliness that filled the pages of the extraordinary *War Against War!* (*Krieg dem Krieg*), Ernst Friedrich's paradigm of pacifist propaganda. Published in Germany in 1924, the work was one of the first to demonstrate the extent to which photographs could serve both as documentary evidence and as a provocation to pacifism. Friedrich employed a relatively simple rhetorical strategy: against shocking images of the devastation wrought by World War I he juxtaposed ironic captions meant to intensify the reader's disgust with war. Moreover, the book's introduction and captions were printed sequentially in four languages—German, Dutch, English, and French—as a gesture to international understanding.[9] In effect, these captions deconstructed militarist and patriotic rhetoric by revealing the human consequences of war: a picture from the illustrated *Family Journal* of a robust "Papa as 'hero' in the enemy country" is paired with an image of "how Papa was found two days later," a corpse mutilated beyond recognition (a depiction, as Friedrich reminds us, that was not published in the *Family Journal*). Such images also served to alert the reader to the ideological basis of war, to the extent to which schools, the church, other social institutions, and even children's toys psychologically prepare us for the beneficence of combat.[10] Against a backdrop of the horrifically disfigured faces of young soldiers, crippled bodies, and violated and emaciated corpses, Fried-

rich allowed stark reality to rage against the mythologies of war.

The public rage engendered by the My Lai massacre in 1968 resulted in one of the great protest statements of the Vietnam period—a large-format, color poster produced in 1970 by a committee of artists representing the Art Workers' Coalition [25].[11] The My Lai incident was one of the most appalling of the war: over a period of several hours a company of Americal Division soldiers systematically murdered women, children, and old men. Many were rounded up into small groups and shot; some of the women and girls were raped and then murdered. After the bloodbath, the GIs burned homes, destroyed livestock and food, and tainted the hamlet's drinking supply.[12] Reminiscent of Friedrich's disturbing juxtapositions, the My Lai poster superimposed a

25. Art Workers' Coalition, *Q. And Babies?/A. And Babies,* 1969–70

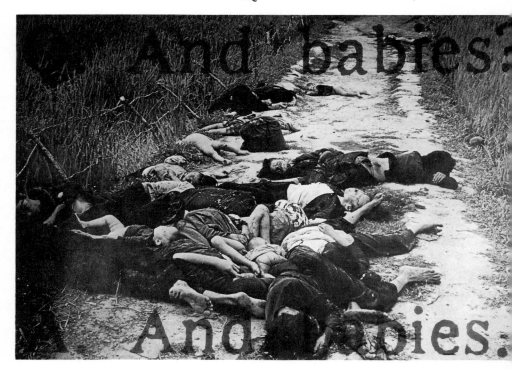

question and its disturbing answer on the photograph of a
pile of blood-soaked corpses lying on a dirt road: "Q. And
babies?/A. And babies." Words and image together serve as
a searing indictment of the military as they blast the lie of
civilian protection; they recall the inflated body counts, the
countless Vietnamese civilians who were magically trans-
formed by the American military into enemy casualties (at
My Lai, for example, Charlie Company reported to its task
force headquarters that 128 Vietcong were killed). More im-
mediately, *And babies?* permits no escape into the heroicizing,
grandiose rhetoric of the military: the valiant heroes of mili-
tary legend are also producers of death—bloody, putrid,
final death. *And babies?* forces us to face our own war-bred
callousness; it reminds us of how easy it is to kill and how
easy it is for *us* to kill.

Such strategies of protest permitted an even more deeply
rooted anxiety to emerge: the fear of dismemberment, of
not being whole. This fear paralyzed American GIs who fell
daily from fragmentation-bomb wounds to the feet, hands,
legs, groin, buttocks, and belly.[13] The technology of the Viet-
nam War was filled with devices for mutilation: napalm,
white phosphorous, and cluster bombs maimed thousands of
Vietnamese soldiers and civilians. Nor were soldiers, when
they killed, always content with dead bodies. The ears of still
warm corpses were sometimes sliced off, strung with bando-
liers, and worn around the neck as evidence of previous
kills.[14] The fear of losing one's wholeness, and the impulse
to deny the enemy his wholeness even in death, drives deep
into the human spirit:

> . . . The American still had one unshakable faith in a de-
> fined zone: his own body. To lose a leg or a hand or a foot
> in American society is a most terrible consequence in a
> society that believes that everyone must be "whole." To be
> missing the capacity to move, as in paraplegia, or to be
> missing an arm or a leg contradicts the ideology that insists
> libido is attracted only to unities. When "Charlie" castrated
> the corpses of its enemy, it wasn't anything else but a sign
> pointing to the fact that dismemberment means a loss of

sexuality, a ruining of Western man's acceptability as man
in the eyes of his peers.[15]

And so America was faced daily with televised human inter-
est stories about severely wounded soldiers or interviews with
veterans who were coping without an arm or a leg. Such
images ironically coincided with the discourse of radical psy-
chiatry in the 1960s—a discourse that spoke to the issue of a
divided self, to the perpetual confiscation of the ego, the
extent to which the dynamic of late-industrial society usurps
control and denies wholeness. If R. D. Laing or later Gilles
Deleuze and Felix Guattari postulated therapeutic modes of
recovery from these divisions,[16] the imagery of Vietnam—a
whirlwind of dismemberment and pain—provoked our
worst nightmare: that the American involvement in Indo-
china was driving the country inexorably out of control as it
threatened the loss of our moral and political integrity. In
other words, a divided America was risking the loss of its
acceptability in the eyes of its people and of its Western
peers.

Not surprisingly, the antiwar movement capitalized on
these bourgeois fears of social and cultural division. Its de-
pictions aimed to *decenter* by confronting the viewer with
shocking or disturbing imagery. The large scale of Leon Go-
lub's napalm-mutilated figures [26] or the directness (and
wide distribution) of Rudolf Baranik's Angry Arts poster of
a burned and bandaged child [27] made it very difficult for
the spectator to turn away; such depictions, reinforcing those
already seen on television, forced us to acknowledge uncom-
fortable realities that we would rather forget. Discomfort was
also introduced by the inversion of the ordinary, by the cou-
pling of everyday rhetoric with improbable imagery. In
1972, during the presidential election campaign, the *And ba-
bies?* poster was redesigned to reflect the political and moral
schism wrought by Nixon's Vietnamization program. The
image of the My Lai dead was now defined by another ques-
tion and answer—"Q. Four More Years?/A. Four More
Years?"—the campaign slogan, with added question marks,
of Richard Nixon's reelection bid.

In the representations of the antiwar movement, the world

26. Leon Golub, *Napalm II*, 1969

was often depicted as gruesomely unwhole, broken or divided. Nancy Spero's depictions of war frequently deployed the body as bloody fragments, a body that functions through its disassembled parts. On Spero's battlefields, libidinal energy insanely serves the interests of death and destruction; in works such as *Swastika* (1968) and *Female Bomb* (1966) [28], tongues act as fiery weapons, decapitated heads and breasts become explosive bombs. Carolee Schneemann's juxtapositions of fragmented actions in her film *Viet-Flakes* [29] are disorienting: what first appear as diaphanous flakes of snow slowly emerge as photographic images of mutilation and death. Inflammatory language and imagery (as an extension of American counterculture) were also employed as tools of division in the antiwar campaign. The appropriation of the American flag in order to question the meaning of patriotism, as in George Maciunas's conversion of the American flag into a controversial register of genocide statistics [30], pitted

72

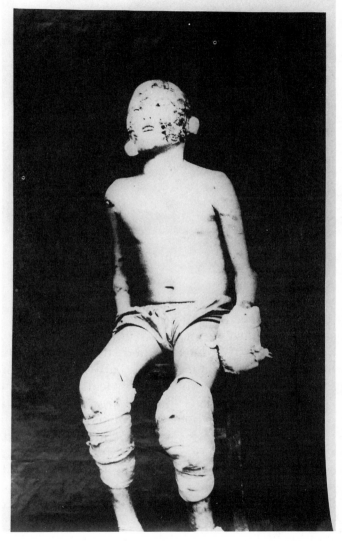

27. Rudolf Baranik, *Angry Arts Against the War in Vietnam*, 1967

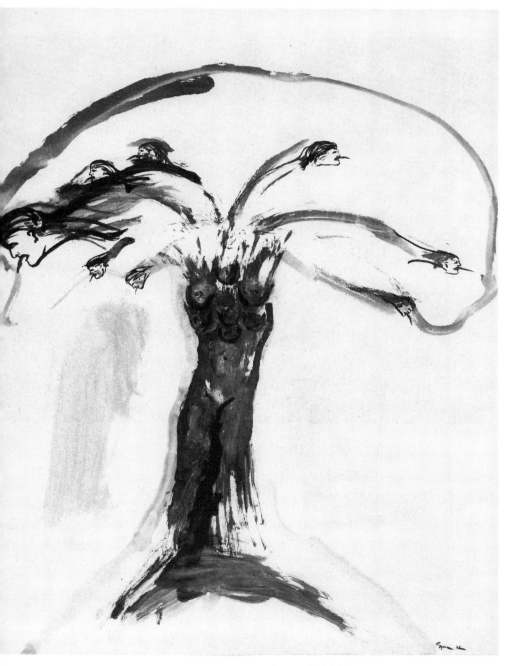

28. Nancy Spero, *Female Bomb*, 1966

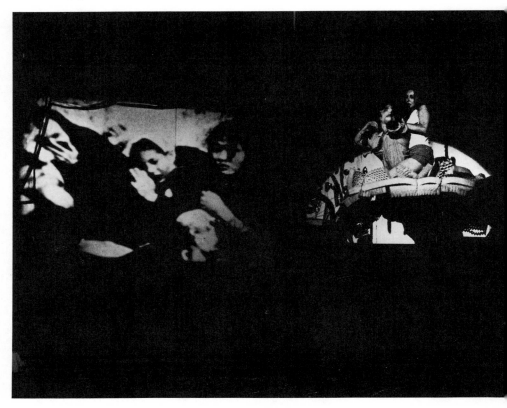

29. Carolee Schneemann, still from *SNOWS: Kinetic Theatre*, 1967

the foremost symbol of our "indivisible" nation against the
divisive reality of our involvement in Vietnam. Such repre-
sentations, combined with the unrelenting television cover-
age of the Vietnam conflict, increasingly served to inflame
the wounds of disunity in America. Indeed, the success of
the antiwar movement can be attributed to its persistent de-
ployment of words and images and to its unwillingness to
allow America to ignore, for even a moment, the horrors of
battle.

Twenty years later, faced with new "enemies" in Central
America, to urge that our nation finally "heal" from the dev-
astation caused by our involvement in Vietnam may be dan-

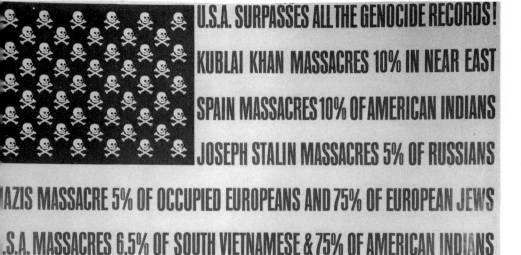

30. George Maciunas, *U.S.A. Surpasses All Genocide Records*, 1966

gerous in itself. Better to recall how easy it is to lapse into military fervor. Better, perhaps, to expose the wounds of Vietnam to young Americans, to encourage them to think before they march blindly onto the "field of honor."

NOTES

1. Barbara Ehrenreich, foreword to Klaus Theweleit, *Male Fantasies*, trans. Stephen Conway, Minneapolis, University of Minnesota, 1987, p. xii.
2. The United States Department of Defense, for example, issued such documentaries as *Why Vietnam* (1965) and *Know Your Enemy: The Viet Cong* (n.d.) as morale boosters for American troops on their way to fight in

Vietnam. Featuring such distinguished political figures as Dean Rusk, Robert McNamara, and then President Lyndon Johnson, *Why Vietnam* presented the North Vietnamese invasion of the South as parallel to Adolf Hitler's invasion of Eastern Europe. The military establishment was understandably sensitive about its public appearance: body counts were distorted in order to reflect a constant ratio of 1 American to 30 Vietcong fatalities; atrocities such as the infamous massacre at My Lai were hastily covered up; and soldiers were given conflicting orders predicated on the presence or absence of photographers or reporters (e.g., "Don't shoot at religious buildings when newsmen are present"). For more on the issue of American distortions of Vietcong body counts, see David Haward Bain, *Aftershocks: A Tale of Two Victims*, New York, Methuen, 1980, p. 67. For excellent accounts and analyses of the events at My Lai see Seymour Hersh, *Cover-Up: The Army's Secret Investigation of the Massacre at My Lai 4*, New York, Random House, 1972. For more on the military attitudes toward the media, see Bain, p. 77.

3. For more on the media and the Tet offensive, see Frances FitzGerald, *Fire in the Lake: The Vietnamese and the Americans in Vietnam*, Boston and Toronto, Little, Brown and Company, 1972, pp. 393–94.

4. By the early 1970s, however, President Nixon's "Vietnamization" policy—in which American ground troops were systematically withdrawn and replaced by Vietnamese armed forces—tended to cut the middle-of-the-road "doves" off from the peace movement. While America continued to manage the war and also to undertake major bombing raids into Laos and Cambodia, the decrease in the number of American ground troops helped to mollify some of the opposition. See FitzGerald, pp. 403–24.

5. The documentary *The War at Home* (1976), for example, examines the effect of the student movement on public opinion through a particularly cogent test-case: the radicalization of students at the University of Wisconsin, Madison from 1963 to 1973. The Vietnam War engendered opposition from members of the armed forces who began publishing their own underground papers, publications ultimately so subversive (in that they appealed directly to conscripts who often already questioned the necessity for the American war effort in Vietnam) that military authorities, unable to tolerate dissent, worked relentlessly to drive them out of existence. For an excellent discussion of military censorship during the Vietnam conflict, see Geoffrey Rips, "The Military Campaign," in *The Campaign Against the Underground Press*, San Francisco, City Lights, 1981, pp. 137–51.

6. See, for example, Lucy Lippard, "The Art Workers' Coalition," in Gregory Battock, ed., *Idea Art*, New York, Dutton, 1973, pp. 102–15; Lawrence Alloway, "Art," *The Nation*, 19 October 1970, pp. 381–82; and Elizabeth Baker, "Pickets on Parnassus," *Art News*, September 1970, pp. 31–34.

7. As Roland Barthes reminds us, "the *punctum* shows no preference for morality or good taste; the *punctum* can be ill-bred." See *Camera Lucida*, trans. Richard Howard, New York, Hill and Wang, 1981, p. 23.

8. *Ibid.*, p. 43.

9. The introduction has been published in more than four languages. The book may have been translated into as many as 40 languages.

10. For an analysis of Friedrich's tactics, see Douglas Kellner, "Introduction: Ernst Friedrich's Pacifistic Anarchism," in Ernst Friedrich, *War Against War!*, Seattle, The Real Comet Press, 1987, pp. 9–18.

11. The poster was, in fact, designed in cooperation with Museum of Modern Art staff members. The Museum ultimately refused to distribute the poster because it had not been submitted to its board. Its shocking imagery no doubt contributed to MoMA's decision. See Baker, p. 33.

12. The description of the My Lai events is extracted from Hersh, pp. 1–2.

13. For more on the idea of injury as the principal object of combat, see Elaine Scarry, "Injury and the Structure of War," *Representations 10*, (Spring 1985), pp. 1–51.

14. American troops were documented as having done this to the dead enemy. See Bain, p. 67.

15. Herman Rapaport, "Vietnam: The Thousand Plateaus," in Sohnya Sayres, et al., eds., *The 60s Without Apology*, Minneapolis, University of Minnesota, 1984, p. 145.

16. See, for example, R. D. Laing, *The Divided Self*, Middlesex, Penguin, 1960, and Gilles Deleuze and Felix Guattari, *The Anti-Œdipus*, trans. Robert Hurley, Mark Seem, and Helen Lane, Minneapolis, University of Minnesota, 1983.

V

Race and Representation

IS TALL, well-proportioned body is graceful and athletic. His face, with its square jaw and cheekbones, is perfectly symmetrical. He is at once average and ideal. Modeled from an averaging of the measurements of thousands of "native white" men from many parts of the United States, he is a composite of available data translated into three dimensions. A model of "normal" perfection, his name is, appropriately, Norman. And along with his perfect sister Norma, he stands as a testament to the "character" of the American nationality. Designed by Dr. Robert Latou Dickinson, who drafted the proportions and posture of the figures, and crafted by Abram Belskie, Norma and Norman recall the psychotic enterprise of the Nazi geneticists who searched for statistics to prove their claims of Aryan superiority and beauty. Dickinson and Belskie's enterprise, however, was neither irrational nor motivated by bigotry; instead, their project underscores the indifference of science and culture to matters of race when fulfilling a blind ambition to determine "truth."[1]

The imperative to be normal, to fit in, to integrate into society's mainstream often feeds racial bias, a need that has

provoked a reexamination of the question of Norma and Norman forty years after their appearance in *Natural History* magazine. The artist Izhar Patkin's collage series *Norman: The Average American Male* (1981–82) resounds with juxtapositions that shatter the complacency of Norman's perfect world. Posed in a range of passive positions—standing, sitting on a chair, sitting on the floor, crouching, kneeling, sleeping—Norman is now vulnerable; he is robbed of his pedestal and his fig leaf, the affectations of artifice and purity that had signified his social removal. Superimposed on Norman's anonymous face in *Men from Mars* (1982), for example, is a photograph of bizarre freaks—pathetic midgets touted by their greedy circus promoters as "extraterrestrial" creatures. Patkin questions the perfection we expect from our cultural models. The image of the well-adjusted, *normal* person advanced by the media and the arts to motivate and tempt the late-capitalist consumer must now compete with the Others that populate our environment. The *Norman* series, in its travesty of Dickinson and Belskie's "Portrait of the American People," restates the extent to which even "innocent" representations sustain racist ideologies. From the perspective of representation, there will always be a threshold beyond which difference becomes intolerable.

Central to a discussion of the rhetoric of racism is the reality that every representation—every painting, photograph, film, video, or advertisement—is a function of "someone's investment in the sending of a message."[2] Because the most successful representations are those which can be most easily apprehended, such rhetoric often collapses into stereotypes that meet the common need to simplify and organize meaning. For Umberto Eco, these "codes of recognition," help to order and interpret the world of information: "These codes [of recognition] list certain features of the object as the most meaningful for purposes of recollection or future communication: for example, I recognize a zebra from a distance without noticing the exact shape of the head or the relation between legs and body. It is enough that I recognize two pertinent characteristics—four-leggedness and stripes."[3] A zebra with three legs or with dots instead of stripes either would not be recognized as a zebra or, perhaps as likely,

would be considered a freak, for what is not recognized is most often relegated to the realm of the alien, the foreign, the abnormal. Both scientific and cultural discourse reverberates with such distinctions: the behaviorist who maintains that stubbornness in children indicates pathology, the psychiatrist who proclaims homosexuality a disease, the geneticist who speaks of racial inferiority, the artist who portrays the lurid "exoticism" of the Other all justify their claims by asserting an equation between the abstract truth of the "normal" and its relation to the wholesome, healthy, and good. To respect what is recognized as normal is to belong to that comfortable majority which lives at society's center. To live outside this world is to exist at "risk."

Today, a number of contemporary visual artists have chosen to deconstruct these racist ideologies and their relationship to conventional representation. Joe Lewis's *Good Question* [31] of 1984, for example, projects a provocative juxtaposition: an apothecary scale that balances brass weights against the artist's shorn dreadlocks. *Good Question* reiterates

31. Joe Lewis, *Good Question*, 1984

the imbalance between the dominant culture and the marginal cultures of the Other as it restates a basic condition: that racial minorities continue to be subjected to the whims of white authority. While the cultural voices of racial minorities are silenced by oppressive societies, such societies do not recognize the immorality of arbitrarily synthesizing the Other's culture into their representations.[4] *Good Question* alludes to the kind of cultural imperialism that sanctions this confiscation of the marginal into the mainstream, a transaction that converts the "exotic" voice of the Other into commodities that can be bought and sold. Lewis's work serves to locate the issues of race in the class structure as it affirms the extent to which racism continues to serve the interests of late capitalism.

For artist Margo Machida, the connection between race and sexuality magnifies her reality of society's indifference to the voice of the Other. Openly defying the categories of gender, her 1986 triptych, *Self-Portrait as Yukio Mishima* [32], juxtaposes disturbing and violent images. The center panel —a self-portrait of the artist half-naked and with a dagger embedded in her rib cage—is flanked by cropped sections of the head and abdomen of Yukio Mishima, the right-wing Japanese novelist who committed suicide (by the disembowelment and decapitation ritual of *seppuku*) in 1970. Machida's juxtapositions disrupt the complacency of the "normal" and the familiar. "By literally breaking up the image and sometimes painting sections differently," Machida writes, "I refer to fragmented experiences of slipping from one state to another: male/female, inside/outside . . ."[5] And as if to underscore the danger of defying established gender roles, Machida concludes her sequence of oppositions with the following, unavoidable consequence: "intense emotional pain"[6] —the pain, tempered by the stoicism, of Yukio Mishima's conflicted life of dual compulsions. To some extent, Machida's representation reiterates the multiple oppositions and confusions of Mishima's life: male/female, artist/warrior, homosexual/heterosexual, man of letters/man of action. Paradoxically, Mishima's incessant flirtation with the lifestyles of the Other was balanced by an almost paranoid need to be "normal," a state he sought to recover through a chauvinistic

32. Margo Machida, *Self-Portrait as Yukio Mishima,* 1986

involvement with right-wing militarist politics. Ironically, it was Mishima's flamboyant warrior stance—brashly recreated in Machida's violent image—that established his reputation in the West,[7] a reputation that posthumously served racist stereotypes of the Japanese warmonger while simultaneously courting the Western fascination with and distrust of the "exotic." [8]

The scientific, political, or cultural imperative to maintain normative standards—a distinction often rooted in racial bias—is an outgrowth of society's relentless need to establish "truth." What determines this "truth" in any society is a sys-

tem of ordered procedures for the production, regulation, distribution, and articulation of the dominant ideologies of the society at large. In this "regime of truth," as the historian Michel Foucault has called it, "[truth is] bound in a circular relation to systems of power which produced and sustain it."[9] "Each society," Foucault writes, "has its . . . 'general politics' of truth: that is, the types of discourse it harbors and causes to function as true; the mechanisms and instances which enable one to distinguish true from false statements; the way in which each is sanctioned; the techniques and procedures which are valorized for obtaining truth; the status of those who are charged with saying what counts as true."[10] It is the last category—those charged with saying what counts as true—that is perhaps the most dangerous, for "truth," sanctioned by the voice of consensus, has often served as the justification for racial oppression.

The refusal to validate—or even to acknowledge—the voice of the Other is often justified by the dominant culture's need to protect the right of the majority. DON'T TALK DOWN TO ME, begins one of Jenny Holzer's assertive *Inflammatory Essays* (1979–82), a series of aphoristic poster-essays that address the complicity of language in the operations of oppression [33]. The words "don't talk down to me"—reiterated by a radical white artist of the political Left—represent Holzer's understanding that even sympathetic forces rarely permit marginalized people to speak for themselves.[11] Barbara Kruger's photomontage of a black female welder restates this problem as the words *speak for yourself* are superimposed over fiery sparks [34]. The Other's indenture to the language of the dominant culture provokes Henry Louis Gates, Jr., to recall the story of M. Edmond Laforest:

> In 1915, Edmond Laforest, a prominent member of the Haitian literary movement called La Ronde, made his death a symbolic, if ironic, statement of the curious relation of the marginalized writer to the act of writing in a modern language. Laforest, with an inimitable, if fatal, flair for the grand gesture, stood upon a bridge, calmly tied a Larousse dictionary around his neck, then leapt to his death. While other black writers, before and after Laforest, have been drowned artistically by the weight of var-

DON'T TALK DOWN TO ME. DON'T
BE POLITE TO ME. DON'T
TRY TO MAKE ME FEEL NICE.
DON'T RELAX. I'LL CUT THE
SMILE OFF YOUR FACE. YOU
THINK I DON'T KNOW WHAT'S
GOING ON. YOU THINK I'M
AFRAID TO REACT. THE JOKE'S
ON YOU. I'M BIDING MY TIME,
LOOKING FOR THE SPOT. YOU
THINK NO ONE CAN REACH YOU,
NO ONE CAN HAVE WHAT YOU
HAVE. I'VE BEEN PLANNING
WHILE YOU'RE PLAYING. I'VE
BEEN SAVING WHILE YOU'RE
SPENDING. THE GAME IS
ALMOST OVER SO IT'S
TIME YOU ACKNOWLEDGE ME.
DO YOU WANT TO FALL NOT
EVER KNOWING WHO TOOK YOU?

33. Jenny Holzer, selection from *Inflammatory Essays*, 1979–82

34. Barbara Kruger, *Untitled (Speak for Yourself)*, 1986

ious modern languages, Laforest chose to make his death
an emblem of this relation of overwhelming indenture.[12]

"It is the challenge of the black tradition to critique this re-
lation of indenture," continues Gates, "an indenture that ob-
tains for our writers and for our critics. We must master, as
Jacques Derrida writes . . . how 'to speak the other's lan-
guage without renouncing [our] own.' "[13] And yet, such a
renunciation is usually a prerequisite for the validation of
the Other by our cultural institutions. To continue to speak
in a foreign voice, to speak provocatively about one's own
disenfranchisement, or to refuse to conform to the codes of
recognition is to arouse the indignation of the dominant cul-
ture. Concomitantly, after ignoring the work of black (and
women) artists for the past 24 years of its reprinting and
revision, H. W. Janson's *History of Art* (1962)—one of the
most widely used undergraduate textbooks in the field—per-
mitted only mainstream abstraction to represent the black
artist in its pristine pages. Because it conforms to the high
modernist canon of apolitical lyrical abstraction as it with-
draws "from the conflicting demands of critics, white and
black, into the privacy of [its] studio,"[14] such work is consis-
tent with the greater motives of Janson's history. The vast
pool of work by activist black artists remains rejected by Jan-
son's revised text, a consequence of their refusal to be com-
fortable and safe.

The irresponsibility of representation is the central issue
of the work of Pat Ward Williams. In *Accused/Blowtorch/Pad-
lock* [35] of 1986, a section of a photograph appropriated
from the pages of *Life* magazine serves as a shocking re-
minder of the indifference of the media and the arts to their
social responsibility. The image—a full view of the mutilated
body of a lynched black man chained to a tree—is joined by
three rephotographed details, uncompromising close-ups
that offer evidence of a vicious and mindless brutality:
gashes, cuts, burns from a blowtorch. To celebrate the my-
thologies of liberalism—the idea of the "heroism" and "dig-
nity" of the "passive victims" of white oppression—is merely
to grant the oppressed a worthless and bogus subjecthood.[15]

35. Pat Ward Williams, *Accused/Blowtorch/Padlock,* 1986

Around the set of photographs, Williams scrawls some diffi-
cult questions about the morality of *Life* magazine's "con-
cerned" representation: "Who took this picture?" "*Life* an-
swers: page 141—no credit." "Couldn't he just as easily let
the man go?" "How could this photograph exist?" The litany
of questions continues as Williams weaves a painful web of
indictments.

Edgar Heap of Birds, a member of the Cheyenne and
Arapaho Nation, wishes to wrest the responsibility of repre-
sentation away from the dominant culture. *In Our Language,*
for example, a computer video presentation in New York's
Times Square, glides comfortably between the language of
his people and the language of White America, speaking, as
Derrida would say, "the other's language without renounc-
ing [its] own." Heap of Birds has compared his art to the
"sharp rocks" that served as weapons of war for the Chey-
enne people. OH! THOSE SOUTH AFRICAN HOMELANDS, intones

one of his "sharp rocks," YOU IMPOSE U.S. INDIAN RESERVA-
TIONS [36]. Heap of Birds's powerful slogans, "insurgent
messages" as he calls them, are arrows intended to pierce the
heart of racism in American life, encouraging native Ameri-
cans (and by inference other racial minorities) to seize con-
trol of the forces of representation:

> The white man shall always project himself into our lives
> using information that is provided by learning institutions
> and the electronic and print media. Through these expe-
> riences the non-Indian will decide to accept or reject that
> the native Americans are a unique and separate people
> with the mandate to maintain and to strengthen indige-
> nous rights and beliefs. Therefore we find that the survival
> of our people is based upon our use of expressive forms
> of modern communication. The insurgent messages
> within these forms must serve as our present day combat-
> ive tactics.[16]

By refusing to filter representations of the Other through
the dominant ideologies of white America, such insurgent
messages "delivered through art [will] present the fact that
native Americans are decidedly different from the dominant
white culture of America."[17] These combative messages call
for the acceptance of difference as they establish a *distinction*
between sameness and equality. The sophistication of Edgar
Heap of Birds's intellectual commitment to the issues of rep-
resentation exposes a fundamental political reality: real
power for the disenfranchised rests in their ability to take
charge of the discourse and to subvert the messages of
"truth" and conformity that govern representation.

In the opening passages of Roy DeCarava and Langston
Hughes's *The Sweet Flypaper of Life* (1955)—a meditation on
Harlem as seen through the eyes of Sister Mary Bradley—
the aging grandmother refuses to "come home" to the Lord.
"I am not prepared to go," she tells St. Peter's messenger.
"For one thing," Sister Mary explains (thinking of the grand-
children left in her care), "I want to stay here and see what
this integration the Supreme Court has done decreed is
going to be like." Hughes's text continues: "Since integration
has been, ages without end, a permanently established cus-

OH! THOSE SOUTH AFRICAN HOME LANDS YOU IMPOSE U.S. INDIAN RESERVATIONS

© 1985 Edgar Heap Of Birds

36. Edgar Heap of Birds, selection from *Sharp Rocks*, 1985

tom in heaven, the messenger boy replied that her curiosity could be satisfied quite easily above. But Sister Mary said she wanted to find out how integration was going to work *on earth* first, particularly in South Carolina which she was planning to visit once more before she died."[18] In the pages that follow, Roy DeCarava's impeccable photographs—honest images of the faces, the streets, and the styles of Harlem in the 1950s—re-echo with Sister Mary's curiosity about integration: was it going to work *on earth?* The unspoken irony of Sister Mary's curiosity is that in her world—in the space of *The Sweet Flypaper of Life*—life continues, it thrives, it is nurtured internally, through the will of its own people. For while the Harlem captured by DeCarava's camera was not economically rich, it reverberated with the voices of a distinct and vital culture. Sister Mary's haunting question tempts another one: Is it integration or social equality that will improve life in black America? Might integration result in the silencing of one's cultural voice into that prized vessel of mainstream culture called the melting pot?

In the end it is *difference* that most frightens the bigot. It produces a fear so great that the fiction of an integrated society—often couched in promises of economic rewards for the Others who "make it" into the mainstream—doesn't seem so bad. In the order of things, the Other is often asked to choose between social hierarchies that serve as the scale on which the innate respectability of his or her life is weighed. "Believer/non-believer," "good citizen/rebel," "self-sufficient/needy," "patriot/militant"—these are words that often serve the needs of those who speak the language of invective and judgment. And, of course, in the degraded realm of apartheid in South Africa—where even "integration" is impossible—such simple oppositions as "white," "colored," and "black" can drive the motor of hatred. Such is the "regime of truth" for the white minority in South Africa, a regime founded on the perverse notion that racial domination may be sanctioned, even dictated, by God. This belief, we are told, "imposes on the Afrikaner the duty of assuring that colored peoples are educated in accordance with Christian-National principles," a teaching that will affirm that the "well-being and the happiness of the colored man resides in

his recognition of the fact that he belongs to a separate racial group."[19] Fully in control of the mechanisms of representation, the figures of white authority in South Africa continue to suppress the voice of the black majority—silencing an important weapon in service of liberation.

The voices of the artists in this exhibition—powerful voices of resistance—speak to the very issue of who, ultimately, will speak for whom. Rejecting the guardianship of the dominant culture, and refusing to be measured and judged by racist standards, these artists speak the official language without renouncing their own. Perhaps the force of their pioneering effort will encourage the sentinels of our collective "truth" to step back, if only for a moment, from the gates of judgment.

NOTES

1. That Norma and Norman made their debut on the pages of an important American magazine in 1945—when news of the horrific Nazi atrocities was filtering out of Europe—confirms the insensitivity of this relentless search for standards and ideals. They were reproduced for the first time in Harry L. Shapiro, "A Portrait of the American People," *Natural History*, 54 (June 1945), pp. 248 and 252.

2. For a discussion of this issue, see Victor Burgin, "Photographic Practice and Art Theory," in *Thinking Photography*, ed. Victor Burgin, London, Macmillan, 1982, pp. 39–83.

3. "Critique of the Image," in *Ibid.*

4. I would like to thank Lowery Sims for suggesting this interpretation of Lewis's work.

5. Artist's unpublished statement.

6. *Ibid.*

7. For more on Mishima, see Yukio Mishima (text) and Eikoh Hosoe (photographs), *Barakei (Ordeal by Roses)*, New York, Aperture, 1985, and Marguerite Yourcenar, "Mishima: A Vision of the Void," *New York Times Book Review* (November 2, 1986), pp. 1 and 42–44.

8. For a discussion on the racist signifier of the "exotic" in 19th-century painting, particularly with regard to French Orientalist painting, see Linda Nochlin, "The Imaginary Orient," *Art in America*, 71 (May 1983), pp. 118–32, 187–91.

9. See John Tagg, "The Currency of the Photograph," in Burgin, p. 129. The conditions of "truth" that sustain representation—from measures and standards of the applied and social sciences to the principles and convictions of the fine arts—are, of course, a function of ideology. The concept of neutrality, that a representation can be entirely value-free, is specious. Even in photography, where the images are often naively understood to directly record reality, the social, political, and cultural motives of the photographer (and of society) intervene. Before the subject is selected, before the image is bracketed in the viewfinder, before the shutter is released, the photographer, through an elaborate set of determinations (selection, point-of-view, angle, distance, posing), inflects the image with ideological meaning. Any "mood" or "feeling" suggested must, in fact, rest on "our common knowledge of the typical representation of prevailing social facts and values." For more on this subject see Tagg, pp. 110–41; Allan Sekula, "On the Invention of Photographic Meaning," in Burgin, pp. 84–109; and Burgin, pp. 38–83.

10. "The Political Function of the Intellectual," *Radical Philosophy* (Summer 1977), p. 13.

11. Often this exclusion is based on matters of taste, style, or the elitism of the Western intellectual.

12. "Editor's Introduction: Writing, 'Race' and the Difference It Makes," *Critical Inquiry*, 12 (Autumn 1985), p. 13.

13. *Ibid.*

14. H. W. Janson, *History of Art*, Englewood Cliffs, N.J., Prentice-Hall, 1986, p. 717. Anthony F. Janson assumed editorial responsibility for the third edition of *History of Art* upon the death of his father.

15. Hazel Carby has analyzed the relationship of the lynching of black men to the political and protectionist imperatives of oppression—a reality that grants the victim neither "heroicism" nor "dignity." "When accused of threatening the white female body," Carby writes, "the repository of heirs to property and power, the black male, and his economic, political, and social advancement, is lynched out of existence." See " 'On the Threshold of a Woman's Era': Lynching, Empire, and Sexuality in Black Feminist Theory," *Critical Inquiry*, 12 (Autumn 1985), p. 276. For more on granting of a "bogus" subjecthood in the service of liberalism, see Sekula, pp. 108–9.

16. Edgar Heap of Birds, "Edgar Heap of Birds," *C.E.P.A. Quarterly*, 1 (Spring 1986), p. 1.

17. *Ibid.*

18. Roy DeCarava and Langston Hughes, *The Sweet Flypaper of Life*, Washington, D.C., Howard University Press, 1984, p. 9.

19. From the charter of the South African Institute for Christian Education (1948). As quoted in Jacques Derrida, "Racism's Last Word," *Critical Inquiry*, 12 (Autumn 1985), p. 297.

VI

Black Skin, White Masks: Adrian Piper and the Politics of Viewing

The white man is sealed in his whiteness.
The black man in his blackness.
FRANTZ FANON,
Black Skin, White Masks (1952)

I T IS BOTH a tradition and a present-day reality that oppression forces its victims into a continual state of emergency. As such, Adrian Piper's 1988 video installation at the John Weber Gallery in New York, *Cornered* [37], suggests an urgency not normally felt in mainstream art institutions. A video monitor is situated catty-corner in the corner of a room. The surrounding wall space is empty except for photocopies of the two birth certificates of the artist's late father—one identifying him as white, the other as black. As if to suggest a prior moment of violent dissension, an overturned table rests against the monitor stand, its upended legs acting as a kind of threatening barrier between spectator and monitor. Piper appears alone on camera, shot from the torso up and sitting catty-corner in a corner of a room that is uncannily synchronized with the space around the video monitor. Her hair drawn back in a chignon, she wears a conservative blue dress, delicate earrings, and a strand of pearls. She affects an impersonal, neutralized tone familiar to us from television news programs and public service announcements.

The video itself could only be disturbing to the white

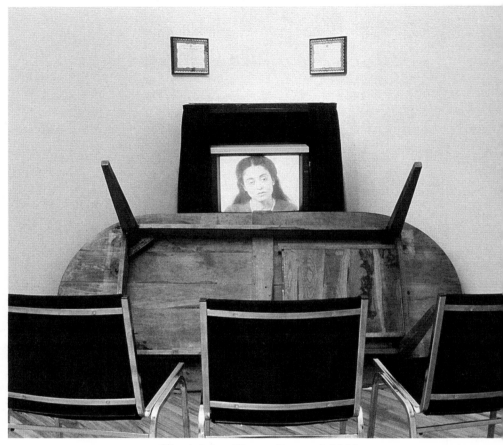

37. Adrian Piper, *Cornered*, 1989

mainstream audience to whom it is principally directed. The artist's precious, junior-miss style and quiet delivery are deceptive as her words challenge and provoke. Piper, a light-skinned black woman who (like her father) could easily pass for white, announces at the outset "I'm black." For the next 20 minutes, the viewer is increasingly, almost claustrophobically, cornered-in by her rhetoric: explaining why passing for white would constitute a self-hating and degrading act, Piper reminds us that "the problem is not simply my per-

sonal one, about my racial identity. It's also your problem, *if* you have a tendency to behave in a derogatory or insensitive manner towards blacks when you see none present." Several moments later, she arrives at the heart of the matter: If, as some researchers estimate, almost all purportedly white Americans have between 5 percent and 20 percent black ancestry then why shouldn't most Americans be classified as black? "What are you going to do about it," she asks, ". . . are you going to tell your friends, your colleagues, your employer that you are in fact black, not white, as everyone had supposed?" Establishing an overwhelming black majority for America, Piper's hypothesis is all the more ironic in light of the institutional context in which it is being made—a pathologically racist art world where the interests of blacks and other people of color are for the most part banished. A world where the political awareness that a state of emergency is necessary for oppressed peoples is at best ignored and at worst disparaged.

Piper's questions are not meant to be rhetorical; instead, they entangle the white viewer in a difficult, even painful, web of personal confrontation and self-analysis. (At the opening reception in March 1989, one man loudly protested "Nobody's going to tell me I'm not white.") Piper's most recent installations, performances, and videos establish an astonishingly direct relationship between a confrontational artist and her spectators. Stemming from a "compulsion to embody, transform, and use [her] experiences as a woman of color in constructive ways, in order not to feel trapped and powerless," Piper's work politically "catalyzes" its viewers into thinking about their own emotional relationship to racism as it "constructs a concrete, immediate and personal relationship between [her] and the viewer that locates [them] within the network of political cause and effect." [1] Her radicalization of the artist's societal role has necessarily shifted the involvement of the spectator; neither artist nor viewer is permitted the usual defensive rationalizations that exempt us from the political responsibility of examining our own racism.

Piper has always been interested in the relationship of the self to its defining social spaces and institutions. Her early

work, commensurate with the phenomenological strategies of the New York avant-garde in the late 1960s, consisted of detailed analytical records of her own activities and surroundings.[2] In the 1968–70 *Hypothesis Series* [38], Piper photographed and charted her own passage through various spatial situations—actions coextensive with the perceptual experiments of "minimalist" artists, choreographers, and filmmakers such as Sol LeWitt, Yvonne Rainer, and Michael Snow.[3] Piper's early conceptual art—her "Garden of Eden" period as she has called it—was entirely removed from the problems of racism and sexism that would preoccupy her from the early 1970s onward. The political upheavals of 1970—the U.S. invasion of Cambodia, the student revolts, and the killing of student protestors at Kent State and Jackson State universities—contributed to a shift in her aesthetic concerns.[4] Piper could no longer reconcile the methodologies of the passive, elitist mind games of conceptual and minimal art with the fact that as a black woman she faced marginalization both within and outside of the art world.[5] Neither could such resolutely formal and hermetic aesthetic devices address the reality of an America resounding with the painful repercussions of racism and sexism.

38. Adrian Piper, *Hypothesis Situation #14*, 1968–69

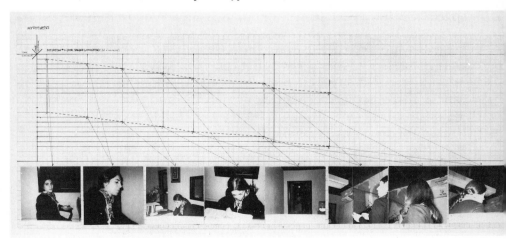

Piper does not entirely reject these devices, however. In a kind of Duchampian strategy, she constantly returns to the forms of modernist culture in order to question their power. The innate formalism of a work like *Cornered*—in which the coordinates of the room and video image are reduplicated in order to intensify the effect of the artist's words—reminds us that the preeminent institutional space of art, the gallery room, is itself a function of modernism's oppressive social order. Piper's performances and installations are at once communal and invasive: in the 1970 *Catalysis Series* [39] she tested people's xenophobia and intolerance by transforming herself in odd or repulsive ways and negotiating everyday situations such as riding a bus or subway; in her *Mythic Being* (1972–76), a menacing street kid took to the streets in an ongoing guerrilla performance [40]; and in *Funk Lessons* [41] of 1982–84 she taught sometimes resistant white people how to funk dance. In contrast, most viewer-oriented conceptual works, such as Hans Haacke's gallery visitor's polls and profiles (1969–73)—in which visitors were asked to fill in statistical questionnaires or vote on relevant political issues—effect a private, meditative relationship between spectator and art object. The sociological positioning of Piper's performances allows them to more fully traverse the boundaries that normally separate art from the rest of society, in effect allowing the artist to take her cultural investigations into spaces that are irrelevant to the art world.

In contrast, modernism, always intent on establishing distance between the avant-garde and the grim realities of the industrial social order, often isolated the artist in a glorified, aesthetic realm. There, the artist's special role was best expressed through Charles Baudelaire's concept of the dandy, an expressive figure who, through his elegant and studied dress and manner, embodied the special and rarified features of "art" itself. Neither wealthy nor impoverished, the Baudelairean dandy existed mostly outside the political boundaries of class, his marginality relegating him to the artificial and classless social category of artist. Baudelaire wrote:

39. Adrian Piper, *Catalysis IV,*
1970–71

40. Adrian Piper, *The Mythic Being,
Getting Back #2, 3, 5,* 1975

41. Adrian Piper, still from *Funk Lessons*, 1984

Whether these men are nicknamed exquisites, *incroyables*, beaux, lions or dandies, they all spring from the same womb; they all partake of the same characteristic quality of opposition and revolt; they are all representative of what is finest in human pride, of that compelling need, alas only too rare today, of combating and destroying triviality. It is from this that the dandies obtain haughty exclusiveness, provocative in its very coldness. Dandyism appears above all in periods of transition, when democracy is not yet all powerful, and aristocracy is only just beginning to totter and fall. In the disorder of these times, certain men who are socially, politically and financially ill at ease, but are all rich in native energy, may conceive of the idea of establishing a new kind of aristocracy, all the more difficult to shatter as it will be based on the most precious, the most enduring faculties, and on the divine gifts which work and money are unable to bestow.[6]

Walter Benjamin would ultimately admonish the modern in-
tellectual's ambiguous politics, exemplified by this kind of
neutralization of race, gender, and class allegiances. Western
intellectuals, he observed, did not see themselves as "mem-
bers of certain professions" but as representatives of a "cer-
tain characterological type," a type located somewhere
between the classes. Advocating a more activist role for the
intellectual, Benjamin called "for the transformation of the
forms and instruments of production in the way desired by
a progressive intelligentsia—that is, one interested in freeing
the means of production and serving the class struggle."[7]

Piper's realignment of the artist/spectator relationship
rests on her desire to work beyond such a characterological
suspension of the artist's connection to the rest of humanity.
This challenge to the forms and instruments of art produc-
tion resulted both in a withdrawal from the precious art ob-
ject and a travesty of modernist conceits: the "apolitical"
intellectual, the "classless" dandy, and the "objective" *flâneur*
who wanders the streets of Paris observing the heroism of
modern life are for Piper the subject of parody and even
derision. Take, for example, her *Mythic Being*. Masquerading
in dark glasses, Afro, and pencil mustache, the *Mythic Being*
was Piper's male alter ego. Neither dandy nor *flâneur*—yet
strangely reminiscent of both—the *Mythic Being* represented
himself as a tough black street kid who engaged in charged
and sometimes hostile encounters with strangers. Piper sent
him into white middle- and upper-middle class social con-
texts—theaters, gallery receptions, museum exhibitions—in
order to observe racist patterns of avoidance and aggression.
After moving to Cambridge, Massachusetts, in 1974 to begin
graduate study in philosophy at Harvard University, Piper
involved her *Mythic Being* in such actions as "cruising" the
streets to experience male sexuality, wandering the Cam-
bridge commons, and venting class antagonisms by mugging
a male accomplice in public view after a provocative conver-
sation.[8]

If Piper's "whiteness" allowed her to escape from the cruel-
est side of racism, the racial and class specificity of her male
alter ego left her particularly vulnerable. Gaining a sense of

her "own marginality as a nonwhite (but not obviously black) member of society," Piper realized that she was now even more threatening to white society at large.[9] As Homi Bhabha observes, "the black presence ruins the representative narrative of Western personhood: its past tethered to treacherous stereotypes of primitivism and degeneracy will not produce a history of civil progress, a space for the *Socius;* its present, dismembered and dislocated, will not contain the image of identity that is questioned in the dialectic of mind/body and resolved in the epistemology of 'appearance and reality.' The white man's eyes break up the black man's body and in that act of epistemic violence its own frame of reference is transgressed, its field of vision disturbed."[10]

Ultimately, *Mythic Being* personifies the mythic *black man*—the presence who ruins the representative narrative of white America. He is the being for whom miscegenation laws were invented, codes that pretended to "protect" white women "but left black women the victims of rape by white men and simultaneously granted to these same men the power to terrorize black men as a potential threat to the virtue of white womanhood."[11] The tragic irony of this social equation is that black men's "power," though threatening to white society, is most often fictive and allusive; since male power within patriarchy is relative, poorer men, frequently men of color, are most often denied the material and social rewards of their participation in patriarchy.[12] With her *Mythic Being,* Piper conflated issues of race and gender in order to question problematic feminist constructions that pit white women against white men in a struggle for power. Any understanding of patriarchal relations which examines the power of men over women outside of broader racial and economic issues is, of course, problematic. Arguments that feature patriarchy as the primary determinant of women's oppression fail to see "the inapplicability of such a concept in analyzing the complex of relations obtaining in the Black communities both historically and at present."[13] Such discourses of patriarchal relations, for example, most often ignore the struggle that men and women of color must fight *together* against the white ruling class. *Mythic Being*—a black woman in the

guise of a black male youth—metaphorically represents this alliance, reminding us that in Western society racism effortlessly crosses the boundaries of gender.

Piper's desire to speak over the oppressive master texts of modernism results in the blasting of another aspect of the artist's mythology—the specter of anonymity. Like Frantz Fanon's existentialist evocation of the "I" that restores the presence of the marginalized (and his own presence within dominant narratives that would silence a black man's voice),[14] Piper at times speaks through personal or autobiographical narratives. *The Big Four-Oh* (1988), a self-portrait video installation, juxtaposes a display of materials soaked in her bodily fluids, an open journal, a suit of armor, forty hard balls, and a repeat videotape of Piper with her back to the camera dancing nonstop to soul music. The work, which represents the artist at the time of her fortieth birthday, affirms her complexity and strength, each of its parts serving as a metaphor for an aspect of her existence. This installation would seem to continue the project of the earlier *Political Self Portraits* (1980) in which Piper superimposed images of her face and body over detailed autobiographical accounts written from the three perspectives that define her marginalization—class, race, and gender. A chronology of the artist's life written by Piper and published in the catalog for her recent retrospective exhibition includes the following note: "This chronology was created solely by Adrian Piper and is presented as part of her artistic work."[15] Rather than narcissistic evocations of the self or acts of romanticized self-expression, autobiography serves a crucial *political* function in Piper's œuvre. As part of a broader structure for dismantling oppressive systems, such narratives acknowledge the extent to which marginalized peoples are spoken at and for, the degree to which people of color, women, gay men, and lesbians have been defined and judged by the narrow standards of a dominant culture governed by white heterosexual males. Indeed, who constructs the master narratives of culture? Who are the patrons of academia, the publishers, the financiers of industrial society? Who writes history?[16]

Marginalized peoples, of course, are generally excluded from defining their own role in the narratives of history.

Women of color, for example, have been alternately catego-
rized as exotic or "pathological" or both—universalizing con-
ditions that deny difference as they create stereotypes of
passivity or abnormality: "But what does the sameness of the
exotic women represent? Female heroism, humor, carnival-
esque gesture, triumph, movement . . . 'trans-cultural, trans-
historical, trans-social'—*exotic*. Here exoticism marks a
universality which systematically negates the very raison
d'être of women's different experiences, strategies and ac-
tions." [17] Like the mythologized dandy, these ciphers of uni-
versality, exoticism, or sameness mask deeper political
motives. As such, autobiographical writing can serve an im-
portant therapeutic function for marginalized peoples. The
fear and uncenteredness associated with psychic and physical
oppression can often be overcome or helped by reconnecting
with the personal narratives of the past. Remembering can
be part of a cycle of reunion, observes Bell Hooks, "a joining
of fragments, 'the bits and pieces of my heart' that the [au-
tobiographical] narrative made whole again." [18] Such speech
will always be difficult for the dominant culture to accept.
Representational marginalization exempts the exotic "oth-
ers"—whether they be women, gays, blacks, or even artists—
from serious consideration by the ruling class. To allow such
peoples to speak in their own voices is to risk hearing their
oppositional speech—discourses that demand rather than
passively accept, that scream rather than whisper.

Although Piper's project is directed at a cultural commu-
nity that is mostly privileged, she reconstructs the ideological
role of the artist in a way that directs her audience to join
her in the struggle against racism and sexism. Indeed, she is
always polite in her address, always conscious of the psycho-
logical threshold of complacent viewers who would rather
look at "art" than confront the painful reality of their own
racism. "I can't bear the thought of violating the norms of
etiquette," Piper has said. "Such norms help me to grease my
way . . . through a hostile white world." [19] The inherent dif-
ficulty of disseminating upsetting information makes this po-
liteness a matter of packaging for Piper; like a good
advertising executive, she understands that style is often as
important as content in reaching an audience. It is through

this "power of passive provocation" that Piper hopes to transform her audience psychologically, by presenting them with "an immediate and unavoidable concrete reality that cuts through the defensive rationalizations by which we insulate ourselves against the facts of our political responsibility. I want viewers of my work to come away from it with the understanding that their reactions to racism are ultimately political choices over which they have control—whether or not they like the work or credit it for this understanding."[20]

To this end, Piper embarked on a series of audience performances in which predominantly white, art world groups were engaged in various consciousness-raising activities. The ground-breaking *Funk Lessons*, for example, began as a question in Piper's mind: Why are white people indifferent, even hostile, to soul music? "I found that response [to funk music] so often," Piper observes. "It seemed to me there was a gap between the purported attitude of openness and receptivity to popular culture that is usually espoused by the art world, according to which *anything* is adequate subject matter for appropriation and reuse within the context of high culture. And what *actually* seemed to be the case is that in fact only *some* things can have that function, and in particular black working-class culture *cannot* have that function."[21] Having incorporated funk music into earlier politically oriented performances, Piper found that white audiences misunderstood her motives or attacked her use of this music as "cheapening" the serious political content of the performance. Such resistance, Piper suggests, is rooted in several areas: "One problem has to do with the overt sexuality of that music—it talks about fucking, it talks about making love, it talks about bodies, and it's very hard to assimilate that in a way that's not threatening to white upper-middle-class culture. Another problem is that it requires a very highly structured use of one's body in order to respond to it."[22]

Piper decided to "educate" white audiences about the significant (if not always acknowledged) role played by this music in both dominant and marginal culture. *Funk Lessons* was structured in an academic format as a participatory performance with Piper as instructor and audience members as students.[23] Piper distributed a bibliography and photocopied

handouts that listed some of the "characteristics" of funk dance and music. She proceeded to discuss certain mainstream presumptions about funk music in an attempt to free her audience from discomforting misconceptions. She then led the group in body isolation exercises, discussed the structure of the music, and practiced dance movements with musical accompaniment. (An extraordinary video version of *Funk Lessons* centers on a particularly successful performance at the University of California at Berkeley in 1983. Piper augments film of the Berkeley evening with voice-over and on-screen commentary and archival footage of influential soul performers [e.g., James Brown, Little Richard, and Aretha Franklin] and the white entertainers [Elvis Presley, Mick Jagger, The Talking Heads] who capitalized on the black funk idiom. The video yields a level of meaning somewhat independent of but not unrelated to the performance—that of the mass-media suppression of working-class black culture and its comfortable, and profitable, appropriation by white artists.) Ultimately, Piper did not want to scare or intimidate her audience; rather she constructed a "comfortable and safe" format that encouraged people to explore their apprehensions about the music and their ability to soul dance. Individual audience reactions to *Funk Lessons* varied from antagonism and resistance to jubilation. Successful performances culminated in a celebratory dance party; failed ones fizzled out in a morass of confusion and resentment.[24]

Piper's *My Calling Cards 1 and 2: A Metaperformance* (1987–) represents one of the most successful and extraordinary attempts at dealing with racism in an art world context. The performance is structured after the traditional slide lecture at which artists discuss their work with public and student audiences. (Duchamp, in a series of talks offered at several universities and museums in the United States in the early 1960s, was one of the first to elevate the artist's lecture to a kind of metaperformance.) *My Calling Cards* centers on only two works. The first part of the lecture deals with a small card, geared for dinner and cocktail parties, that informs guests who make racist remarks that Piper is black and offended [42]. The second work, also a calling card, is for distribution in bars and discotheques or anywhere that

an unescorted Piper might be subjected to aggressive sexual advances by men: "I am not here to pick anyone up, or to be picked up," the card reads in part, "I am here alone because I want to be here, ALONE" [43]. Such cards fall into the category of "reactive performances" that are entirely spontaneous; the utterance of a racist comment or a persistent come-on commences the performance.

Because white people generally don't realize that Piper is black, she is left in the difficult position of being privy to their racist comments. As such, her calling cards constitute an important catalyst in her process of dealing with the pain

Dear Friend,
 I am black.
 I am sure you did not realize this when you made/laughed at/agreed with that racist remark. In the past, I have attempted to alert white people to my racial identity in advance. Unfortunately, this invariably causes them to react to me as pushy, manipulative, or socially inappropriate. Therefore, my policy is to assume that white people do not make these remarks, even when they believe there are no black people present, and to distribute this card when they do.
 I regret any discomfort my presence is causing you, just as I am sure you regret the discomfort your racism is causing me.
 Sincerely yours,
 Adrian Margaret Smith Piper

42. Adrian Piper, *My Calling Card #1*

Dear Friend,

 I am not here to pick anyone up, or to be picked up. I am here alone because I want to be here, ALONE.

 This card is not intended as part of an extended flirtation.

 Thank you for respecting my privacy.

43. Adrian Piper, *My Calling Card #2*

and discomfort of racism. Ultimately, Piper serves as an invisible but ever vigilant black presence who unwillingly observes yet willingly analyzes "the forms racism takes when racists believe there are no blacks present." Piper continues:

> I am the racist's nightmare, the obscenity of miscegenation. I am a reminder that segregation is impotent; a living embodiment of sexual desire that penetrates racial barriers and reproduces itself. I am the alien interloper, the invisible spy in the perfect disguise who slipped past the barricades in an unguarded moment. I am the reality of successful infiltration that ridicules the ideal of assimilation.[25]

Such disguises, of course, can be employed as a means of challenging colonialism and racism from within the system. In the fragile interstice between the black body and the white body is "a tension of meaning and being" that can engender both psychic and political strategies of subversion. Homi Bhabha writes:

> [Such strategies] offer a mode of negation that seek ... not to unveil the fullness of Man but to manipulate his representation. It is a form of power exercised at the very limits of identity and authority, in the mocking spirit of mask and image; in the lesson taught by the veiled Algerian woman in the course of the revolution as she crossed the Manichean lines to claim her liberty. In [Frantz] Fanon's essay, "Algeria Unveiled," the colonizer's attempt to unveil the Algerian woman does not simply turn the veil into a symbol of resistance; it becomes a technique of camouflage, a means of struggle—the veil conceals bombs. The veil that once secured the boundary of the home— the limits of woman—now masks the woman in her revolutionary activity, linking the Arab city and the French quarter, transgressing the familial and colonial boundary.[26]

Piper continually reenacts the role of the Algerian woman. With her polite and genteel manner and her "white" skin, she smuggles bombs past the protective barricades of racism. All the while, she remains masked in her revolutionary activ-

ity of deconstructing with intense force the emotional, intellectual, and spiritual motivations of bigotry. While the pointed act of receiving one of her calling cards, of being exposed in one's racism, is undoubtedly repudiating, one is spared the spectacle of a public censuring. Piper's calling cards are not intended to embarrass; instead, they gently encourage people to think about the potential of their racist words to hurt, to alienate, to violate.

When Piper publicly reveals her motives and methods, as in the *My Calling Card* metaperformance, her white middle- and upper-middle-class audiences most often respond defensively. While the convivial atmosphere of *Funk Lessons* eased the pressure somewhat for most white audiences, *My Calling Card* was far more confrontational, eliciting personal anecdotes about racial and sexual tensions. A videotape of a performance of *My Calling Cards 1 and 2* at the Randolph Street Gallery in Chicago in 1987, in which a white audience interacts with Piper, is particularly revealing. As Piper lectures on the first calling card, the audience becomes visibly agitated: nervous laughter is heard as people shift uncomfortably in their seats. Questions are defensively directed at Piper. Her strategies are scrutinized and she is admonished for humiliation-causing behavior. The second card provokes even sharper inquiry about Piper's radical self-assertion as a woman. Indeed, not until much later do members of the audience address the therapeutic and positive side of the consciousness-raising exercise at hand. It is not until the final minutes of the performance that someone acknowledges Piper's own pain by asking her what it feels like to hand someone one of her cards: "They ruin my evening," she answers.

While these metaperformances are directed principally at white audiences (as the only enfranchised people in the art world), Piper also works with integrated and black audiences. In a metaperformance at the Studio Museum in Harlem in 1988, she showed the earlier Randolph Street tape to a racially mixed audience of critics, students, and artists.[27] (Interestingly, white racism was considerably more overt in the New York performance.) Eventually, Piper will view the Stu-

dio Museum performance tape with an all-black audience. Piper writes of her work:

> For a white audience, it often has a didactic function. It communicates information and experiences that are new, or that challenge preconceptions about oneself and one's relation to blacks. For a black audience, the work often has an affirmative or cathartic function: It expresses shared emotions—of pride, rage, impatience, defiance, hope— that remind us of the values and experiences we share in common. . . . Whether particular individuals feel attacked . . . affirmed . . . or challenged [by my work,] it can teach them something about who they are.[28]

Whether through the familiar strategies of talk show host (the metaperformances), newscaster *(Cornered),* or interloper (the *Mythic Being*), Piper gently positions the spectator into a mode of self-examination. She succeeds because she insists on challenging at the outset the complacent attitudes and aesthetic presuppositions that make culture so inherently racist and sexist. Rather than simply "destroying or disrupting man-centered vision by representing its blind spots, its gaps, or its repressed," Piper struggles "to construct other objects and subjects of vision, and to formulate the conditions of representability of another social subject."[29] While she rejects the exclusive positioning of the spectator as white, heterosexual, and male, she does not shift the focus of her inquiry solely to women and people of color. Instead, she oscillates between various channels of address, provoking her viewers into multiple levels of self-inquiry.[30]

Piper sets into motion fascinating exchanges that suggest most convincingly that art can contribute to the struggle against racism and sexism. The discourse that Piper engenders in her work is that of self-knowledge. Such knowledge, of course, has always been forced upon women, people of color, and gays as a means of survival. Yet, Piper demands the same kind of self-interrogation for white, heterosexual men (and women who ignore their relationship to racism); she gently persuades her subjects to examine their own mo-

tives and fears. She does not encourage white people to ana-
lyze black culture, but instead calls for an exploration of
"what is going on with whiteness."³¹ Why do liberal whites
speak for people of color but resist sharing their power so
that these "Others" can speak for themselves? Why is it
"cool" for white people to emulate black culture but not ac-
ceptable to enfranchise black artists? Who is getting hired to
teach, write about, and represent black culture? From these
questions emerge more fundamental ones: Why do we fear
people of color? What is the relationship between racism and
sexism? Piper's commitment to cultural transformation at-
tempts to ask these questions and in turn to foster change
through a carefully constructed dialogue with people who
are fundamentally afraid of the kind of transformation she
suggests. As such, her gentility, evident even in confronta-
tional works like *Cornered,* is genuine; she wants people to
engage these painful questions rather than abandon them in
fear. Contrasted against an apolitical and complacent art
world, her critical intervention is nevertheless dramatic. No
matter how softly she speaks, her actions continually reiter-
ate the state of emergency that makes her project necessary
in the first place.

NOTES

1. Adrian Piper, "General Statement About My Art," unpublished
manuscript, p. 1.
2. Of the work, Piper writes: "My work during this period was very
strictly minimalist. All aesthetic decisions were dictated by my exploration
of perspectival spatiotemporality. I thought further about the space per-
spective defines, and in which objects protrude and recede. . . . I made
another small hop, this time to the level of abstract thought about space,
time, and the objects within it; their materiality, concreteness, their infinite
divisibility and variability, their indefinite serial progression through
stages, their status as instances of abstract concepts." Adrian Piper,
"Flying," *Adrian Piper: Reflections 1967–1987*, New York, The Alternative
Museum, 1987, p. 21.

3. For more on the phenomenological imperatives of minimalism, see Rosalind Krauss, "The Double Negative: A New Syntax for Sculpture," in *Passages in Modern Sculpture*, New York, Viking, 1977, pp. 243–87. For a critique of these imperatives, see Maurice Berger, "Introduction: Robert Morris Outside Art History" and "Against Repression: Minimalism and Anti-Form," in *Labyrinths: Robert Morris, Minimalism, and the 1960s*, New York, Harper & Row, 1989, pp. 1–18 and 47–80.
4. Piper writes in "Flying" (p. 21): "I traumatized myself, burned out, and began to withdraw from the artworld into the external work. The political upheavals of 1970 . . . [as well as] others' responses to my perceived social, political, and gender identity braked my flight a bit. I struggled to transcend both. . . . It didn't work. I plummeted back to earth, where I landed with a jolt."
5. Piper discusses this issue in an interview with Dale Jamieson, taped in March 1989 at the University of Colorado at Boulder.
6. Charles Baudelaire, "The Painting of Modern Life," in Jonathan Mayne, trans. and ed., *The Painting of Modern Life and Other Essays*, New York, Da Capo Press, 1964, p. 28.
7. See Walter Benjamin, "The Author as Producer," in Peter Demetz, ed., and Edmund Jephcott, trans., *Reflections*, New York and London, Harcourt Brace Jovanovich, 1978, p. 226.
8. Piper writes in "Flying" (p. 22): "Some of my artwork during this period [the later *Mythic Being* performance and poster pieces] reflected the ongoing initiation into personal confrontation, political alienation, failures of communication, rejection, ostracism, and mutual manipulation I had been experiencing in my social relations." For a detailed account of the *Mythic Being*, see Lucy Lippard, "Public Disturbances (and/or Flying Lessons)," unpublished manuscript, n.p.
9. As quoted in Lippard, n.p.
10. Homi K. Bhabha, "Remembering Fanon: Self, Psyche, and the Colonial Condition," in Barbara Kruger and Phil Mariani, eds., *Remaking History*, Seattle, Bay Press, 1989, p. 135.
11. Hazel Carby, " 'On the Threshold of Woman's Era': Lynching, Empire, and Sexuality in Black Feminist Theory," *Critical Inquiry* 12 (Autumn 1985), p. 268.
12. For an important discussion of these issues, see Bell Hooks, "Reflections on Race and Sex," *Z* 2 (July/August 1989), p. 60.
13. Valerie Amos and Pratibha Parmar, "Challenging Imperial Feminism," *Feminist Review* 17 (Autumn 1984), p. 9. For an excellent analysis of this issue, see Desa Philippi and Anna Howells, "The Conjuncture of Race and Gender in Anthropology and Art History: A Critical Study of Nancy Spero's Work," *Third Text: Third World Perspectives on Contemporary Art and Culture* (Autumn 1987), pp. 34–54.
14. Bhabha, p. 133.
15. This statement appeared in a special edition of the catalog published for the traveling exhibition. See Adrian Piper, "Chronology," *Adrian Piper: Reflections 1967–1987*, New York, John Weber Gallery, 1989, n.p.

16. Kruger and Mariani in the "Introduction" to *Remaking History* write (p. ix): "There is one answer because there has purportedly been only one history: a bulky encapsulation of singularity, a univocal voice-over, an instructor of origin, power, and mastery. History has been the text of the dead dictated to the living, through a voice which cannot speak for itself. The ventriloquist that balances corpses on its knee, that gives speech to silence, and transforms bones and blood into reminiscences, is none other than the historian. The keeper of the text. The teller of the story. The worker of mute mouths." For an important deconstruction of the patriarchal historical narrative, see Janet Abu-Lughod, "On the Remaking of History: How to Reinvent the Past," in Kruger and Mariani, *Remaking History*, pp. 110–29; James Green, "Engaging in People's History: The Massachusetts History Workshop," in Susan Porter Benson, Stephen Brier, and Roy Rosenzweig, eds., *Presenting the Past: Essays on History and the Public*, Philadelphia, Temple University Press, 1986, pp. 339–59 and 415–19. For more on the political imperatives of autobiography in artists' writing, see Maurice Berger, "Splashes in the Ebb Tide: Robert Morris's Subversive Discourse," in Robert Morris, *The Collected Writings of Robert Morris*, Cambridge, Mass., and London, MIT Press, forthcoming.

17. Philippi and Howells, p. 47. For more on the problematized expressions of marginalized and "pathologized" women, see Catherine Clément, "Culture and Repressive Structures," in Hélène Cixous and Catherine Clément, eds., *The Newly Born Woman*, trans. Bets Wing, Manchester, Manchester University Press, 1986, pp. 5–6.

18. See Hooks, "Writing Autobiography," in *Talking Back: Thinking Feminist, Thinking Black*, Boston, South End Press, 1989, p. 159.

19. Piper, videotaped interview with Dale Jamieson.

20. Piper, in "A Dialogue with Adrian Piper," *P-Form: Performance Art News*, no. 4 (April/May 1987), p. 22.

21. "A Dialogue with Adrian Piper," p. 22.

22. *Ibid.*

23. This was a familiar role for Piper. She received her Ph.D. in Philosophy from Harvard University in 1981. A philosopher of international renown, Piper has served in full-time professorial positions at the University of Michigan, Georgetown University, and the University of California, San Diego.

24. Piper recalls a particularly disastrous performance: "The [students'] attitude of . . . studied nonchalance . . . was just *impossible* to crack. People just *could not* be honest about their feelings. I remember talking about some of the sexual associations and some of the racial associations of the music and someone got up and said, 'What do you mean? We're all cool here.' That was really a perfect expression of people's attitudes that evening. . . . There were a lot of expressions, 'Well, why are you telling me this? I already know about this. I don't need to hear about this. I'm hip. I've done all of this already. . . .' And so on. Whereas of course what you would expect if they really were at peace with themselves as far as this music was concerned was that they would just party and enjoy it. . . . It

was . . . absolutely a deadly evening. I'll never forget it." See "A Dialogue with Adrian Piper," pp. 22–23.

25. Piper, "Flying," p. 23. On this racial interaction, Piper writes: "Blacks who look and sound like me bring out the racial discrimination in those who believe they know better, who believe they have transcended their racism. We bring out a vehement insistence, a curiosity, a compulsion to impose the stereotype at any cost, even at the cost of good manners. 'Perhaps your great-grandmother?' 'Oh, it was your great-grand*father* who was black?' (i.e., 'You mean white women consorted with black Africans in the 1850s?')." See Piper, "Adrian Piper," *Women Artists News* (June 1987), p. 6.

26. Bhabha, p. 145.

27. In another metaperformance at the Randolph Street Gallery, Piper showed the Berkeley *Funk Lessons* videotape and discussed it with her white audience.

28. Piper, "General Statement About My Art," p. 1.

29. Within quotation marks, Teresa de Lauretis is referring to the new women's cinema. See Teresa de Lauretis, "Rethinking Women's Cinema: Aesthetics and Feminist Theory," in *Technologies of Gender*, Bloomington and Indianapolis, Indiana University Press, 1987, p. 135.

30. Indeed, Piper carries this dialogue into her most recent photographic work. In *Why Guess* (1989), for example, she confronts white viewers with images of successful middle-class blacks culled from the pages of *Ebony* magazine. Such images bring home the idea that economic empowerment for blacks, while threatening to whites who fear erosion of their own economic clout, is a critical part of social enfranchisement for blacks. The *Ur-Mutter* series (1989) underscores the way white indifference disguises a subliminal, implicit acceptance of racism. In effect, Piper juxtaposes blasé newspaper and magazine advertisements featuring middle-class whites with graphic images of disadvantaged blacks. (In a particularly incisive work, Piper places an image of a healthy, smiling white woman and her son next to a photograph of an emaciated, prematurely aged black woman holding a child.) The message of *Ur-Mutter* is uncompromising: whites must acknowledge their investment in an economic status quo that perpetuates racist and classist oppression.

31. Bell Hooks continues: "If much of the recent work on race grows out of a sincere commitment to cultural transformation, then there is serious need for immediate and persistent self-critique. Committed cultural critics—whether white or black, whether scholars, artists, or both—can produce work that opposes structures of domination, that presents possibilities for a transformed future by willingly interrogating their own work on aesthetic and political grounds. This interrogation itself becomes an act of critical intervention, fundamentally fostering an attitude of vigilance rather than denial." See Hooks, "Expertease," *Artforum* 17 (May 1989), p. 20.

VII

Culture Stories/American Myths

a.
YVONNE RAINER'S *Privilege*

Since its release in 1985, Yvonne Rainer's film *The Man Who Envied Women* [44] has stood as an important challenge to the white, middle-class values of most academic theoretical feminism. The film's narrative centers on Jack Deller (Bill Raymond and Larry Loonin)—a white college professor, "feminist," and lover of women—and his estranged wife (not seen but narrated by Trisha Brown), whose words serve as a kind of Marxian-feminist counterpoint to Deller's more hermetic appropriations from Foucault and Lacan. Deller is indeed complicated, as becomes clear when we see him doing what he presumably does best: lecturing to his students. His rehearsal of male master texts that speak *at* rather than *with* women represents a kind of frightening primal scene of academia—the place where we are often taught to discount our bodies, our emotions, and our contradictions in the service of an all-consuming and numbing theory.

Toward the end of the film, Brown remarks provocatively: "If a girl takes her eyes off Lacan and Derrida long enough to look she may discover she is the invisible man."[1] Perhaps it is the first part of her sentence that is the most important. If we look beyond such texts, these words suggest, we might be able to see another dynamic more clearly: the interrelations of power, both public and private, that establish our relationship to each other as men and women.

Ultimately, Rainer's deconstruction of the language of academic feminism, post-Structuralism, and psychoanalytic theory never underestimates the insights such discourses offer into the linguistic and psychological formation of our sexuality; instead, she merges the experiential, the political, and the theoretical into a significant metanarrative on power.

Rainer's newest film, *Privilege* (1990), pushes this ideologi-

44. Yvonne Rainer, still from *The Man Who Envied Women*, 1985, with Thyrza Goodeve and Larry Loonin

cal inquiry even further through a subversive fracturing of the traditional alliances of the various feminisms of white women [45, 46]: the white-identification and Marxian/psychoanalytic dialectic of *The Man Who Envied Women* now gives way to questions about the relationship of gender to racism and economic class, and about the legal, scientific, and medical discourses that define, and ultimately oppress, our bodies. Some of these problems were, of course, also addressed in the earlier film, but in *Privilege* Rainer refuses the rhetorical indirectness and theoretical density of the previous work, spelling out these problems with uncompromising frankness and wit. She constructs a remarkably coherent pastiche, juxtaposing a fictional narrative about a menopausal heterosexual woman recounting an experience she has kept secret for 30 years with excerpts from vintage educational films on menopause and contemporary interviews with women who in real life are coping with the often painful and lonely passage into "change of life."

At the film's outset, antinuclear activist Dr. Helen Caldicott (Rainer) is seen making a public farewell address. "One of the reasons that I'm stopping," she remarks in a kind of political call to arms, "is that I have to go away and work out how we do it, because *we've done nothing yet.* . . . We talk all this equal rights, and we beg men for equal rights and we've achieved nothing." While she speaks, a black woman interprets her words in American Sign Language. In voice-over, Yvonne Washington (Novella Nelson)—Caldicott's (and Rainer's) African-American alter ego—begins to extrapolate on a project that might contribute to the battle for women's rights. After years of activism on behalf of deaf people, Yvonne has decided to make a documentary film on menopause and "the dominant medical attitudes . . . that tell us we are 'deficient' and 'diseased' "—a situation she sees as analogous to the hearing establishment's pathologizing of the deaf community. As part of her preparation, she interviews women for the film, especially her old friend Jenny (Alice Spivak), a menopausal white woman with whom she had danced years before. It is through their dialogue—and Jenny's "hot flashbacks" that interrupt it—that the film's central narrative emerges.

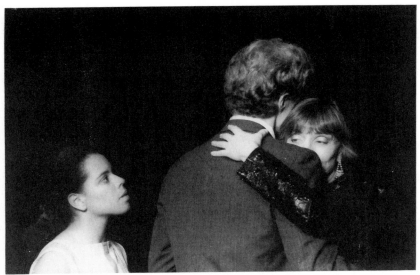

45. Yvonne Rainer, still from *Privilege*, 1990, with Gabriella Farrar, Dan Berkey, and Alice Spivak

46. Yvonne Rainer, still from *Privilege*, 1990, with Gabriella Farrar

The interview is at first difficult for Jenny: "When you're young they whistle at you, when you're middle-aged they treat you like a bunch of symptoms, and when you're old they ignore you," she observes with a sense of resignation. Jenny soon brings the conversation around to her days as a young aspiring dancer living on the tumultuous and racially tense Lower East Side of Manhattan in the early 1960s. She then reveals her long-held secret: an act of perjury committed during a trial for the attempted rape of her lesbian neighbor, Brenda (Blaire Baron), in which she implied she had seen the defendant in Brenda's apartment. Through flashbacks—in which the middle-aged Jenny plays herself as a young woman—we become witness to the complex issues surrounding this pivotal event in her life. We are introduced to the segregated building she lives in. We meet the young, upper-middle-class Robert (Dan Berkey), the prosecutor in the rape case, with whom Jenny eventually starts a romance. And, perhaps most important to the film's ideological point of view, we meet Carlos (Rico Elias) and Digna (Gabriella Farrar), the Puerto Rican couple who live in the racially mixed building next door. Carlos goes to jail for Brenda's attempted rape; Digna, suffering from bouts of anger and depression, is committed to a mental hospital.

Rainer's characters serve as conduits for a range of provocative political critiques; their contrasting words—which are often taken directly from texts by Piri Thomas, Lenny Bruce, Joan Nestle, Ntozake Shange, Eldridge Cleaver, Nicholas Mohr, and Frantz Fanon, among others—contribute to the narrative fracturing. The cinematic structure of the film, in which various subtexts freely interrupt the central narrative, further emphasizes its complex textuality. The black-and-white clips of a drug promotional film from the early '70s, while often hilarious in their naïveté or outright stupidity, frighteningly demonstrate the devastating vulnerability of women's bodies and minds in the space of medicine and science [47]. Throughout the film, in a provocative internal commentary on the narrative, Rainer generates passages of text on a Macintosh computer screen. At one point we read: "There is a popular saying among gynecologists that there is no ovary so healthy that it is not better removed,

The most remarkable thing was the silence that emanated from friends and family regarding the details of my single middleage. When I was younger, my sex life had been the object of all kinds of questioning, from prurient curiosity to solicitous concern. Now that I did not appear to be looking for a man, the state of my desires seemed of no interest to anyone.

47. Yvonne Rainer, still from *Privilege*, 1990

and no testes so diseased that they should not be left intact."
Jenny's hot flashbacks are themselves interrupted by the various characters who, speaking directly into the camera, extemporate on issues of race, gender, sexuality, and class. In one particularly poignant monologue, Digna, dressed in a hospital robe and speaking in Spanish (with English subtitles) asks, "*¿Dime por qué la mujer puertorriqueña en este país es mas susceptible a la enfermedad mental que el resto de la población?*" And "*¿Por qué es que no florecemos aquí?*" ("Why is the Puerto Rican woman in this country more vulnerable to mental illness than the general population? Why do we not flourish here?")

This chattering of multiple voices serves an extremely important ideological function: it contributes to the film's remarkable intellectual clarity as it recreates the complexity of social and cultural difference. What Rainer is fighting for—and her struggle is indeed risky—is a multivalent feminism

that acknowledges the vicissitudes of race and class long ig-
nored by much white-identified feminist discourse. *Privilege*
categorically refuses to essentialize feminism, women, or
people in general, as it acknowledges alliances that rest en-
tirely outside the complacent expectations of most middle-
class white people.

It is indeed in the area of race that Rainer takes her great-
est risk. For one, the attempted rapist is Puerto Rican and
his actions are not clearly innocent. While the device of play-
ing Carlos as both victim and "villain" (the latter in the jurid-
ical sense at least) is problematic, his actions provoke some
of the film's most significant monologues on race and racism.
Through these statements, crucial questions emerge: If the
vast majority of women are raped or sexually abused by men
from their own racial group, why do white women so deeply
fear men of color? Is the sexism of African-American and
Hispanic men—people who are often made to feel powerless
under the tyranny of the white male hegemony—rooted in
psychological and economic causes that make it different
from the sexism of their white counterparts? To what extent
is the American legal system classist and racist? Why is it so
easy for women to be used as pawns in the macho power
plays of men? And, as Yvonne Washington asks, to what
degree do "white women . . . manage to use their own victim
status as a way of pleading innocent to the charge of racism"?

Rainer's racial gambit goes beyond giving voice to the
"other"; the white people here engage in frank and painful
acts of self-interrogation. In one brilliant example, an argu-
ment between Jenny and Yvonne Washington on the relative
merits of psychoanalytic versus Marxian understandings of
the root causes of racism is followed by a series of computer-
generated first-person confessions, headed by the title "Who
Speaks? Quotidian Fragments: Race." One person admits
resenting a black cleaning woman because she persisted in
"putting on airs" as if she were an upper-crust lady. Another
remembers questioning the competence of a nurse simply
because she was Puerto Rican. While someone remarks: "Roy
Wilkins said somewhere that the most he could ever hope to
be was a permanent recovering sexist. Is 'permanent re-
covering racist' the most *we* can ever hope to be?"

But Rainer is calling for empathy, something even more difficult than self-inquiry. Just as we must know ourselves in order to understand why we hate, we must also begin to understand how it feels to be oppressed. Only then might we begin to acknowledge the pain and frustration that our own bigotry and indifference causes. If white women and women of color have a different relationship to power in this country, Rainer appears to be asking, then what points of convergence can help women understand each other?

Indeed, merely allowing the "other" to speak, or engaging in acts of self-analysis, while important, does not address the whole problem of how we can begin to unlearn our racism, sexism, classism, and by extension homophobia. As *Privilege* eloquently suggests, the social, cultural, and emotional status of being different must be examined—especially by those who have power. Such an enterprise openly acknowledges the need for cross-cultural and cross-emotional examinations, for empathetically comparing *our* conditions to *theirs*. The idea that only members of one particular racial, economic, or sexual group can interpret or understand that group might therefore be replaced by the more open view that sees the real sociological benefits of intercultural studies. Gayatri Spivak writes:

> Can men theorize feminism, can whites theorize racism, can the bourgeois theorize revolution. . . . It is when *only* the former groups theorize that the situation is politically intolerable. Therefore it is crucial that members of these groups are kept vigilant about their assigned subject-position. . . . The position that only the subaltern can know the subaltern, only women can know women and so on, cannot be held as a theoretical presupposition either, for it predicates the possibility of knowledge on identity. Whatever the political necessity for holding the position, and whatever the advisability of attempting to "identify" [with] the other as subject in order to know her, knowledge is made possible and is sustained by irreducible difference, not identity.[2]

Rainer employs these identifications with difference as powerful political tools. *Privilege* charts a radical course for feminism. But rather than cynically pleading her own victimization, Rainer, like Caldicott at the film's outset, calls her fellow feminists to arms—to a battle of sustained self-interrogation and empathic analysis that might lead to a brilliant and powerful coalition of the disenfranchised: "Utopia," Rainer flashes on the screen near the end of the film. "The more impossible it seems, the more necessary it becomes."

NOTES

1. Typical of the film's emphasis on multivalent voices and textual strategies, Brown is, in fact, reiterating and completing a line first spoken by Jackie Raynal. Raynal's "monologue" in the film is, in turn, lifted directly from an essay by the Australian theoretical feminist Meaghan Morris. See Morris, "The Pirate's Fiancée," in *Michel Foucault: Power, Truth, Strategy,* ed. Morris and Paul Patton, Sydney, Ferol Publications, 1979.
2. Gayatri Chakravorty Spivak, "A Literary Representation of the Subaltern: A Woman's Text from the Third World," in *In Other Worlds: Essays in Cultural Politics,* New York and London, Routledge, 1988, pp. 253–54.

b.
YOUNG K.'s *Friendly America*

On August 3, 1982, an Atlanta police officer arrived at the home of Michael Hardwick to serve a warrant for failing to pay a fine for public drunkenness. A male occupant of the house answered the door and, not knowing whether Hardwick was home, suggested that the officer come inside and check. Walking down the hall to a bedroom where the door

was ajar, the policeman saw Hardwick engaging in sex with another man. Both men were arrested and charged with violating a Georgia statute that authorized the court to imprison a person for up to 20 years for a single private, consensual act of sodomy. Hardwick subsequently challenged the arrest, asserting that the law violated various constitutionally afforded rights. On June 30, 1986, a bitterly divided United States Supreme Court issued a ruling that would have grave consequences for justice in America. Associate Justice Byron White, writing for the Court's 5-to-4 majority, held that while heterosexual activity fell within the "zone of privacy" articulated in the United States Constitution, the right to privacy did not extend to homosexual conduct. Chief Justice Warren Burger, in an astonishing concurring opinion that attempted to establish moral and legal precedents, declared that "decisions of individuals relating to homosexual conduct have been subject to state intervention throughout the history of Western civilization"—from Roman law to the 1816 Georgia statute that sanctioned the Hardwick arrest.

Why, at a moment of increasing public acceptance of gay men and lesbians, was the reactionary notion of homosexuality's "illegality" more important to a majority of the Court than the fundamental constitutional rights of due process, freedom of association, and, by extension, the right to privacy? How could the "right to be left alone" in one's bedroom, which the Court had extended two decades before to consenting heterosexual adults, not apply to gay men and lesbians?[1] The chief justice's application of moral history begs another question: Can the majority *learn* to accept the different aspirations, desires, and practices of a minority? In other words, can America change its mind on questions of morality?[2] Associate Justice Harry Blackmun requested to read from the bench a detailed passage from his impassioned dissenting opinion, an unusual act meant to dramatize the chilling reality that a majority of the Court was willing to interrupt or even turn back the expansion of the concept of privacy on which it had embarked more than half a century before. Blackmun observed angrily: "I can only hope that the Court soon will reconsider its analysis and conclude that depriving individuals of the right to choose for them-

selves how to conduct their intimate relationships poses a far greater threat to the values most deeply rooted in our nation's history than tolerance of nonconformity could ever do."

Painted less than a year after the infamous *Hardwick* decision, Young K.'s *The Authority of Law and the Contemplation of Justice: The United States Supreme Court, Washington, D.C., 1987* [48] reverberates with the still raw passions of that tragic judicial episode. For Young, a Chinese-American artist who was born in the People's Republic of China and emigrated to the United States from Hong Kong in 1975, the meaning of American justice had become contradictory: Inspired to come to this country by the promise of democracy and freedom, he soon realized that constitutional rights were neither absolute nor equally disposed. On a formal level, the artist's visual allegory examines the meaning of American jurisprudence through its symbolic representations: the neoclassical architectural and artistic forms that characterize the federal presence. Like the United States Constitution itself, these stately forms encode the relatively conservative, capitalist values of our political system. Indeed, federal planners and administrators have privileged the hierarchical, imperialist associations of architectural classicism over the more egalitarian and utilitarian pretensions of modernism—a style embedded in the politics of socialism.[3] Young's image of the Supreme Court, like his other depictions of federal architecture, represents a visual fantasy meant to reorient our perceptions of governmental power. James Earle Fraser's heroic statues *The Authority of Law* and *The Contemplation of Justice*, seated figures that flank the steps of the Supreme Court building, are in Young's painting posed standing in front of the building. In the foreground, *Law* holds out a quill, as if to invite the individual to participate more directly in the judicial process. Gesturing toward the Court's door with her left hand, *Justice* welcomes her subjects into the imposing edifice. "In this painting I have rendered the power of the state and its institutions subservient to the individual needs of the people," the artist has said. "This image implies that the American people are the masters of the Supreme Court, and that they should have the right to define for themselves

48. Young K., *The Authority of Law and the Contemplation of Justice:
The United States Supreme Court*, 1987

what is morally right and wrong and what is justice. . . . The
law is not an abstract force that affects everyone without
exception; it is a human product that can be adjustable ac-
cording to the needs of each individual in a given circum-
stance."[4]

The seemingly contradictory juxtaposition of imperial art
and architecture with an allegory of populist ideals suggests
the reality of a Supreme Court where individual rights are
protected only selectively. This past term, for example, saw
an increasingly conservative Court reaffirm its constitutional
protection of flag burning as free speech while it further
eroded the rights of adolescent women seeking abortions. As
part of his "Historiograph" series, a group of paintings
begun in 1987, *The Authority of Law and the Contemplation of
Justice* drives deeper than the problem of the Court itself; it
seems to be asking whether democracy can ever be more
than a myth, whether it can ever be fully extended to Michael
Hardwick and the "others" of the country for whom consti-
tutional rights cannot be taken for granted. Young remains
optimistic, as if the sheer power of his utopian vision could
help usher in a new world: "Maybe it is better to build and
to create a whole new society. . . . I simply document what I
would like to see happening in the world, here and now,
making the impossible visible."[5]

These forays into symbolic and utopian representations,
however, are not without a strong sense of social criticism
and irony. In a particularly poignant and personal work that
speaks to the inherent bigotry of the art world, Young al-
tered a page from the catalog of the California Institute of
the Arts. The school from which Young received both a
B.F.A. and an M.F.A. in the early 1980s, CalArts is distin-
guished by its commitment to recent trends in critical theory
—an emphasis that has earned its graduates important
teaching positions and gallery representation throughout the
country. But as Young realized soon after his graduation,
the art world's racist indifference to artists of color might
well result in his exclusion from that world. On a pedestal,
the catalog lies open to the page that declares the school's

compliance with affirmative action requirements—regulations themselves threatened by recent Supreme Court rulings. Below the school's official statement, Young has added an ironic "education amendment" that recognizes the problematic status of the "other" in the art world: The alumni of CalArts are insured "equal opportunity in the arts . . . [and are protected] from discrimination on the basis of race, color, sexual preference, national and ethnic origin, or handicaps in cultural programs, activities, or employment in . . . art institutions, organizations, or communities in the United States of America."

The CalArts catalog is part of Young's most recent project, an extension of the "Historiograph" series *The Friendly America*. The artist has now turned from painting to captioned photomurals and altered objects. The murals self-consciously re-create the style and presentation of such government-sponsored documentary projects as the Historical Section of the Farm Security Administration. But unlike the "straight" photography of the FSA, Young employs photomontage techniques "to transform and [reconstruct] the visual, physical aspects of external reality"[6] into images of an idealized America that most immigrants expect but never realize. The meaning of these images is further isolated through captions that are themselves reminiscent of the FSA. Young's verbal/visual pairings concern such issues of American activism as antiapartheid demonstrations [49], amnesty for illegal aliens, education of the handicapped, the animal-rights movement, and United States solidarity with student protesters in China. While some of his murals represent montaged fantasies, others consist of undoctored media images—from a 1962 shot of a Peace Corps workers in Colombia to a piercing 1967 news photograph of a young antiwar protester inserting pink carnations into the barrels of rifles held by Pentagon guards [50]. The seamless flow of documentary and fantasy images creates a narrative of American good will in which reality often cannot be discerned from fiction.

As such, the myth of the photograph's ideological neutrality is blasted in *The Friendly America*, where simple devices like cropping or posing manipulate as effectively as the more

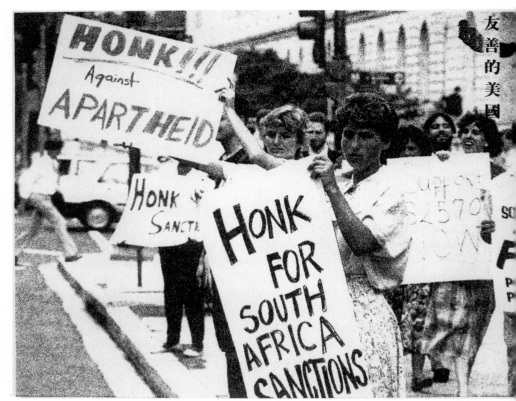

49. Young K., *An anti-apartheid demonstration in Washington, D.C.,*
 1990

complicated constructions of photomontage.[7] The peaceful
euphoria of Young's fantasies is interrupted time and again
by the painful reality that such scenarios may no longer be
possible in the reactionary space of post-Reagan America.
An aerial view of New York City, for example, bears the
following caption: "Censorship-free Zone, a fifteen-mile ra-
dius from the Statue of Liberty in New York. The bill is
passed by Congress on June 4, 1990." This at a time when
the mean-spirited Helms Amendment, passed overwhelm-
ingly by Congress in 1989, encourages the National Endow-
ment for the Arts to deny grants to openly gay artists, while
others are now required to sign repressive, self-censoring
oaths in order to receive their grants.

50. Young K., *A young antiwar marcher places pink carnations into the rifle barrels of army guards at the Pentagon,* 1990

Several murals deal with the U.S. policy toward China. In one such image, Young adds the words AMERICA LOVES CHINA/CHINA LOVES AMERICA to the glistening night sky during Fourth of July fireworks in Washington, D.C. In Tiananmen Square, Beijing, on May 26, 1989—several days before China imposed martial law in a violent crackdown on dissent—student protesters are depicted holding up a banner emblazoned with the same words. (The artist fabricated the imaginary banner in his studio, then superimposed a photograph of it onto a news photo.) Such images contrast with President Bush's misguided policy of appeasing Beijing in order to protect American business interests. While Bush hailed China's lifting of martial law in January of 1990, dissenting Chinese students were quietly being subjected to "steady, numbing sessions of political education."[8] While the president vetoed a congressional bill authorizing trade sanctions against China, Beijing officials continued to oppress intellectuals and students, banishing many of the latter to work farms before allowing them to resume their studies.

Another mural shows a queue of illegal aliens in front of the Houston Immigration and Naturalization Center waiting to be processed into a new, congressionally mandated amnesty program [51]. The federal program, which offered amnesty to "aliens" who had lived illegally in the United States since before 1982, appeared to be a generous step in the previously problematic history of American immigration policy. Yet the vulnerable, anxious faces of these people expose their suspicion of a retributive bureaucracy that has branded them a priori "alien" and "illegal." As a recent survey concluded, there is a reason to be fearful. Because the 1986 law places a heavy burden of proof on future immigrants and extreme legal penalties on employers who hire illegals, it engenders "widespread job discrimination" against Hispanic-Americans, Asian-Americans, and legal aliens.[9] But this is not surprising in a nation where the antiquated McCarran-Walter Immigration Act has been invoked by both Democratic and Republican administrations for more

51. Young K., *Illegal aliens apply for amnesty on the first day of the new immigration law at the Immigration and Naturalization Center in Houston*, 1990

than 35 years to exclude, among others, writers and political figures with unpopular political views.[10]

Young's generic images of an idealized America ironically remind us of how easy it is for minorities to be ignored and even hated. While America's "others" are depicted benefiting from our kinder, gentler nation, the absent narratives of their unsettled lives continually haunt us. Echoing through our minds as we pass from one image to another are hundreds of such stories: the elderly woman who died of exposure in her unheated East Village tenement apartment, the homeless man who froze to death in Times Square, the gay couple who were bashed with pipes in the doorway of their Brooklyn Heights home, the adolescent woman who died from a back-alley abortion, the African-American man in Harlem who must live with the reality that his life expectancy is lower than that of a man in Bangladesh. In these

ghostlike afterimages we come to realize that our "friendly" neighbors rarely tolerate "difference," and, in turn, that tolerance itself is a myth. "The fact that someone is 'tolerated' is the same as saying he is 'condemned,'" observed Pier Paolo Pasolini several months before he was to die in a brutal, bias-related murder. "In fact they tell the 'tolerated' person to do what he wishes, that he has every right to follow his own nature, that the fact that he belongs to a minority does not in the least mean inferiority, etc. But his 'difference' —or better, his 'crime of being different'—remains the same both with regard to those who had decided to tolerate him and those who have decided to condemn him. No majority will ever be able to banish from its consciousness the feeling of the 'difference' of minorities." [11]

52. Young K., *Democracy: East Executive Avenue Entrance, Treasury Department, Washington, D.C.*, 1988–89

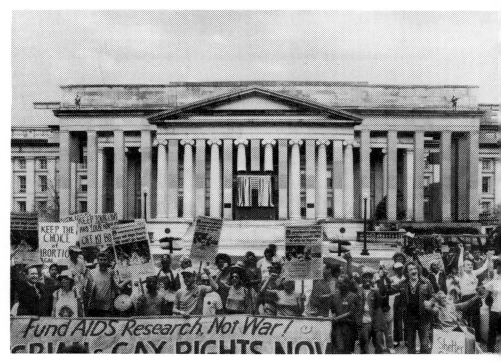

Indeed, the "others" of this country can hope for no more than tolerance from the left as neoconservative legislators and strict-constructionist judges move to condemn us. It is becoming increasingly clear to the disenfranchised that the hope for survival rests in their own vigilant hands. Despite ominous signs to the contrary, Young continues to believe that the voices of oppressed individuals collectively rising in dissent will bring about change. Nowhere is this conviction more evident than in his painting *Democracy: East Executive Avenue Entrance, Treasury Department, Washington, D.C., 1989* [52], a depiction of an imaginary protest rally in which various forces battling for enfranchisement unite. They stand stoically before one of the foremost protectors of the American monetary system, reminding us that it is often only through the threat of boycotts, and hence of significant economic losses, that institutions can be persuaded to abandon overtly discriminatory policies.

While *Democracy* represents a fantasy of an undivided and powerful left, the image suggests a fundamental truth: that oppressed peoples cannot rely on the tolerance of others. Indeed, Justice Blackmun in another recent Supreme Court dissent (this time involving a Missouri law that further diminished the rights of women to secure legal abortions) has issued a thinly veiled warning to women that they themselves must wage the battle to stem the erosion of their constitutional rights. "For today, at least, the law of abortion stands undisturbed," he wrote in conclusion. "For today, the women of this nation still retain the liberty to control their destinies. But the signs are evident and very ominous, and a chill wind blows. I dissent." Ultimately, we must all dissent if we are to preserve our limited right to speak without fear of censorship and retribution or to make fundamental decisions about our bodies, our sexuality, and our associations. Only then is there even a chance of realizing the friendly America of Young K.'s immigrant dreams.

NOTES

1. As Associate Justice Harry Blackmun pointed out in his dissent in *Bowers* v. *Hardwick*, a 1968 legislative revision of the Georgia antisodomy laws explicitly extended these statutes to heterosexual conduct. Yet state authorities were willing to enforce the law only against gays.

2. Such a shift was acknowledged, for example, in a 1967 ruling by the Supreme Court that declared unconstitutional Virginia's antimiscegenation laws, even though the tenets of these laws were deeply rooted in longstanding legal and religious precedents. Indeed, lawyers for the state of Virginia defended these laws on the ground that they protected "traditional moral values."

3. For more on the innate conservatism of the federal style, see Lois Craig, *The Federal Presence: Architecture, Politics, and Symbols in United States Government Building*, Cambridge, Mass., and London, The MIT Press, 1978, pp. 298–302. On the social and messianic origins of the modernist architectural style, see Reyner Banham, "Actual Monuments," *Art in America* 76, no. 10, October 1988, pp. 173–76, 213–15.

4. Young K. in conversation with the author, 24 July 1990 and 14 August 1990.

5. Young K., "A Preface," in *Historiograph: A Documentary*, New York, Conrad Gleber, 1988, n.p.

6. Young K., unpublished statement for *Historiograph: A Documentary*, New York, 1989, n.p.

7. "Every photographic image," writes Allan Sekula, "is a sign, above all, of someone's investment in the sending of a message." For more on the myth of the photograph's ideological neutrality, see Sekula, "On the Invention of Photographic Meaning" in Victor Burgin, ed., *Thinking Photography*, London, Macmillan, 1982, pp. 86–88.

8. For more on China's response to the remnants of the pro-democracy movement, see Steven Erlanger, "Beijing Journal: On the Stifled Campuses, Faint Echoes of Dissent," *The New York Times*, 2 January 1990, p. A4.

9. This conclusion was drawn by a recent survey of immigration patterns conducted by the California Fair Employment and Housing Commission. For more on this project, see Katherine Bishop, "California Says Law on Aliens Fuels Job Bias," *The New York Times*, 12 January 1990, p. A1.

10. The exclusionary provisions of this law also extend to gay men and lesbians and, more recently, to HIV-affected people.

11. Pier Paolo Pasolini, "Genneriello," in *Lutheran Letters*, trans. Stuart Hood, Manchester, Carcanet Mill Press and Dublin, Raven Art Press, 1983, pp. 21–22.

c.
BARBET SCHROEDER'S *Reversal of Fortune*

> *The effect is certain but unlocatable, it does*
> *not find its sign, its name; it is sharp and yet*
> *lands in a vague zone of myself; it is acute yet*
> *muffled, it cries out in silence. Odd*
> *contradiction: a floating flash.*
> ROLAND BARTHES,
> *Camera Lucida* (1981)

It is a bitterly cold night in Newport, Rhode Island, several days before Christmas 1980. The camera focuses on the lavish dining room of Clarendon Court, the palatial estate of Martha "Sunny" von Bülow and her second husband, Claus von Bülow. The attractive von Bülow family—Claus, Sunny, their teenage daughter Cosima, and Sunny's 21-year-old son by her first marriage, Alexander—are eating dinner around an elegantly appointed table. The mood is tense. No one speaks. Cosima and Alexander glance nervously at one another, and every so often Claus looks up anxiously at his wife. Sunny's blond hair is neatly coiffed. She wears an elegant blue dress, a strand of pearls, and, incongruously, a pair of sunglasses. With her shaky left hand she holds a lit cigarette; with her right a spoon, which this reactive-hypoglycemic woman uses to eat her dinner—a huge ice cream sundae.

This incident, which purportedly occurred in the hours before Sunny von Bülow fell mysteriously into an irreversible coma, may not have happened as the scene above suggests. But in Barbet Schroeder's recent film *Reversal of Fortune*, which explores the successful appeal of Claus von Bülow's conviction on charges of assault with attempt to murder his wife by injecting her with insulin, establishing what happened is never really the issue [53, 54]. So many American movies celebrate the values of truth and justice. Even when the mood is *noir*, there is usually some kind of restitution of order, some kind of redemptive victory. But Schroeder's interweaving of sometimes conflicting voices—

53. Barbet Schroeder, still from *Reversal of Fortune*, 1990, with Glenn Close and Jeremy Irons

54. Barbet Schroeder, still from *Reversal of Fortune*, 1990, with Jeremy Irons and Ron Silver

including those of Claus (Jeremy Irons), his attorney Alan Dershowitz (Ron Silver), and Sunny (Glenn Close)—refuses to allow a single version of "reality." Take the dinner scene, painted not in the black and white of satire or parody but as a difficult gray space of hypothetical possibilities. The action reads on multiple levels. First we laugh at Sunny's weirdness; then we are horrified by her self-destructiveness. Are we witnessing a cry for help before a self-administered overdose? Or is her morbid behavior pushing her husband that much closer to killing her? Is his "murderous" act one of passively doing nothing as she moves closer to suicide? Or does the scene's humorous edge make this guessing game absurd? In Schroeder's recreation of life in Clarendon Court —which departs considerably from Dershowitz's journalistic account of the case in his book *Reversal of Fortune*—a fact is never just a fact; through visual and verbal ambiguities, and extraordinarily nuanced performances by Irons and Close, the film continually questions the mythologies of truth and justice.

As the movie opens, the camera takes us past a private security guard into Sunny von Bülow's hospital room. A pale yet still beautiful Sunny lies comatose in an elegant antique bed. In voice-over, she introduces us to some of the details of the case against her husband: his refusal to call for a doctor despite her life-threatening symptoms; the mounting suspicion of her children and personal maid Maria (Uta Hagen) that Claus was up to no good; the "discovery" of a vial of insulin and an insulin-encrusted needle in his closet; his affair with soap-opera actress Alexandra Isles; and finally the $14 million he stood to inherit if Sunny died.

The scene then shifts to the comfortable but rumpled home of Harvard law professor Alan Dershowitz, who receives a call from Claus asking him to handle the appeal.[1] The film is thus divided into two realms; the world of the combative Jewish Dershowitz and his multiracial, male-and-female team of former and present students, and the icy private world of the aristocratic von Bülow family at the time of the alleged crime. This structural bifurcation does not always work in the film's favor: the scenes of Dershowitz and his students (except those directly involving Irons's Claus)

invariably read as pedantic and flatfooted. Those representing Clarendon Court, however, are far more complex.

In these scenes Schroeder attempts to re-create "testimony" in a manner that constantly reveals its vulnerability. The approach seems to share concerns with Errol Morris's brilliant but problematic docudrama *The Thin Blue Line* (1988) [55], which used re-created action and interviews to investigate the injustice dealt Randall Dale Adams, a drifter convicted of murdering a police officer in Dallas, Texas, in

55. Errol Morris, still from *The Thin Blue Line*, 1988

1976. But Morris's film, which contributed significantly to the commutation of Adams's sentence, is obsessed with the details of what really happened on the night of the murder. And it is not actually the function of the legal system to uncover the truth: the lawyer's task is more to tell a story— to build the most persuasive possible narrative out of the known facts.

Not only prosecution and defense produce these stories— judge or jury, who must tell themselves a story that supports their verdict, do as well. A preeminent juridical myth blasted in Schroeder's film is that such are inevitable, self-evident narratives of truth. Of course, the difference between a "true" history and an "invented" one, as the contradictory verdicts of the two von Bülow trials prove, is "finally nothing more than a distinction between a persuasive interpretation and one that has failed to convince."[2] The production of judicial history inevitably hinges on a relationship between word and world. As such, judgments on truth and falsehood are just as circumstantial and interpretive as "judgments of felicity," where the question of a statement's factuality will receive a different answer in different circumstances.[3] Thus truth, to one extent or another, is the hostage of interpretation, and interpretation is always motivated by the ideological imperatives and biases of the interpreter. In *Reversal of Fortune*, Schroeder foregrounds these obvious problems inherent in legal decision making.

In Schroeder's film, not even Sunny herself can tell us what happened on that fateful day in 1980. In Dershowitz's book, however, the law professor himself appears to buy into the myth of truth: "In law, as distinguished from art," he writes, "there *is* generally a truth. It may be difficult, indeed impossible, to discern. But discerning the truth is the central, though not the only, object of the legal system."[4] Dershowitz's civil-libertarian writings have challenged the economic and racial disparities of the American legal system, but his uncritical acceptance of these tenets of truth fails to acknowledge the extent to which judicial history is inflected with the biases of the people charged with its construction and of the constitutional system on which it is based. Indeed, the space of American jurisprudence continues to be fraught with big-

otry, leading Dershowitz's fellow Harvard Law School pro-
fessor Derrick A. Bell, Jr., to ask whether civil rights
litigation in the United States is now "a freedom train that
has run out of steam."[5]

The issue of civil rights might seem extraneous to a discus-
sion of *Reversal of Fortune*—which, for all its intelligence, is
also designed as scandals-of-the-rich-and-famous entertain-
ment—were it not for the film's somewhat understated sub-
plot. Early on, Dershowitz angrily discusses with his son the
case of the Johnson brothers, two black death-row inmates
from Alabama who are about to exhaust their appeals. (The
brothers helped their father escape from jail, and have been
held criminally responsible for a murder he committed while
on the lam.) This case serves several functions in the film:
for one, Dershowitz's *pro bono* defense of the Johnsons gives
him a moral dimension, offsetting and justifying his accep-
tance of the sleazy, economically profitable von Bülow case.
(The attorney actually tells von Bülow that the destitute
Johnsons are "another case you're paying for.") The plight
of the brothers also tends to underline the economic and
racial inequities of the law. Taking Claus on a tour of his
home, where a number of rooms have been allocated to dif-
ferent groups of students analyzing the von Bülow case, Der-
showitz points out the closed door of the sole room devoted
to the Johnson brothers' appeal. At another point in the film,
the attorney talks to one of the brothers over the telephone;
we never hear Johnson speak, but he is clearly distraught.
Von Bülow, too, faces a murder charge, yet he is cool, re-
solved, a confident white heterosexual male. With Johnson,
on the other hand, we register—though we do not hear or
see—the screams and tears of a man who realizes how little
his life matters to society. And as the final credits roll we are
informed that "the Johnson brothers are still on death row"
—a sharp contrast to von Bülow, who has won his appeal,
even though, unlike them, he is not obviously innocent of
murder.

The Johnson brothers would appear to satisfy a function
consistent with the rest of the film—that of overriding the
mythology of truth. However, the Johnson brothers do not
exist. Their story, in fact, seems based on another case han-

dled by Dershowitz and associates of the Boston law firm of Hale & Dorr—that of the Tison brothers of Arizona. The Tisons, who freed their father and a friend in a violent jailbreak in 1978, are white, not black. They are also not on death row, their sentences having been set aside by the United States Supreme Court in 1987. Dershowitz, who mentions neither the fictitious nor the real brothers in his book *Reversal of Fortune,* and who did not have final script approval for the film, explained recently to *The Boston Globe* that the Johnsons represent a composite of his *pro bono* capital-punishment clients, at least one of whom is black. And he defended this conflation of characters as an effective dramatization of the "disproportionate discrimination against blacks on death row, which has been part of my crusade against capital punishment."[6]

While the Johnson brothers are at best marginal in *Reversal of Fortune,* the haunting contrast they offer to the lush world of the von Bülows (and even to Dershowitz's upper-middle-class life at Harvard) suggests a powerful rhetorical device. It is curious, though, that they exist only through their white attorney's mouth. Of course Schroeder was making a film about life and living death in Newport, not about the many and various Johnson brothers currently lost in the legal system. It is to his credit that he also found a way to reflect, however tangentially, on social and juridical inequity. But it is unfortunate that the voiceless black brothers are so clearly an instrumental device, invented to throw a flattering spotlight on Dershowitz, the fighter for "truth."

NOTES

1. For details on the case, see Alan Dershowitz, *Reversal of Fortune: Inside the von Bülow Case,* New York, Pocket Books, 1986.

2. Stanley Fish, *Doing What Comes Naturally: Change, Rhetoric, and the Practice of Theory in Literary and Legal Studies,* Durham and London, Duke University Press, 1989, p. 95.

3. See ibid., pp. 87–102. See also Ronald Dworkin, "Law as Interpreta-

tion," *Critical Inquiry* 9, Chicago, 1982, pp. 179ff. On the ideological imperatives of the text, see Roland Barthes, "Myth Today," *Mythologies,* trans. Annette Lavers, New York, Hill and Wang, 1972, pp. 109–59.

4. Dershowitz, *Reversal of Fortune,* pp. xxiii–xxiv. Dershowitz has concluded that Claus von Bülow was "probably innocent" (p. xxii). In contrast, Barbet Schroeder says that this film "will not tell you whether von Bülow is innocent or guilty, but . . . the audience will have all the elements to create their own theories." Schroeder, in *"Reversal of Fortune:* Production Information," Warner Bros. press release, 1990, p. 4.

5. Derrick A. Bell, Jr., quoted in Ken Emerson, "When Legal Titans Clash" *The New York Times Magazine,* 22 April 1990, p. 63.

6. Dershowitz, quoted in Alex Beam, "Reversal of Facts," *The Boston Globe,* 23 November 1990, p. 62.

VIII

Are Art Museums Racist?

WALKING THROUGH a group exhibition installed in the fall of 1989 at the New Museum of Contemporary Art in New York, I heard the distinctive, albeit muffled, voice of the late Malcolm X. The sounds emanated from a multimedia installation by the African-American artist David Hammons. The installation itself, titled *A Fan* [56], was almost surreal in its juxtapositions: a funereal bouquet, its flowers dried and decayed, stood next to an antique table on which the head of a white, female mannequin "watched" one of Malcolm X's early television interviews. The work was powerful, challenging, even painful. Rather than advocating conciliation (as he would later), in this video interview Malcolm X spoke of his distrust of white people and of the inherent foolishness of integration. An understandable sense of frustration echoed in his voice when he said, "There is nothing that the white man will do to bring about true, sincere citizenship or civil rights recognition for black people in this country. . . . They will always talk but they won't practice it."

These words offered an appropriate postscript to my museum experience. The exhibition in question was "Strange

56. David Hammons, *A Fan*, 1989

Attractors: Signs of Chaos," what the curator called an ex-
ploration of "some of the most compelling issues raised by
the new science of chaos as they relate to recent works of
art." The confluence of Malcolm's ideas and the show's the-
oretical perspective summarized for me the difficult place of
African-American artists in museums—even in ones as os-
tensibly supportive of racial inclusion as the New Museum.
The charismatic presence of Malcolm X's voice in "Strange
Attractors" simply underscored how irrelevant both the ex-
hibition and its catalogue were to the issues about which he
was speaking—that is, when those words could be heard at
all, given the video monitor's subdued volume. The cata-
logue reverberates with the jargon of "the new chaos sci-
ence": words like *period doubling, bifurcation cascade, phase*

space, limit cycle, hysteresis appear throughout its pages. As one reads through the catalogue, one recognizes the names of white, male academics. And while curator Laura Trippi maintains that "the discourse of postmodernism sets up within the aesthetic (sometimes to the point of shrillness) a situation of extreme urgency and indeterminacy," nowhere are the systemic, institutionally defined conditions of racism discussed.[1]

Twenty-five years after Malcolm X was assassinated, "his voice is being heard again and his ideology is being reexamined" as many African-Americans search for new social structures for survival and growth in a period of renewed conservatism and indifference.[2] This search contemplates a radical realignment of society that is unthinkable to most white people—a realignment that is not about chaos but about order. Perhaps it is the urgency of this project that made the inclusion of Malcolm X in this art exhibition so striking. Without the Hammons piece the sensibility of "Strange Attractors" would have been very different, more typical of the splashy group shows of contemporary art that simply ignore the issue of race. That one image threw the entire show into question and pointed up the racial bias of its institutional context. Increasingly, across the country, similar catalysts are inserting painful questions into the heretofore complacent space of exhibition as curators with good intentions attempt to "include" the cultural production of people of color.

Having grown up in a predominantly black and Hispanic low-income housing project on Manhattan's Lower East Side —a place that was presumably also about good intentions— I am used to the experience of witnessing social and cultural indifference to people of color as a white person on the inside. It is startling to me, however, that in a nation that has seen at least some effort made by white people to share mainstream cultural venues (and the concomitant social and economic rewards) with African-Americans and other people of color—most notably in the areas of popular music, dance, literature and theater—the visual arts remain, for the most part, stubbornly resistant. My point in this article, then, is to examine the complex institutional conditions that result in

the exclusion or misrepresentation of major cultural voices in the United States. These muted voices are complex and varied. There are veteran black artists, such as Al Loving, Faith Ringgold and the late Romare Bearden, who have received considerable art-world attention but are prevented from rising to the superstar status available to white artists of equal (or less than equal) talent. There are the younger African-American artists of the so-called MFA generation, such as Maren Hassinger, Pat Ward Williams and David Hammons, who have had considerable difficulty finding gallery representation. And finally, there is a new generation of "outsiders," artists and collectives that function independently of the gallery system in communities across the country.

Viewed in the broader context of social changes in American race relations—from the advances of the civil rights movement in the 1960s to the reversal of many of these advances in the Reagan era—the question of black cultural disenfranchisement seems daunting. Is the art world merely mirroring social changes or can art institutions actually play a role in challenging the conditions of institutional racism in America? Sad to say, with regard to race, art museums have for the most part behaved like many other businesses in this country—they have sought to preserve the narrow interests of their upper-class patrons and clientele. It is this upper-class, mostly white bias that I want to interrogate in order to find out "what's going on with whiteness" (as the writer Bell Hooks might say) at one of America's most racially biased cultural institutions—the art museum.

Despite the recent increase in exhibitions devoted to African-American art in major museums, these shows rarely address the underlying resistance of the art world to people of color. Such exhibitions often fall into what the art historian Judith Wilson has called the syndrome of "separate-but-unequal programming": African-American shows in February, during Black History Month, white shows the rest of the year.[3] A recent study of "art-world racism" in New York from 1980 to 1987 by artist Howardena Pindell seems to

verify that white-identified galleries and museums have little interest in enfranchising African-Americans and other people of color. Based on her statistical overview of the demographics of mainstream art exhibitions, Pindell concludes that "black, Hispanic, Asian, and Native American artists are . . . with a few, very few, exceptions systematically excluded."[4] PESTS, an anonymous group of New York–based African, Asian, Latino, and Native American artists organized in 1986 to combat "art-world apartheid," came to a similar conclusion. In 1987, the *PESTS Newsletter* published a roster of 62 top New York galleries whose stables were all or nearly all white.[5] While the situation would appear to be somewhat better outside of New York (a city where, Wilson claims, "the relative economic powerlessness of [the] black population . . . keeps displays of the . . . largest, publicly funded museums less integrated"[6]), African-American and other artists of color remain underrepresented in museums and galleries across the United States.

During the past 25 years a number of institutions devoted to African-American art and culture have opened in the United States, a response to the general problem of institutional racism and the art world's frustrating indifference to people of color.[7] The Studio Museum in Harlem, for example, was founded in 1967 to fill a void left by mainstream institutions; its mission was to support the "study, documentation, collection, preservation and exhibition of art and artifacts of Black America and the African diaspora." The Studio Museum is to the African-American art world as the Museum of Modern Art is to the white art establishment in terms of visibility and prestige. But there are literally hundreds of smaller, lesser-known institutions across the country devoted to the art of African-Americans and other people of color. Such alternative museums raise a number of questions about the relationship between white and black culture in America. Are African-American artists stifled by the segregation by black museums, or do these institutions allow their art to flourish despite the dominant culture's lack of interest? Must African-Americans renounce their own cultural identity in order to be accepted by mainstream institutions? To what extent does the mere existence of African-

American museums unintentionally absolve majority institutions of their social responsibility to black Americans?

Kinshasha Holman Conwill, executive director of the Studio Museum in Harlem, maintains that African-American museums are necessary:

> Black artists are segregated by society. If we waited for Romare Bearden, Al Loving or Betye Saar or other black artists to have their retrospectives at the Museum of Modern Art or in some of the wonderful contemporary museums around this country, we would be waiting a long, long time. Many people ask me if the [Studio Museum] perpetuates [this problem]. It's as if racism would end tomorrow if we disbanded the Studio Museum in Harlem, and there would be this great opening of doors and black artists would start pouring in to the mainstream of American art. Well, that's not what is happening.[8]

On the whole, the financial situation for African-American and other minority art institutions remains poor. The American Association of Museums (AAM) in Washington, D.C., has begun to address the needs of these institutions, but their own rigorous accreditation standards, including stringent technical and acquisition guidelines, actually discourage validation of younger and economically poorer institutions. The Studio Museum in Harlem, accredited in 1987, is still the only black or Hispanic museum certified by the AAM. Because most corporate and private sponsors insist on proof of accreditation as part of their grant-giving process, lack of accreditation has serious consequences for institutions seeking outside funding. As a result, alternative spaces devoted to African-American art, a relatively recent programming phenomenon, are often dependent on severely limited funding sources. This problem of accreditation is so serious that the Association of African-American Museums was formed recently to help validate institutions overlooked by the AAM. The Ford Foundation, responding to its own study of 29 black and Hispanic art museums, recently instituted a three-year, $5-million program designed to improve economic conditions in these museums.

Still, few programs are directed toward improving Afri-

can-American representation in white-identified, mainstream art venues. Even fewer programs press the culture industry to examine its own racism and indifference. A rare instance was the program for the 1990 annual conference of the College Art Association in New York, where an unprecedented number of presentations were devoted to issues of cultural disenfranchisement and institutional racism.[9] Mainstream support of the interests of the "Other" (when it does occur) generally takes one of two forms. By far the more prevalent approach depends on a pragmatic, statistically calibrated inclusion of artists of color, either as tokens in mostly white group shows or, more likely, in token exhibitions devoted exclusively to people of color. This statistical approach is one way of correcting years of exclusion from the art world. Other institutions take a second approach. Wishing to go beyond mere quotas, they organize exhibitions concerned with exploring and ultimately embracing cultural and social differences. The Dallas Museum of Art, for example, has instituted progressive programming in order to confront the reality that "our museums are devoted almost exclusively to the representation of 'white' culture, our libraries to the Western tradition of literature, our universities to the history of ancient Mediterranean and modern Europe."[10] Significantly, the 1987 appointment of Alvia Wardlaw as the DMA's adjunct curator of African-American art made her the first holder of such a position at a major museum.

But in an art world that remains what Judith Wilson has called "one of the last bastions of white supremacy-by-exclusion,"[11] most art museums offer little more than lip service to the concept of racial inclusion. Art that demonstrates its "difference" from the mainstream or that challenges dominant values is rarely acceptable to white curators, administrators and patrons. This cultural elite bases its selections on arbitrary, Eurocentric standards of "taste" and "quality"—the code words of racial indifference and exclusion. "Race has become a trope of ultimate, irreducible difference between cultures, linguistic groups, or adherents of specific belief systems which—more often than not—also have fundamentally opposed economic interests," writes Henry Louis Gates, Jr., in an observation that has searing relevance to the

art world. "Race is the ultimate trope of difference because it is so very arbitrary in its application." [12]

These tastemakers, in turn, reflect the interests of the ruling caste of cultural institutions. The boards of art museums, publishers of art magazines and books and owners of galleries rarely hire people of color in policy-making positions. Thus, the task of cultural interpretation—even in instances where artists of color are involved—is usually relegated to "people of European descent, as if their perspective was universal." [13] The very ground of art history, in fact, has proven infertile for most African-American students. As Lowery Sims, associate curator of 20th-century art at the Metropolitan Museum of Art, observes:

> Art history was not a career that black middle-class children were taught to aspire to. For one, the Eurocentrism of art history often made it irrelevant to black college students who never heard African-American culture discussed in art-history classes. Museums—the major conduit for teaching young people about art—were not always accessible to blacks. African-Americans were socialized into certain careers after Reconstruction; visual art was not one of them. The economic realities made a career in art even less desirable. You didn't see many black visual artists until the 1920s and '30s, when the black colleges started to establish art departments. Black art historians are an even rarer breed. [14]

While majority museums have not totally ignored the interests of people of color, they have had an extremely difficult time approaching cultures outside of the Anglo-European tradition. The 1969 exhibition "Harlem on My Mind" at the Metropolitan Museum in New York remains the classic example of the deep problems between white institutions and people of color [57]. Twenty years later, the issues surrounding "Harlem on My Mind" offer an interesting model for rethinking our own era of cultural indifference to people of color.

Organized by the white art historian Allon Schoener, then visual-arts director of the New York State Council on the Arts, the exhibition represented an unprecedented effort on

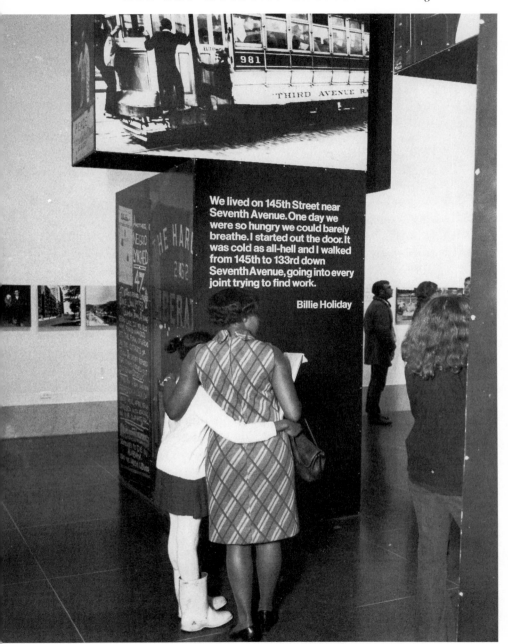

We lived on 145th Street near Seventh Avenue. One day we were so hungry we could barely breathe. I started out the door. It was cold as all-hell and I walked from 145th to 133rd down Seventh Avenue, going into every joint trying to find work.

Billie Holiday

57. Installation view of "Harlem on My Mind," Metropolitan Museum of Art, 1969

the part of an old-line American art museum to sociologically "interpret" African-American culture. The exhibition was not an art show in the traditional sense but an ambitious historical survey of Harlem from 1900 to 1968. Attempting to celebrate Harlem as the "cultural capital of black America," the show consisted of blown-up photographs, photomurals, slide and film projections and audio recordings. As Schoener explained in his introduction to the exhibition's catalogue, the objective of "Harlem on My Mind" was "to demonstrate that the black community in Harlem is a major cultural environment with enormous strength and potential . . . [a] community [that] has made major contributions to the mainstream of American culture in music, theater, and literature."[15] Art was one form of cultural expression not mentioned by Schoener, despite the exhibition's location in a major New York art museum. This omission seemed to reflect Schoener's conviction that "museums should be electronic information centers" and that "paintings have stopped being a vehicle for valid expression in the 20th century." While responding to the ideological inadequacies of elitist art museums, Schoener's view also allowed the Metropolitan to almost completely ignore African-American painting and sculpture.[16] Schoener felt free to construct a sociopolitical profile of Harlem, but he never applied this sociological methodology to his own position or to that of the museum that commissioned him. Rather than engaging Harlem writers, art historians and intellectuals to help interpret the culture of Harlem, a "curious" Schoener felt compelled to conduct his own investigation of the subject because *he* decided "it was time . . . [to find] something out about this other world."[17]

When it opened, the show was widely condemned by African-Americans and others as yet another example of white carpetbagging and well-intentioned meddling.[18] In a 1969 *Artforum* critique, historian Eugene Genovese questioned the proliferation of material related to Malcolm X in the exhibition:

> There are pictures of Malcolm the Muslim minister and the street-corner speaker and of Malcolm the corpse, to-

gether with indifferent excerpts from his magnificent au-
tobiography. The exhibit immediately involved political
decisions: should you emphasize the early or the late Mal-
colm? Malcolm the uncompromising black nationalist or
Malcolm the man who ended his life edging toward a new
position? The exhibition settles these questions in a man-
ner that will not be to everyone's taste, but the real prob-
lem lies elsewhere: Who is making the decision to interpret
Malcolm? Since the show purports to be a cultural history
of Harlem, only that community as a whole or, more real-
istically, one or more of the clearly identified groups rec-
ognized as legitimate by the people of Harlem have that
right.[19]

Concluding his discussion of Malcolm X, Genovese sug-
gested a compelling metaphor for the problem with "Harlem
on My Mind." Trying to listen to Malcolm's speeches in the
exhibition galleries, Genovese realized that he could not hear
them because "the loudspeaker in one room drown[ed] out
the one in the next."[20] As in "Strange Attractors," the voice
of one of America's most influential black leaders had been
subjugated by the curatorial apparatus of an art exhibition.
In each case, the museum's attempt to deal with African-
American culture was in the end simply embarrassing. While
Malcolm X can be an engaging, even sympathetic figure for
white curators, his complex teachings must be understood
first of all in relation to the African-American community to
whom he was principally speaking. It is not that white people
are incapable of analyzing his ideas but rather that cultural
interpretations offered in exhibitions like "Harlem on My
Mind" and "Strange Attractors" can never stray too far from
the interests of their white, upper-class patrons or their prin-
cipally white audience.

Black cultural separatism (which was usually a matter of
necessity during the first half of the 20th century and a mat-
ter of preference since the mid-1960s)[21] has only served to
reinforce the historical marginalization of African-American
artists in art museums. Only rarely do mainstream institu-
tions acknowledge African-American artists who have en-

gaged or modified more traditional European cultural traditions. One need only think of the exclusion of prominent African-American artists who worked in an Abstract Expressionist idiom—Norman Lewis, Hale Woodruff and Romare Bearden—from the white-identified art-historical canon of Abstract Expressionism.[22] "The idea that black artists can produce work that is not visibly black offers a great point of resistance for white historians, curators, and critics," suggests Beryl Wright, curator of "The Appropriate Object," a traveling exhibition of contemporary abstract art by African-Americans. "This art cannot be easily ghettoized; it's harder to control work that doesn't fit white people's perceptions of who black people are."[23]

The influence of African-American culture on European and American modernism is also often denied, underestimated, or misunderstood. Art critic Eric Gibson, for example, denigrates the profound influence of black jazz culture on the modernist sensibility in a review of "The Blues Aesthetic: Black Culture and Modernism," a traveling exhibition recently organized by Richard Powell at the Washington Project for the Arts. Gibson writes, "The reason 'The Blues Aesthetic' finally breaks down is that black culture's influence on modernism was at most one of the spirit, not form. To be sure, there were any number of artists who were deeply taken with jazz . . . but in every case, when it came to making a work of art, it was existing modernist idioms—in particular cubism—to which they turned."[24] Gibson's observation is particularly embarrassing given the Cubists' appropriation of African tribal art—work that helped shape the structural and conceptual dynamic of Cubism itself.

While a number of contemporary art exhibitions over the past decade have sought to highlight the art of African-Americans and other people of color, most of the major group shows have all but excluded artists of color or discussions of racial issues. The Whitney Biennial, a bellwether of recent art trends in the United States, for example, has consistently had notoriously poor representation of artists of color. (Perhaps this is not so surprising since the Biennial closely reflects the New York gallery scene; the show may

simply be an accurate reflection of how underrepresented such artists are in the city's most profitable galleries.)

Another recent example of the pervasive art-world insensitivity to racial issues was "Culture and Commentary: An Eighties Perspective," mounted in 1989 at the Hirshhorn Museum in Washington, D.C.—a city with one of the largest black populations in the country. This group exhibition of socially oriented art in the 1980s was almost entirely white; the one exception, Yasumasa Morimura, lives in Osaka, Japan. Guest curator Kathy Halbreich claimed that the purpose of "Culture and Commentary" was to "locate a particular set of intellectual concerns that have informed the cultural dramas of the past ten years."[25] Various catalogue essays by scholars generally outside of art history attempted to contextualize the exhibition's cultural artifacts: advanced technology, the politics of gender and AIDS, the new global economy, and genetic engineering were discussed in detail.[26] Apparently for curator Halbreich, the politics of race in America or the issue of black liberation in Southern Africa do not rate among the "cultural dramas" of the 1980s worthy of extended discussion. In fact, the one work that addressed the issue of American race relations—a room-size installation by Sherrie Levine and Robert Gober in which wallpaper designed by Gober juxtaposed drawings of a lynched black man with those of a sleeping white man—offended some of the museum's African-American security guards [58]. In an attempt to calm tensions, the museum installed an explanatory sign (with an epigraph by the artists) at the room's entrance. "When we were invited to make this installation in Washington, D.C.," Gober and Levine are quoted as saying, "we thought about the underside of the American Dream— the alienation, the denial, the violence."[27] Given that no African-American artists were represented in "Culture and Commentary," the words "alienation" and "denial" had a sardonic relevance.

On the other hand, several recent projects in major museums suggests that the situation for African-Americans may

58. Sherrie Levine and Robert Gober's installation (detail) for "Culture and Commentary: An Eighties Perspective," The Hirshhorn Museum, 1990

be improving somewhat. An extraordinary pairing of exhibitions at the Corcoran Gallery of Art in Washington, D.C. early in 1990 represented one of the most interesting and unexpected efforts at cultural enfranchisement for African-Americans.[28] The two exhibitions—"Facing History: The Black Image in American Art 1710–1940" (organized by the Corcoran) and "Black Photographers Bear Witness: 100 Years of Social Protest" (organized by the Williams College Museum of Art)—were strikingly unusual in their approaches to the issues of race and racism in America. Significantly, both shows were curated by African-American art historians: "Facing History" was developed by the late Guy McElroy, who was at the time of his death a doctoral candidate in art history at the University of Maryland, and "Black Photographers" was organized by Deborah Willis, head of the Prints and Photos Division at the Schomburg Center for Research in Black Culture in New York.

In "Facing History," McElroy documented the variety of ways in which American painters (mostly white) "created a visual record of African-Americans that reinforced a number of largely restrictive stereotypes of black identity."[29] The aim of "Facing History," McElroy stated in the catalogue's introduction, was to illuminate "the shifting, surprisingly cynical nature of the images white men and women created to view their black counterparts."[30] In effect, the show documented the history of representations of blacks in American art, work that was coincidental with the acceleration of racism over the same period. The works in the show—which ranged from acknowledged masterpieces by John Singleton Copley and Thomas Eakins to an unattributed silhouette of a slave that accompanied a bill of sale—suggested that artists were not always in agreement in their attitudes toward slavery or toward African-Americans in general [59, 60]. While many of the images are clearly derogatory, others are sympathetic to or even openly supportive of racial enfranchisement. (The show's impressive educational slant was enhanced by its installation: extended wall labels and an accompanying video program helped to explain racist iconography and offered historical points of reference. Additionally, the Corcoran installed a context room where

59. William Sidney Mount, *The Bone Player*, 1856

60. John Singleton Copley, *Head of a Negro*, 1777–78

museum-goers could read various books by black writers.)
McElroy assumed a role rarely afforded African-Americans
in the art world: that of interpreter of culture—both black
and white. In so doing, he exposed the underlying racist
attitudes of many American artists, including such venerated
master figures as Eakins and William Sidney Mount.[31] While
McElroy's iconographical approach sidestepped the broader
institutional and patronage issues contributing to the for-
mation of racist representations, "Facing History" upset the
complacent notion of high culture's immunity from social
responsibility.[32]

"Black Photographers Bear Witness" was one of three
shows organized by the Williams College Museum of Art to
celebrate the centennial of Gaius Charles Bolin's graduation
from Williams in 1889—the college's first African-American
graduate. "Black Photographers Bear Witness" was also the
first exhibition to present photographic documents of the
African-American social-protest movement exclusively
through the lens of black photographers [61]. What is more,
in addition to straight documentary photography, the show
included Conceptual art pieces—most notably by Pat Ward
Williams and Carrie Mae Weems—that examine some of the
theoretical and political issues surrounding the documentary
idiom, particularly as it relates to people of color. Finally, the
elegant catalogue, with essays by Willis and historian Howard
Dodson, represents a paradigm of what museums can be but
most often are not: a space where art is placed in the broader
social, economic and cultural context of the society that pro-
duces it.[33]

Not surprisingly, this confluence of "Facing History" and
"Black Photographers Bear Witness" at the Corcoran created
a positive and inviting atmosphere for Washington's black
community. "We are definitely reaching new people, people
who are not regular museum-goers," observed the museum's
outgoing director of public affairs. "I would guess that about
60 percent of our audience for these shows is African-Amer-
ican. What's especially rewarding is the broad spectrum of
people all coming and looking at the show together."[34]

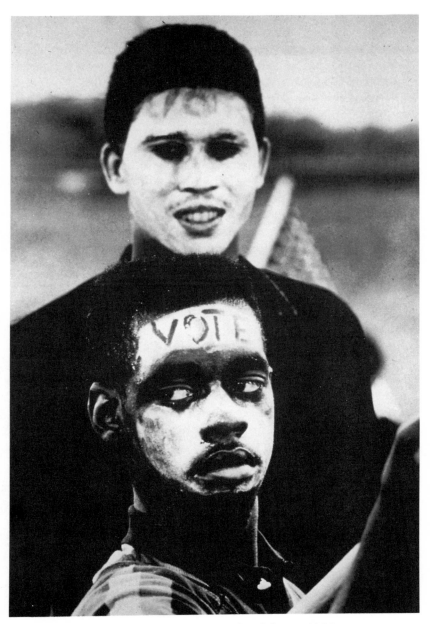

61. D. Moneta Sleet, Jr., *Selma March, Alabama,* 1965

Despite the positive climate engendered at the Corcoran, both exhibitions were organized by outside institutions or curators. Like most exhibitions devoted to African-American culture in major museums, these shows were token gestures. While the Corcoran, like many other majority museums, has instituted a minority internship program to encourage young people of color to enter museum professions, it will take a far broader range of programs and projects to begin to correct the problem of institutional racism in America's majority museums. For a start, more exhibitions like "Facing History" are necessary so that white people can begin to examine their own problematic attitudes toward people of color. Of course, museums must also increase their commitment to showing the art of people of color, and curators— white and black—should be encouraged to pay closer attention to this work. Internship and education programs for minority students could be expanded to include education programs that introduce white people, children and adults, to the cultural production of people of color. Large, economically stable museums might be encouraged to open satellite museums, much like the Whitney's branch museums (located in various corporate centers), in culturally diverse neighborhoods; such spaces could serve as experimental outposts for marginal work, community-based projects and art generally not accepted by mainstream venues. Most important, museums must institute educational programs to examine the institutional hierarchies of museums themselves— programs designed to explore the institutionally validated and encoded racism, classism, sexism, and homophobia of museums.

In June 1990, in Chicago, the American Association of Museum Directors took a step in this direction as it held the first of a two-part conference on multiracial and cultural issues. The conference, called "Different Voices: The American Art Museum and a Social, Cultural, and Historical Framework for Change," dealt with such questions as staff diversification, approaches to multicultural audiences, the politics of display and the new art histories. This conference was important not only for developing a politics of inclusionism, but for suggesting that museum directors can have a

direct impact in the battle against cultural racism. One voice for these new attitudes was Marcia Tucker, the conference's cochair and director of the New Museum of Contemporary Art in New York, who insisted that "museum" administrators have to reeducate themselves completely. We must read the new art histories, we must read theory in order to put ourselves in touch with all culture. We must learn to listen, keep our eyes and ears open and stop speaking for others."[35]

As if to embody this new multicultural ethos, Tucker's New Museum in the summer of 1990 participated in an unprecedented collaborative exhibition on the art and issues of the 1980s. "The Decade Show: Frameworks of Identity"— organized in conjunction with the Studio Museum in Harlem and the Museum of Contemporary Hispanic Art—embraced the esthetic, cultural and intellectual positions of diverse racial and ethnic groups and examined issues of gender and sexual orientation [62]. While the exhibition was commendable in its attempt to bring together a broad range of institutional, racial, ethnic, and sexual perspectives, it nevertheless suggested the ongoing dilemma for artists of color. While "The Decade Show" purported to be about the 1980s, its cultural position could only suggest future possibilities. Nowhere in the cultural scene of the 1980s were artists of color embraced in the ways suggested by "The Decade Show" —not even at the New Museum itself.

The New Museum's hasty attempt to redress past exclusions was underscored by the overstuffed and sloppy installation of the show (a situation less evident at the Studio Museum or MoCHA). Devoid of didactic wall labels to guide viewers through a diversity of cultural and esthetic positions, the installations and performance and video programs afforded only the most cursory glimpse of the work of the 140 or so participating artists. Each visual or performance artist was represented by only one or two works, so complex careers were often reduced to a single statement. Of course, such brevity was less problematic for blue-chip white artists like Cindy Sherman, Bruce Nauman, Eric Fischl, and Jenny Holzer, who already have been enthusiastically embraced and championed by galleries and museums. But this one-shot treatment shortchanged many of the "minority" artists

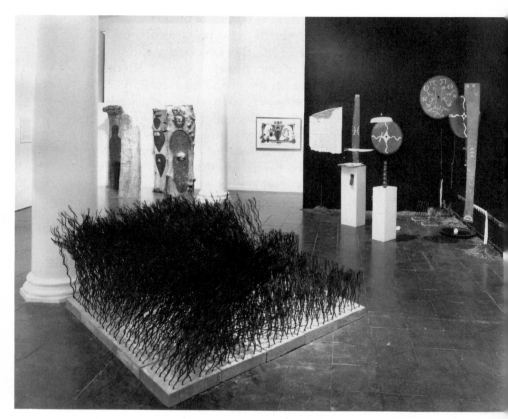

62. Installation view of "The Decade Show," New Museum of Contemporary Art, 1990

(ranging from "established" artists such as Melvin Edwards, Robert Colescott and the late Ana Mendieta[36] to community-oriented and activist art collectives such as the New York–based Epoxy Art Group, an experimental collaborative formed in 1982 by immigrants from Hong Kong), who rarely participate in the "art world." The cramped installation at the New Museum underscored the sense of an institution desperately making up for lost time, hurriedly cramming in a generation of artists ignored and victimized by indifference and racism.[37]

So, for all the signs of change, many of the fundamental structures that keep people of color out of the art world remain in place. For many years alternative spaces devoted to art by people of color have instituted programs and policies that majority institutions are only now beginning to think about. Literally hundreds of such alternative institutions exist in the United States, but few white curators make an effort to come into contact with them. These alternative venues often have organized training and education programs for young people of color; they also generally have racially diverse staffs. Efforts like these have been slow to appear in majority institutions, where even the best intentions often fall short.

Not until the white people who now hold the power in the art world scrutinize their own motives and attitudes toward people of color will it be possible to unlearn racism. This realization raises a number of crucial questions: Who are the patrons of art, the museum board members, the collectors? Who is the audience for high culture? Who is allowed to interpret culture? Who is asked to make fundamental policy decisions? Who sets the priorities?

These questions are part of a broader sociological discourse on white attitudes toward difference, a discourse which must begin with self-examination. As Bell Hooks writes,

> If much of the recent work on race grows out of a sincere commitment to cultural transformation, then there is a serious need for immediate and persistent self-critique. Committed cultural critics—whether white or black,

whether scholars, artists, or both—can produce work that opposes structures of domination, that presents possibilities for a transformed future by willingly interrogating their own work on aesthetic or political grounds. This interrogation itself becomes an act of critical intervention, fundamentally fostering an attitude of vigilance rather than denial.[38]

When it comes to the question of why we ignore the art of African-Americans and other people of color, simply learning how to listen to others is not enough. We must first learn how to listen to ourselves, no matter how painful that process might be.

NOTES

1. See Marcia Tucker, "Preface," and Laura Trippi, "Fractured Fairy Tales, Chaotic Regimes," in *Strange Attractors: Signs of Chaos*, New York, New Museum of Contemporary Art, 1989, n.p. Hammons's installation is neither mentioned nor illustrated in the catalogue.
2. See C. Gerald Fraser, "The Voice of Malcolm X Has an Audience Again," *New York Times*, Feb. 20, 1990, p. B3.
3. Judith Wilson, "Art," in Donald Bogle, ed., *Black Arts Annual, 1987/ 1988*, New York, Garland, 1989, p. 7.
4. See Howardena Pindell, "Art World Racism: A Documentation," *New Art Examiner*, vol. 16, no. 7 (Mar. 1989), pp. 32–36. In addition to a listing of New York galleries with mostly white stables (and the percentage of artists of color represented by each of these galleries), Pindell supplied a detailed statistical overview of exhibition records for artists of color at the following New York museums: Brooklyn Museum, Guggenheim Museum, Metropolitan Museum of Art, Museum of Modern Art, Queens Museum, Snug Harbor Cultural Center (Staten Island), and the Whitney Museum of American Art. Statistics were also given for selected group exhibitions and publications.
5. For more on PESTS, see Wilson, "Art," p. 5.
6. Judith Wilson then continues in "Art" (p. 4): "Thus black artists often find it harder to gain exposure in New York than in other parts of the country, because the economic stakes are generally higher in a town that serves as the hub of the international art market."
7. For more on the historical resistance of the "white cultural avant-

garde" to artists of color, see Michele Wallace, "Reading 1968 and the Great American Whitewash," in Barbara Kruger and Phil Mariani, eds., *Remaking History*, Seattle, Bay Press, 1989, pp. 106–9.

8. Kinshasha Holman Conwill, audiotape of an interview with Adrian Piper, International Design Conference, Aspen, 1988.

9. The panels (followed by their chairpersons in parentheses) included: "Exoticism, Orientalism, Primitivism: Modes of 'Other-ness' in Western Art and Architecture" (Frederick Bohrer); "Reflections on Race and Racism in Modern Western Art (1800 to the Present)" (Kathryn Moore Heleniak); "Firing the Canon" (Linda Nochlin); "Ethnicity/Ethnography: The Uses and Misuses of Traditional Aesthetics by Contemporary Artists" (Leslie King Hammond); "Abstract Expressionism's Others" (Ann Gibson); "De-facto Racism in the Visual Arts" (Howardena Pindell); "Vanguard Art of Latin America, 1914–30" (Jacqueline Barnitz); "Institution/ Revolution: Postmodern Native-American Art" (W. Jackson Rushing); and "Mainstreaming Independent Film" (Isaac Julien).

10. This statement was made by Richard R. Brettell, director of the Dallas Museum of Art, in the preface to *Black Art/Ancestral Legacy: The African Impulse in African-American Art*, Dallas, Dallas Museum of Art, 1989, p. 7.

11. Wilson, "Art," p. 3.

12. Henry Louis Gates, Jr., "Writing 'Race' and the Difference It Makes," *Critical Inquiry*, vol. 12, no. 1 (Autumn 1985), p. 5. For more on the issue of racial difference and culture see Maurice Berger, "Race and Representation: Representing the Normal," and David Golberg, "Images of the Other: Cinema and Stereotypes," in Maurice Berger and Johnnetta Cole, eds., *Race and Representation*, New York, Hunter College Art Gallery, 1987, pp. 10–15 and 29–37. For an excellent analysis of how racism actually functions in a cultural setting, see Adrian Piper, "High-Order Discrimination," in Owen Flanagan and Amelie Rorty, eds., *Identity, Character and Morality*, Cambridge, Mass., and London, M.I.T. Press, 1990.

13. Pindell, "Art World Racism," p. 32.

14. Lowery Sims, in conversation with the author.

15. Allon Schoener, ed., *Harlem on My Mind: Cultural Capital of Black America, 1900–1968*, New York, Metropolitan Museum of Art, 1969.

16. Allon Schoener, as quoted in Grace Glueck, "Adam C., Mother Brown, Malcolm X," *New York Times*, Jan. 12, 1969, p. 26.

17. Ibid.

18. Black and white demonstrators picketed the exhibition's press preview, wearing signs that read "Tricky Tom at It Again" and "That's White of Hoving"—references to Metropolitan Museum president Thomas Hoving, who brought the show to the museum. The demonstration was organized by the "Black Emergency Cultural Government," an activist art group, to express outrage at a show that had been organized by "whites who do not begin to know the black experience." A leaflet handed out by the protesters urged "the entire black community" to boycott the show, called for the appointment of blacks to policy-making and curatorial po-

sitions and insisted that the museum "seek a viable relationship with the total black community." "They should make a serious statement, or no statement at all," said artist Benny Andrews, one of the protest organizers. "There are artists in the black community and they're not represented." For more on the protest, see "Soul's Been Sold Again," a leaflet of the Black Emergency Cultural Government, quoted in "Museum Pickets Assail Hoving Over Coming Harlem Exhibition," *New York Times*, Jan. 15, 1969, p. 41.

19. Eugene Genovese, "Harlem on His Back," *Artforum*, vol. 7, no. 6 (Feb. 1969), p. 35.

20. Ibid.

21. Ibid.

22. For more on the general issues involving this exclusion, see Ann Gibson, "Norman Lewis in the Forties," in *Norman Lewis, from the Harlem Renaissance to Abstraction*, New York, Kenkeleba Gallery, 1989, pp. 9–23.

23. Beryl Wright, in a telephone conversation with the author, Feb. 13, 1990. Also see Wright, *The Appropriate Object*, Buffalo, Albright-Knox Art Gallery, 1989.

24. See Eric Gibson, " 'The Blues Aesthetic': A Pretty Sad Selection," *Washington Times*, Sept. 14, 1989, p. E2. Also see Richard Powell, *The Blues Aesthetic: Black Culture and Modernism*, Washington, D.C., Washington Project for the Arts, 1989. For comprehensive studies of the complex influence of African art on African-American artists in the 20th century, see Alvia Wardlaw, "A Spiritual Libation: Promoting an African Heritage in the Black College," and Robert Farris Thompson, "The Song That Named the Land: The Visionary Presence of African-American Art," in *Black Art/ Ancestral Heritage*, pp. 53–74 and 97–141.

25. Kathy Halbreich, "Culture and Commentary: An Eighties Perspective," in Halbreich, *Culture and Commentary: An Eighties Perspective*, Washington, D.C., Hirshhorn Museum and Sculpture Garden, 1990, p. 16.

26. The catalogue included a general essay by Halbreich as well as essays by London-based AIDS activist Simon Watney; Sherry Turkle, associate professor of sociology in the Program in Science, Technology and Society at the Massachusetts Institute of Technology; novelist Michael Thomas; and Harvard Medical School professors Vijak Mahdavi and Bernardo Nadal-Ginard. The artists represented were Laurie Anderson, Siah Armajani, Francesco Clemente, James Coleman, Tony Cragg, Katharina Fritsch, Robert Gober, Jenny Holzer, Jeff Koons, Sherrie Levine, Yasumasa Morimura, Reinhard Mucha, Julian Schnabel, Cindy Sherman, and Jeff Wall. Another glaring omission, particularly given Simon Watney's excellent essay on the politics of the body in the realm of AIDS, were the various AIDS-activist artists and art collectives (such as Gran Fury and Testing the Limits). While the inclusion of essays by non–art historians is insightful, the show's roster of mainly blue-chip contemporary artists represents a market-oriented bias that, although commensurate with recent curatorial practice, displays little vision or creativity.

27. After the artists' statement, the museum's text continues, "As with

many provocative works of contemporary art, there is no single interpretation possible for this untitled collaboration. . . . It is clear, however, that one of the work's principal themes is racism, particularly that which has victimized African-Americans historically. By juxtaposing the repeated images of a lynched black man with that of a sleeping white man, the artists suggest that the prevailing response to incidents of brutal racial violence has more frequently been indifference and neglect rather than outrage. Moreover, the reduction of the black and white figures to components of the wallpaper pattern implies in yet another way how sensibilities have been deadened by repetition and how one people's tragedy has been trivialized into nothing more than another's neutral background."

28. Needless to say, viewing an exhibition about cultural exclusionism at the Corcoran Gallery of Art is disturbing given the museum's earlier cancellation of a traveling exhibition of photographs by the late Robert Mapplethorpe (a show booked for the museum by former chief curator and associate director Jane Livingston, who has since resigned her position in protest). "Facing History" in no way challenges the censorial actions of the Corcoran or disguises the fact that the museum caved in to the forces of bigotry and ignorance. Despite the board of directors' decision to oust director Christina Orr-Cahall, the person presumably responsible for the cancellation, the museum has made no substantive gesture to the people most harmed by its actions—gay men and lesbians. Until the Corcoran sponsors positive exhibitions around issues of gay and lesbian identity, it will continue to be identified with the homophobic philistinism that intimidated it in the first place.

29. Guy McElroy, "Race and Representation," in *Facing History: The Black Image in American Art 1710–1940*, San Francisco, Bedford Arts, 1990, p. xi. While *Facing History* is the first deconstruction of the images of blacks in American painting to be done by a black art historian, such projects have been undertaken by white art historians in the past. For example, Sidney Kaplan, professor emeritus of American literature and American art at the University of Massachusetts at Amherst and a founder of the W. E. B. DuBois Department of Afro-American Studies there, curated two pioneering exhibitions in the 1960s and '70s: "The Portrait of the Negro in American Painting" (Bowdoin College, 1964) and "The Black Presence in the Era of the Revolution, 1770–1800" (National Portrait Gallery, Washington, D.C., 1973). For other recent explorations see Hugh Honour, *The Image of the Black in Western Art*, Cambridge, Mass., 1989, and Peter Wood and Karen Dalton, *Winslow Homer's Images of Blacks: The Civil War and Reconstruction Years*, Austin, Texas, The Menil Collection, 1989.

30. McElroy, "Race and Representation," p. xi.

31. McElroy was recruited for the project by Jane Livingston.

32. See Henry Louis Gates, Jr., "The Face and Voice of Blackness," in McElroy, *Facing History*, pp. xxix–xliv. For important discussions on the issue of patronage and African-American art, see Beryl Wright, "The Harmon Foundation in Context," and Clement Alexandre Price, "In Search of a People's Spirit," in Gary Reynolds and Beryl Wright, *Against*

the Odds: African-American Artists and the Harmon Foundation, Newark, Newark Museum, 1989, pp. 13–25 and 71–87. Because of limitations of space, *Facing History* does not concern itself with images of African-Americans in popular culture, initially an area that McElroy wanted to cover. The absence of this material tends to strand significant questions about racial stereotyping in a high-art context, thus avoiding the public channels through which most people are conditioned to accept racist imagery. The Brooklyn Museum, the only other venue for "Facing History," decided to address this problem by rewriting certain wall labels and installing a multimedia slide show at the entrance to the exhibition.

33. See Deborah Willis and Howard Dodson, *Black Photographers Bear Witness: 100 Years of Social Protest,* Williamstown, Mass., Williams College Museum of Art, 1989.

34. Gina Kazimir, in conversation with the author.

35. Marcia Tucker, in conversation with the author. The New Museum, for example, has published a multiracial anthology of essays that address the theme of cultural marginalization, engaging "fundamental issues raised by attempts to define such concepts as mainstream, minority, and 'other,' and open[ing] up new ways of thinking about culture and representation." See Russell Ferguson, Martha Gever, Trinh T. Minh-ha and Cornel West, eds., *Out There: Marginalization and Contemporary Cultures,* New York, New Museum of Contemporary Art, and Cambridge, Mass., and London, M.I.T. Press, 1990.

36. Colescott and Mendieta were, in fact, given retrospectives at the New Museum during 1987–88.

37. This rushed quality extends to the catalogue as well. "The Director's Introduction," for example, which consists of a transcript of a conversation between Marcia Tucker (New Museum), Nilda Peraza (MoCHA) and Kinshasha Holman Conwill (Studio Museum), begins and ends with Tucker speaking—an insensitive imperative to establish the first and last word that tends to accentuate the hierarchical role played by the New Museum in the organization of the show. This lack of forethought extends to the selected bibliography, which is plagued by glaring omissions, particularly the work of intellectuals involved in analyzing cultural colonialism, sexism, homophobia and racism. The arbitrary, sometimes irrelevant list includes works like T. S. Eliot's *Four Quartets* and John Graham's enigmatic *Systems and Dialectics of Art* (1937), while ignoring ground-breaking texts of such authors as Homi Bhabha, Gayatri Spivak, Barbara Ehrenreich, Simon Watney, Bell Hooks, and Cornel West. In addition, while the issue of AIDS is discussed at length in the catalogue, Douglas Crimp's widely known anthology *AIDS: Cultural Analysis/Cultural Activism* (London and Cambridge, Mass., M.I.T. Press, 1988) is omitted from the bibliography.

38. Bell Hooks, "Expertease," *Artforum,* vol. 27, no. 9 (May 1989), p. 20.

IX

Speaking Out:
Some Distance to Go

MARY SCHMIDT CAMPBELL

Mary Schmidt Campbell is dean of New York University's Tisch School of the Arts. From 1987 to 1991, she was commissioner of the Department of Cultural Affairs for New York City. Prior to her appointment to that post, Campbell was for 10 years the executive director of the Studio Museum in Harlem. Campbell has written extensively on African-American art and she completed her Ph.D. from Syracuse University with a study of Romare Bearden (forthcoming from Oxford University Press).

MAURICE BERGER: Your appointment as Cultural Affairs Commissioner sent a powerful message to the people of New York City and the nation. An African-American art historian, curator, and museum administrator who has vigorously supported the work of African-American artists, you are now to oversee a cultural community often indifferent to artists of color. How have you worked to change this problematic situation?

MARY SCHMIDT CAMPBELL: I can't honestly say that I set out with that as a goal. I can't even say this was my goal when

I was executive director of the Studio Museum in Harlem. I made a very simplistic and maybe naive assumption that excellence is the criterion against which you measure any artist. The problem is that most museums in this country, not just in New York, have edited out excellent artists of color. When I was at the Studio Museum, I was always uncomfortable with the fact that somehow it was the responsibility of people of color to correct this problem. Those questions need to be asked of *all* museum directors. The history of art shows some very interesting patterns. For example, the Museum of Modern Art under Alfred Barr's leadership in the early years was very comfortable with including a wide range of artists. Diego Rivera was given one of the museum's earliest one-man shows. William Edmondson, a black sculptor, also had an early solo exhibition at the Modern. In fact if you look at the museum's permanent collection, you'll see they have a surprisingly strong representation of African-American artists. The question one must ask is why the museum has submerged its own history. I don't feel as though I have to be their conscience and answer that question for them.

MB: The work I'm doing on race and culture, and particularly this project concerning African-Americans and museums, is about examining white indifference and even hostility toward black culture. It's not about interpreting black culture but about interpreting the inherent racism of white mainstream institutions.

MSC: I'm not comfortable with the word racism because it is one of the words that has been used so much that it doesn't mean anything anymore. What strikes me as a historian is the extent to which there has been a refusal to consider certain ideas, an unwillingness to confront certain aspects of history. That is the crux of the problem. The refusal to look at certain aspects of our history.

MB: Do you feel that alternative institutions—as opposed to mainstream, white-identified museums—offer the best hopes for African-American cultural enfranchisement? Do you think it is possible for mainstream museums to open up and not be so indifferent?

MSC: I would not deliver a wholesale indictment of all mainstream institutions. Some have been outstanding. The

Brooklyn Museum is a fine example, not only because of its comfort with including people of color in the exhibition schedule but also because of its uninhibited appointment of people of color to leadership positions. Silvia Williams, a former curator there, is now director of the Museum of African Art in Washington. Claudine Brown, who was assistant director for government and community relations, is now interim director of the African-American presence on the Mall project in Washington, D.C. The Brooklyn Museum's relationship with its community is excellent. It's clear that here is a mainstream institution that is deeply comfortable with itself and a continuing reexamination of its own history.

MB: The art historian Judith Wilson has suggested that artists of color have generally fared better outside of New York City in terms of representation in mainstream museums. Do you agree? Do you think this situation is changing?

MSC: I think it's true in that New York is very much like the 19th-century institution of the salon. Our art community represents the most traditional and conservative aspects of the art world. Just as the 19th-century salon grew ever more parochial and provincial, so to some extent has the New York art world. People of color play the role of the upstarts like Degas and Cézanne and others who could not get into the salon or who could get in only from time to time. Alternative spaces are like the *Salon d'automne* or the *Salon des refusés*. This vast network of alternative spaces offers a very exciting range of possibilities.

MB: Do you see the situation changing somewhat in the near future? In other words, will certain mainstream institutions catch up with alternative spaces or is a kind of bifurcated situation inevitable—heavily funded museums versus alternative institutions which are really doing the major work and yet often struggle for funding?

MSC: Things don't remain the same. I think positive things can eventually happen. Ten years ago, the Studio Museum in Harlem was hanging by a thread. That is not true anymore. The extent to which the museum has rooted itself in its community and developed a radically different level of professionalism in just a decade is impressive. I'd be very interested to see what the next 10 years will bring. I wonder

if the landscape will not change so that instead of having only the big guys and the little guys it will level out.

MB: To what extent will Mayor David Dinkins's recent budget cuts affect the Department of Cultural Affairs? Will these cuts hurt programs that aid artists of color? Will private funding have to replace government money?

MSC: Thus far the most devastating cuts to organizations that represent people of color were actually done prior to the Dinkins administration. There was a decision made to eliminate a small fund used to assist new or struggling multi-cultural organizations. That was a devastating blow.

MB: Were these cuts instituted by Mayor Koch?

MSC: No. They were the result of last minute budgetary horse trading. These funds were eliminated without people really understanding what was at stake. The cuts that are projected for fiscal year 1991 are serious. They will affect every organization in New York, large and small. The problem that the communities themselves are faced with is not just the reduction or downsizing of local governments but shrinking support in the private sector and unfavorable tax laws that no longer encourage private donations. In a generally shrinking economy, those who are most economically fragile to begin with are obviously most at risk. And this tends to mean, more often than not, that organizations representing people of color are among the first to suffer. It's not just the result of government actions, but of a whole web of circumstances that have been created over the past four or five years, starting with the 1986 tax reform act. It is, in fact, going to be a very difficult couple of years for smaller cultural groups. My sense is that the one advantage they have is that they often have a very strong relationship with their community. They tend to have very good support systems. Also, they often have smaller operations to support so they can live in an economical way frequently impossible at a higher level. But it is going to be very tough for them, very tough.

DAVID HAMMONS

David Hammons is an artist who lives and works in New York City. In 1989/90 he was a fellow at the American Academy in Rome. A 22-year retrospective of his work opened in 1990 at the Institute for Contemporary Art (P.S. 1) in Long Island City.

MAURICE BERGER: You have said, "I feel it is my moral obligation as a black artist to try to graphically document what I feel socially." How might this statement apply to your art works and installations of the past decade?

DAVID HAMMONS: I think I spend 85 percent of my time on the streets as opposed to in the studio. So when I go to the studio I expect to regurgitate these experiences of the street. All of the things that I see socially—the social conditions of racism—come out like a sweat. I'm responding to the social condition in New York. The reason I love New York is that the social conditions are so raw there. You don't have to guess what's going on; it is so visually stimulating. The interaction between people reminds me of being in a wolf's den as opposed to a fox's den. A fox is so foxy with his maneuvering; you don't really know exactly what he's saying. In New York—in the wolf's den—the wolf tells you exactly what he's thinking: "I don't want you in here, so don't come in here."

So my alignment in that situation as a black man is very clear. My defense against this offense is to deal with racism and how racism is destroying our country internally. It's such a joke to see America spending so much energy looking for the communist red demon on the outside, a demon that doesn't even exist. We're dealing with the illusion of someone outside threatening our security when the real threat is happening within our own borders. Blacks and whites are being played against each other for the capitalist gains of a few individuals.

MB: You also say that your work "will make people think, think about themselves and what that means." Who are you directing these statements to?

DH: I'm speaking to both sides. I'm really right in the middle of the battle, and not, as most artists believe, on the

outside looking in. I'm directing my work toward the galler-
ies, toward the museums and toward the people who are
coming into these places. As an artist I'm not aligned with
the collectors or the dealers or the museums; I see them all
as frauds.

MB: Your work often positions itself in a way that chal-
lenges the complacency and conservatism not just of the art
world itself but of America in general as it addresses issues
of race and class. Who have traditionally been your patrons?
I noticed that in the 1970s your work was purchased by black
collectors such as Herbie Hancock, Bill Cosby and Stevie
Wonder. But I didn't see any major white patrons, at least
back then. Has that changed?

DH: No, it hasn't. Now I have one patron, A. C. Hudgins.
He has been buying my work for over 15 years. He is a black
person who lives on 163rd Street in upper Manhattan. He's
been my only patron. He lends me money, and I'll pay it
back with a piece, or he'll buy something to keep me going.
I don't expect white Americans to purchase my work. If I
made abstract art, things might be a little different. Abstract
art has gotten so watered down that the bourgeoisie can con-
sume it, because it expresses no force, no attitude, no opin-
ion. It just has shape, form and color. It generally has no
political substance. If art by African-Americans has quality,
content and a clear opinion, then white collectors can't rally
around it. That's the reason they don't collect my work.

MB: Because it's threatening?

DH: No, it's not threatening. It just has too much content
and intention. It has a point of view.

MB: What you're saying is that mainstream institutions are
generally unwilling to accept such powerful political state-
ments?

DH: They can't, because somebody would get fired. When
the work has no political energy, when it's just a formalist
statement, then everybody can like it and curators can main-
tain their jobs. It is my belief that artists should disturb,
upset, criticize, make fun of the establishment. But now art-
ists are stroking the system. They want to join the king's
court.

MB: Do you think there is an unevenness to the way Afri-

can-Americans are respected and absorbed into mainstream culture? Even if there is an economic disparity, it seems to me that African-American culture has played a greater role in American music, for example, than in art. Museums and galleries seem to be the cultural spaces least willing to hear the cultural voice of African-Americans.

DH: Yes, but the visual arts are in many ways the most problematic for African-Americans. You have to sit down and physically make art. And that takes a lot of time. In music you could sing the songs while you were picking the cotton; it didn't matter how much hell you were catching. Music was always growing and advancing for black people.

MB: So art takes the kind of time and money that has rarely been available to African-Americans.

DH: Yes, our basic problem in America, as black Americans, is financial. As long as our capital base is weak, we will never get the kind of respect we deserve.

MB: You are currently a fellow at the American Academy in Rome. How do you find the cultural environment in Europe?

DH: People are moving toward "people power" over here in Europe. It's very interesting being here at this time. People are much more polite and respectful. In New York when I walk into a supermarket someone follows me around to see if I'm going to steal something. I can't even hail a taxicab. That's humiliating. It's insulting that some cabdriver can have an opinion about me without even knowing who I am. America is so much about "I got mine and fuck everybody else." That has to change. People don't want to work together. We have no leaders to rally around. We've had con artists as presidents. You get a bad actor in B films. You get an ex-CIA man. America just doesn't have any statesmen, no real leaders. Personally, I want to get out of America. Maybe I'll come back and visit occasionally. But I'm not interested in spending the rest of my life in that Mickey Mouse, Donald Duck, fast-food, McDonald's mentality.

HENRY LOUIS GATES, JR.

Henry Louis Gates, Jr., is professor of English at Harvard University. The author of several books including Figures in Black: Words, Signs, and the "Racial" Self *(1987) and* The Signifying Monkey: A Theory of African-American Literary Criticism *(which won an American Book Award in 1989), he is also general editor of both the Schomburg Library of Black Women Writers and* The Norton Anthology of African-American Literature.

MAURICE BERGER: Speaking of the period between 1710 and 1940 in your catalogue essay for the exhibition "Facing History," you write: "Black people were expected to function in a society in ways that conformed to a public image—a white fiction of blackness." Does this "fiction" continue to exist in high and popular culture?

HENRY LOUIS GATES, JR.: Certainly. Despite the passage of the Civil Rights Act and the Voting Rights Act in the mid-1960s and the subsequent emergence of the black power and black esthetic movements, the received stereotypes of black people, though extensively critiqued by black artists and writers, still obtain. Stereotypes have a life which is difficult to end. In 1933, the great black poet and critic Sterling Brown divided the full range of black character types in American literature into seven categories that often still apply: the contented slave, the wretched freeman, the comic Negro, the brute Negro, the tragic mulatto, the local-color Negro and the exotic primitive. In a recent *New York Times* article I used these seven categories to analyze the way black people are represented on contemporary American television programs. It seems obvious to me that even a positive image—"The Cosby Show," for example—is still caught in the same web of stereotyping as can be seen in such obviously negative images as those of Amos and Andy. In one sense, there really is not much difference between negative and positive idealization; they are equally far from reality, except in opposite ways. It makes little difference if a black person is represented as a king or god on the one hand or as a devil

and a force of evil on the other. Both sets of images serve equally to create an unreality in the life of a black person. It doesn't matter if a white person encounters an actual black human being through a positive or a negative stereotype; the actuality is still removed. I don't think that enough of us who try to critically analyze black images have taken account of this paradox.

MB: In an essay on "Writing and Difference," you state that in the "proper study of literature in this century race has been an invisible quantity, a persistent yet implicit presence." This observation is, of course, applicable to other fields such as the study of the visual arts, where the interest in examining racial issues—particularly among white critics and art historians—is almost nonexistent. To what do you attribute this cultural and academic indifference?

HLG: I attribute this willful ignorance to an almost complete lack of respect for African-American intellectual endeavors on the part of the larger society. I believe there is an even worse root cause: a fundamental doubt or skepticism about black people's capacity to create "great art" or "classics" in any field. American society still perpetuates the most subtle and most pernicious form of racism against blacks— doubt about our intellectual capacities. All the talk about SAT scores and black people's competency on standardized tests reflects deeper skepticism on the part of the larger society about our intellectual capacity. It's a skepticism, of course, which was forged laboriously from the Renaissance through the Enlightenment, with all sorts of Western philosophers wondering aloud about the fundamental inequality of the mind of the black versus the European. Such viewpoints were important to establish in order to justify an economic and social order that kept black people in the basement. We are still caught in this intellectual heritage. Take for example the most famous and probably most brilliant African-American intellectual, W. E. B. Dubois. Although he was one of the fathers of American socialism, he is rarely taught in American sociology courses. People in the sociological professions must be ashamed of these roots. In music our contributions have been acknowledged to a much

greater extent than they have been in philosophical or dis-
cursive endeavors; yet even in music people say that Charlie
Parker is a genius . . . "in jazz"!

MB: It's like what happened to Norman Lewis in art his-
tory. He was an intensely creative and interesting Abstract-
Expressionist painter, yet he is never mentioned in the white-
identified canon of art history. Whenever there is a discourse
which tries to formulate what Abstract Expression means,
Norman Lewis is omitted.

HLG: Exactly. That's how it works.

MB: I wanted to follow up on what you said about SAT
scores and standardized testing. Such "tests" arise from the
systems that the white world or the mainstream world sets
up for evaluation and "truth"—standards that are them-
selves perhaps incapable of evaluating or even addressing
culturally diverse work because they are themselves white-
identified.

HLG: Absolutely. But I wouldn't use the term "white-iden-
tified." I would say that these systems are culture-bound;
they are culturally specific. Preexisting esthetic systems arise
from a specific body of texts. When these texts—be they
artistic, musical or discursive—emerge from another tradi-
tion, they often clash with the esthetic systems that are being
used to interpret them. It's what I call the signifying black
difference in a painting, a musical composition or a work of
fiction. This difference is often bracketed, excluded, not
understood or judged through a misinformed esthetic. What
we must have is the production of new esthetic systems that
account for the full complexity of American art, music, and
literature—in all of their multicolored strains—instead of
trying to place works of black tradition on a bed of Pro-
crustes, lopping off their arms and legs to make them fit a
shape which is not really theirs. To say that black art is a
thing apart, separate from the whole, is a racist fiction. We
have to conceive a new esthetic status for American art in all
of its facets—whether Hispanic, Native American, Asian
American or white.

MB: On the subject of difference, to what extent do you
believe that African-Americans must deculturalize their own
voices in order to be accepted by mainstream institutions in

America? In other words, must African-Americans renounce their own cultural identity to be accepted by the white upperclass patrons who control the mainstream cultural institutions?

HLG: I don't think so. It's incumbent upon the artist to speak in his or her own voice, whatever that voice might be. The cultural establishment will have to accommodate this voice. The surest prescription for artistic disaster, by which I mean inauthenticity, is when an artist tries to change his or her idiom to suit the patron. Such art never rings true. Sometimes when I look at some of the art of the Harlem Renaissance, for example, I wonder who this work was for. It's hard for me to read it. It seems to me that the esthetic is so mixed that I often get the feeling that visual artists were pandering to their patrons. It was different in music, where generally the artists' patrons were black.

MB: Ultimately, what I am asking is, are things so bad now that a separate black patronage class has to be created in order to assure a place for African-American culture?

HLG: I think we have to do two things. First, we do have to develop a black patronage class. And this is something that I think we are only now in a position to do. People need a tremendous amount of financial security to want to give money away to artists or even to buy art. The larger changes in American society after 1965, when certain forms of American apartheid began to fall, produced a new black middle class. The difference between the old and new black middle classes is what my mother used to call the difference between having colored money and white money. Now we have a whole new class of people educated like me in well-known white schools. We are now economically comfortable. We will start to become patrons of the arts once we feel secure enough, once we know that our checks won't bounce or we won't be evicted.

In addition, however, we need to connect with wealthy white patrons, so that we have a more integrated patronage class. It's not the presence of white patronage that's so bad; after all we are all patronized in some way by white people in America—I teach at Cornell University, for example. We can't be naive about it. The question is what strings patron-

age brings with it. That's where integrated patronage can be important. We can have money from the broadest source possible, yet we can develop sensitivity toward the artists themselves. We can free black artists in the way that Langston Hughes and Zora Neale Hurston were not free under the patronage of whites who ultimately weren't interested in their opinions.

MB: What do you, as a prominent academic, think the university might do to further the cause of cultural enfranchisement for African-Americans and other people of color? What structural, curricular and employment policies must change in order to bring students closer to these issues?

HLG: The most important thing the university can do is to develop strong ethnic studies programs. Given the changing demographics of American society and the calls on the cultural left for a much more diverse curriculum from preschool to college, I think that the role for ethnic studies programs has never been potentially greater. The emergence of a crude and vulgar nationalism throughout the Soviet Union and the Eastern Bloc now that Communism appears to be dead only reinforces our sense of the importance of ethnicity in the 21st century. We must be cautious— we do not want the celebration of ethnicity to turn into chauvinism or racism. The university can facilitate this whole process by developing interdisciplinary theoretical frameworks within new or strengthened ethnic study departments.

MB: I would expect art historians to be resistant to this idea, since art history is one of the fields in the humanities least open to people of color or ethnic studies in general.

HLG: Art history hasn't changed in the way that my own field, literature, has because of the absence of a large body of black and other scholars of color. But English departments didn't change on their own. We changed them through black studies programs. In the 1960s, black studies programs identified history and literature as the most important areas for study. We have seen dramatic transformations in both these fields over the past years. We have to make the study of art and music more and more essential to black studies programs and other ethnic studies programs so that the same thing will happen in those disciplines. I think it's

also important to say that while we insist on the development of new esthetic systems and new institutional constructs that account for the complexity of our experience, it's important not to fall into the racist trap of thinking that one has to be black to write about black culture. What would we say to someone who said that I couldn't write about Picasso because I'm not Spanish. We would probably say that person is a racist. The fundamental premise of the academy is that things are knowable and that things are teachable. Anyone can learn to write about our culture; there's no biological basis for understanding other people's cultures. We have to resist any attempts to replicate the racist constructs that oppress us.

PAT WARD WILLIAMS

Pat Ward Williams teaches in the photography department at the California Institute of the Arts in Valencia, California. A recent solo exhibition, an installation examining the May 1985 Philadelphia police bombing of the headquarters of the activist organization MOVE, was mounted at the Los Angeles Center for Photographic Studies in 1989.

MAURICE BERGER: You often use historical images in your photographic constructions to comment on contemporary social issues. In *Accused/Blowtorch/Padlock* (1986), for example, you surround *Life* magazine images of a lynched black man with handwritten questions about the social and ethical responsibility of media representation. In what way does American culture currently deal with its responsibility to represent African-Americans and other people of color?

PAT WARD WILLIAMS: Once again it's a problem of African-Americans being effectively invisible. White people often see a color instead of a person; they think that being black is a condition rather than a racial difference. Very often black people are lumped together in one category to facilitate people's handling of difference, which was one of the reasons that I started making photographs. Historically,

photographic images of black people were often ignored by white people, who thought such images were meant to speak only to black people. When I first started taking photographs, especially in the documentary tradition, I was trying to fight against what I thought were the negative messages that photography had previously communicated to black people. I also realized how easy it was to fall into the same trap and become my own oppressor. A single, documentary shot is usually too little to express a broader idea about racism. That's why I started to make photographic constructions; by giving my images a larger context I could say directly what I wanted to say.

MB: These constructions are incredibly powerful. How do white-identified institutions respond to your politically charged images? Do you find much interest in this work from mainstream museums and galleries or college museums?

PWW: Mainstream galleries completely ignore me. Larger institutions with an academic affiliation are most likely to accept my work. My constructions promote discussion. People can talk about the provocative or controversial images. Someone's curiosity might be sparked to look further into a situation or issue.

MB: Why do you think galleries and other nonacademic institutions ignore you?

PWW: Those institutions are based on selling work or amassing collections of valuable objects. My work is just not going to sell. You would be surprised how many people wouldn't want a lynched man hanging over their sofa.

MB: Your work has a strong relationship to theories of representation. You were recently hired to teach photography on a full-time basis by the California Institute of the Arts —a school noted for its emphasis on theory. Has the recent interest of collectors in theoretically oriented art extended to your work?

PWW: No. But the CalArts experience has been very encouraging. Because I'm interested in theories of representation, problems in documentary photography and deconstructing images of black people, I fit in very well here.

MB: But collectors are not biting.

PWW: Not at all.

MB: What are some of the theoretical models that interest you?

PWW: Early on, I was very much interested in Brian Wallis's anthology *Art After Modernism,* and especially Abigail Solomon-Godeau's essay "Photography After Art Photography." I was thrilled to meet Allan Sekula after reading a lot of his work. I have recently been reading post-structuralist theory. But one must not overestimate theory. You can quote all the theory that you want, but then you have to go back and apply what you've read to your life. Theory sometimes makes what you say too vague, too elitist. Sometimes I have to say to my students, "Let's see what you can do with these theories now that you've got them." They get intellectually frozen to the point where they can't produce any art work at all. My role as a teacher has been to help them make the connections to reality.

I enjoy working with theoretical issues, but these ideas really aren't new to the black community. Theories of representation which had formerly been applied by blacks to images of blacks have recently been engaged much more broadly in the entire art world.

MB: In certain of your constructions, the problems of racism are reflected through the discourse of gender, and vice versa. In other words, you are often concerned with the particular kind of disaffection felt by African-American *women.* Could you comment on that relationship?

PWW: I sort of sit on the fence with feminism. I agree with a lot of the basic tenets of feminism, especially those concerning representation and the construction of gender. Yet, at the same time, I am more strongly concerned with the issues of race representation. If I were to identify too strongly with the white feminist movement, I'd still be identifying with the oppressor.

GUY McELROY

Guy McElroy died on May 31, 1990. At the time of his death, McElroy was a doctoral candidate in art history at the University of Maryland. As adjunct curator at the Corcoran Gallery of Art in Washington, D.C., from 1986 to 1989, McElroy organized the exhibition "Facing History: The Black Image in American Art 1710–1940."

MAURICE BERGER: You recently suggested that in the 1960s black artists made a conscientious effort to esthetically separate themselves from white mainstream culture in order to celebrate their own identity as African-Americans with a distinctive culture, in other words, to create a "Black Style." Do you think this ideological shift toward cultural difference has made contemporary African-American art more difficult for mainstream museums to absorb?

GUY McELROY: Responsive institutions in the late 1960s and '70s did try to absorb African-American culture into the museum structure. Certain museums did become more responsive to their audience and to the way museum activities affected the museum-goer. At the same time, although there were changes in artistic styles, many African-Americans chose to avoid working within an overtly black esthetic. Today, the term "black art" is most often used to refer to art by black people rather than to art with a black theme. Consequently, the idea that a visible difference exists has lost some significance. It is true, too, that the idea of political art seems to be taken less seriously today than during that period.

MB: So you feel that the idea of a black style was more of a 1960s phenomenon that does not necessarily carry over to the present.

GM: The political impulse is definitely not as strong today in the art of African-Americans as is the desire to create an art that might appeal to a broader public. One recent exhibition at the Howard University Art Gallery, "4 + 1," gave some idea of the complexity of this phenomenon. The show was actually criticized by some for being too entrenched in feelings of frustration and desperation with the American

system and for being specifically aimed at a black audience. Yet in looking at the work, you would hardly know by either its style or content that it was produced by black artists. The kind of radical black art that was made in the 1970s—Afri-Cobra, for example—is not done much today.

MB: But a great deal of politically radical African-American art is being done today. When the political content of such work speaks strongly about the issue of racism, isn't it more difficult for mainstream institutions to accept?

GM: Most African-Americans don't end up in mainstream museums anyway. They don't get the kind of exposure that would allow them to become desirable for collectors. Yes, some of this work does have themes that may be difficult for the American mainstream to look at and to respond to positively. Only the exceptional curator would not see these works as a problem. The recent questions over public funding for art, initiated by Jesse Helms and others in Congress, would suggest that there is an interest in censoring certain themes. It's interesting to me that the Mapplethorpe exhibition, while it was not a show of work by a black man, was still an exhibition that was often *about* black men. And some people felt it was important to remove the show from the public eye. Aside from the issue of homophobia, I think depictions of white women or white men would have been less alarming.

MB: In relation to the Helms initiative, some of the curators with forthcoming shows at the Corcoran decided to withdraw their exhibitions in protest. Did you make a decision not to withdraw "Facing History" for a particular reason?

GM: My exhibition was in the organizing stage years before the Mapplethorpe show became a battleground. The people at the Corcoran and elsewhere who came together to generate this exhibition were very much concerned with the issues of minority access to museums and the idea of museums being responsive to groups that were not in the mainstream. The value of "Facing History" was that it could address these issues in a way that would appeal to a fairly large audience. The work in the show deals with very unpleasant political issues. It was no less important that the show be mounted despite the Mapplethorpe problem. When the Mapple-

thorpe impasse happened, our show was close to opening. A lot of money had been invested. We would have been much the poorer by not having the show appear in Washington.

MB: You now hold the position as manager of Technical Information Services for the American Association of Museums in Washington, D.C. What are some of the programs being instituted by the AAM, both educational and practical, for helping to enfranchise African-Americans and other people of color into white-identified, mainstream institutions? Is there a move to speed up the accreditation process so that smaller spaces can be in a better position for funding?

GM: While I'm new in this job, I do know efforts are being made to include black museum leaders and curators in the programs initiated by the AAM. There is also a major effort to search out and accredit black cultural institutions.

MB: How must the institutional structure of white-identified museums change in order to enfranchise African-Americans and other people of color? Or must alternative spaces continue to be the predominant venues for these interests?

GM: I think it's funny that we are having this discussion in 1990, since this debate was a major point of issue in the early 1970s. There was a concern about getting more blacks into museums. I think that what happened was that the move to share, to locate and place African-Americans in the larger cultural institutions didn't succeed as much as it should have. It was difficult to find blacks who had the academic or experiential background that would allow them to be hired and to remain in key positions. At this point, we need to place professionally experienced blacks in positions that would allow them to be interpreters of American culture. They must be intrepreters not only of African-American culture but, like other curators and museum professionals, of culture across the board. In order to have the whole picture while working on my Ph.D. on American art, I have to be aware of the important things being done by mainstream American artists. Yet, in museum studies classes and Ph.D. programs, people can go through their entire education and never learn anything about African-American art, or Chinese-American art, or any work being done by other eth-

nic groups. Consequently, there is a kind of bias in terms of the interpretations we are allowed to make.

MB: Some writers and institutions have criticized your recent exhibition "Facing History" for centering too much on negative images of African-Americans painted by white artists. How would you respond to this criticism?

GM: The purpose of the exhibition was to show how American art from the 18th century to the 1940s portrayed blacks. Most painters of that time were white. The exhibition needed to address the fact that these were the images that were pervasive in high culture. I take exception to the idea that all these images were negative. The negative images should not, of course, be ignored just because they are not pleasant to look at. These images were selected because they say something about how people were looking at African-Americans at a certain time. And we tried to select works that were of high esthetic value.

MB: I think one of the underlying issues here is how difficult it is for white Americans to face the reality of their own representations and their own racism. "Facing History" presents cherished American master figures painting deeply racist images. Why did you decide to limit "Facing History" to examples from fine art instead of expanding your inquiry, as you first intended, to popular culture? Don't you think such mass imagery would have better contextualized the historical and ideological issues of racism you are addressing?

GM: The reason for narrowing the exhibition down to the fine arts was mostly one of scale. The original proposal was just too big. Also, an uncomfortable dichotomy exists between high art and popular images. Could "Great Works of Art" be juxtaposed with works from Currier & Ives? The fine-art images could easily represent the range of ideas we wanted. Also, we didn't want people not to lend to the show because they thought we didn't appreciate the difference between high art and popular culture. In fact, a couple of corporations were initially very interested but wimped out when they realized it would be more than just pretty pictures. Socially and contextually the productions of popular culture are indeed equivalent to what we call the fine arts.

But in terms of how the two modalities are represented publicly, there is a vast difference. The social bases for these popular-art images could be explored and contextualized elsewhere—maybe in a book or another exhibition.

JOHNNETTA COLE

Johnnetta B. Cole is president of Spelman College in Atlanta, Georgia. She is president of the International Women's Anthropology Conference, past president of the Association of Black Anthropologists and a member of the Council on Foreign Relations. Her books include All American Women: Lines that Divide, Ties That Bind *(1986) and* Anthropology for the Nineties *(1988).*

MAURICE BERGER: Mainstream cultural institutions in America tend to privilege the cultural production of whites over that of African-Americans and other people of color. Nowhere is this more evident than in major museums, where people of color are almost never granted solo exhibitions or retrospectives. What do you think are the reasons for this marginalization?

JOHNNETTA COLE: How could it be otherwise? The institutions of cultural expression cannot be divorced from the society that forms their base. At the same time, art has the power to confront that base. While I would like to see every institution—the institutions of education, the institutions of government—be a positive agent for change in our society, the arts can play a special adversarial role. The profound disappointment—indeed I'm prepared to say the obscenity —of today's art world is that this unique responsibility is not being honored. Indeed, artists of color often have little expectation that they can be included in this world. I would like to read to you the words of a young artist that just pierce my heart. His name is Alonso Adams, a 28-year-old African-American born in Harlem. At the moment he's studying fine arts at the University of Pennsylvania. He says: "I want to have my work showing in the Metropolitan Museum of Art or in another prominent museum. If I were content with

only showing my work in black galleries and shows that would be all right. But I know if that happens I'll never be found in history books . . . only in the few and hard-to-find books about black people in this country. I want to leave something for my children . . . so they know who I was. . . ." When a young artist begins his career knowing that he may not endure in our society, this is very painful.

MB: Do you think that African-Americans should push for greater inclusion in mainstream institutions, where there is often little hope of major representation, or are they better served by alternative institutions, such as the Studio Museum in Harlem, that are specifically committed to perpetuating and supporting black culture?

JC: There is simply no choice but to push for both. What concerns me about the young man I talked about is the possibility that in order to find himself in mainstream museums he must deculturalize himself just as women often must degender themselves in order to be permissible to the dominant culture. The objective then becomes for us to say, "Oh that happens to be done by an African-American," or, "That just happens to be done by someone who is gay." In other words, you're defined as an artist first and a black, a woman, or gay person second. If one does not create out of the integrity of who one is then one does not produce art but junk. By maintaining a relationship with our alternative institutions we have a better chance of presenting our many selves. I fear the consequences of giving up what now works for us before we find mainstream institutions prepared to receive our work.

MB: On the economic side of this question, do you believe that the white, upper-class people who constitute the patronage base for museums and galleries can ever be educated to appreciate or even tolerate African-American culture? Or must African-Americans themselves form a new patronage base in order to enfranchise artists of color?

JC: My husband and I recently went to a wonderful gallery in Philadelphia, the October Gallery, owned by an African-American man and woman. In the course of our looking together at art that was at once exciting and disturbing, they shared with us something that responds to your question.

They showed us a photograph of a young, very successful African-American rap artist who was rolling in money. His mother, a school teacher, brought him to the gallery and said, "You can buy those chains around your neck. Maybe you can even buy yourself a car. But you're also going to buy a piece of art." Now that's unbelievably exciting, because only recently have blacks realized their power as patrons.

MB: This a point that Bill Cosby makes.

JC: Bill is a perfect example. This man is an incredible patron of the arts. I do think we have to find ways to expose, to educate, to make acceptable to different peoples among us our cultural production.

MB: Speaking as a college president, what role do you think universities can play in breaking down the forces that marginalize African-American culture? Can we teach people to undo their racism?

JC: Let me answer both questions at once. If I ever conclude that racism is genetic, that sexism is genetic, that homophobia is genetic, that any form of bigotry is genetic, then I'll be prepared to roll over and die. These wretched "isms" are learned. And, of course, the basic lesson of anthropology, maybe the only lesson we've given the world, is that so much of culture is learned. If you learn it, you can unlearn it. So, yes, I insist that we can unlearn racism. The key question is who is in charge of learning? The answer is that we academics are. What is absolutely criminal is when we, with all of the mechanisms for learning and unlearning at our disposal, do not enter into this discourse. We can critique the major museums. We can talk about the art establishment. We can critique the art critic. But the folks we must critique first are ourselves, because if we are not, as a part of these institutions, raising questions that might provoke a change in the attitudes of our society, then we are not producing well-educated women and men.

MB: Yet such a project, especially in art history, can be very threatening to the academic "old boys" who have little regard for the cultural production of those who have not been officially enfranchised by the dominant discourse. Consequently, younger academics, if they are not already

indifferent to these issues, can be paralyzed by the fear of upsetting the status quo and so being denied tenure.

JC: There is good reason for this fear, it seems to me. I would like to return to the art world's extraordinary resistance to people of color. This is a world where the economic stakes can be high, so I understand the resistance to sharing the economic rewards. Those folks are not prepared, as Frederick Douglass said, to give up power. They concede nothing. They never have. They probably never will.

MB: Over the past decade, the art industry has indeed become extraordinarily powerful on the economic level.

JC: Our society has also placed another kind of power in mass-produced visual imagery. Imagine if the kinds of political realities we are talking about not only found their way into the Museum of Modern Art or the Guggenheim but found their way into the mass media. In other words, we have the technological means to use art as a major force for positive education and change.

MB: Do you think that museums, or more generally, the institutions of high culture, are appropriate venues for communicating the political reality of oppressed peoples?

JC: Rare is the museum curator who understands that culture must be socially and politically contextualized in order to be relevant to most people. Yet when that realization is somehow achieved, it can become an extraordinarily exciting thing. We're tending to do that, it seems to me, much more in the museums of science and technology than of "high art." Talk about the bastion of the status quo! Art museums clearly imagine themselves as being able to exhibit only certain things, in certain ways.

MB: Do you see a general improvement or decline over the past decade in the status of African-Americans and other people of color in American culture at large?

JB: Maurice, you know that I'm not a dogmatic person! But where is the evidence that things have gotten better? Where is the evidence? On the contrary, statistically, African-Americans are losing all the things that are good for us—decent health care, reasonable if not dedicated education and adequate housing. Our accessibility to the arts has improved in

certain areas; in others, like museums and galleries, we are still pathetically underrepresented. African-Americans have become more and more affected by everything that is destructive in our society—from drugs, to AIDS, to homelessness. Yes, there are some African-Americans who have definitely become better-off materially, but the decrease in the quality of life for large numbers of African-Americans is also obvious. Of course I would have to say that things have improved to the extent that African-Americans can walk legally into mainstream social and cultural institutions. Jim Crow segregation does not exist any more. We shouldn't belittle that. People lost their lives. Black and white folks lost their lives struggling for that right. But it is now ten years before the next century. We've got to talk about what happens when we have a Supreme Court that is systematically taking away the very rights we worked so hard to win. The question you ask is the most crucial question in America today. We have got to talk about the quality of life and the viability of our culture, not only for African-Americans but for other Americans of color. At a moment when we are excited about the changes, the positive changes, going on in Eastern Europe, we cannot assume that the struggle is over in our own land. The struggle is not over. Where we've got to go is some kind of a distance.

INDEX

Note: Page numbers in italics refer to illustrations.